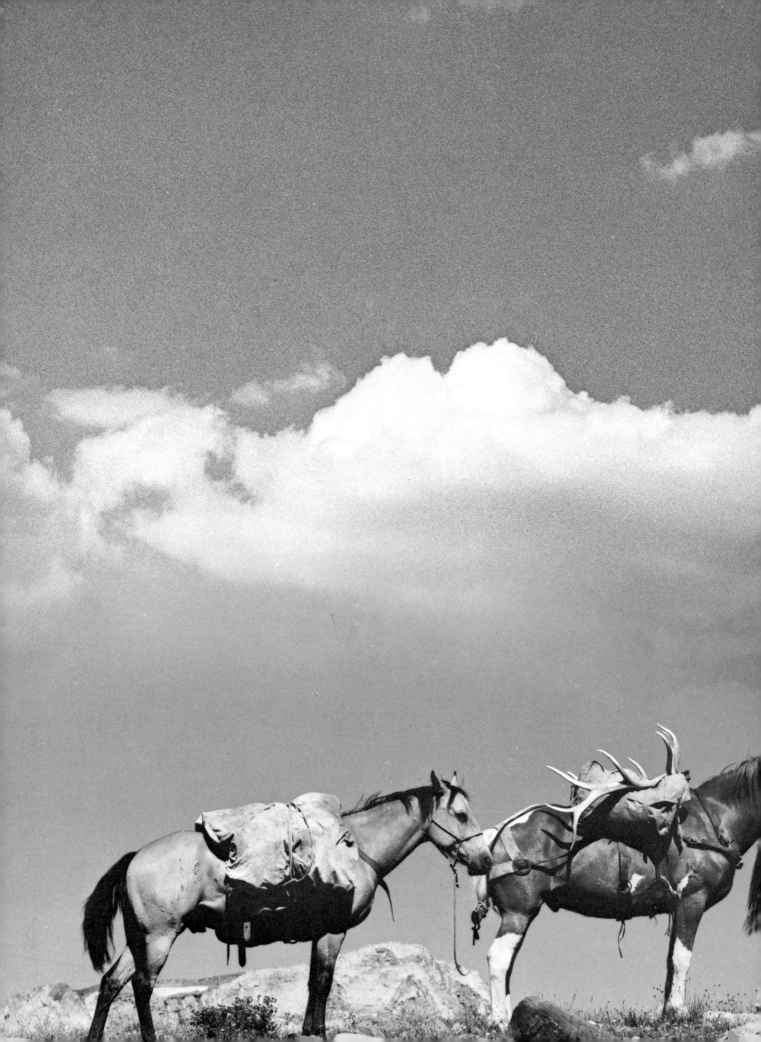

CAMERA AFIELD

SID LATHAM

published by **Stackpole Books**

Cameron and Kelker Streets, Harrisburg, PA 17105

CAMERA AFIELD
Copyright © 1976 by
Sid Latham

Published by
STACKPOLE BOOKS
Cameron and Kelker Streets
Harrisburg, Pa. 17105

Designed by Fred Samperi
Photos by the Author

Printed in the U.S.A.

Library of Congress Cataloging in Publication Data

Latham, Sidney.
 Camera afield.

 Includes index.
 1. Travel photography. 2. Photography of sports.
3. Nature photography. I. Title.
TR790.L37 770'.28 75-38812
ISBN 0-8117-0311-8

To my wife, Lilyan,
who has been blessed with
infinite wanderlust.

Table of Contents

Acknowledgments

Most professional photographers can only complete their assignments through the kindness of strangers. There were many who helped me over the years with their special knowledge and skills and to those men I owe a debt of gratitude. Without their support, these strangers who became friends, neither my work nor this book would have been possible.

To Ponsiano Semwezi, Chief Game Warden of Uganda's Murchison National Park, who guided me into remote areas for photography and John Stephenson, Chief Game Warden of Tanzania's Southern District, who opened the vast domain under his care to my wandering—to both my thanks.

Mountaineer Virg England of Anchorage who guided me into the Chugach mountains and Alaskan friends, knifemaker Gil Hibben and guide Phil ''Pierre'' Lobred, who took time from other duties to show me much of their wonderful state.

In Colorado there were Dick Arnold and Scott Bowie of Aspen Mountain Rescue who demonstrated spectacular feats of climbing and Charlie Loughridge of The Ranch At Roaring Fork who introduced me to trout fishing at its finest. Also from the ranch was Dick Reidy, a wrangler of no mean repute, who took me on a pack trip into the Rockies which gave some idea of how the early men of the West must have felt after ten hours in the saddle.

And, finally, Bob Isear, a good friend and colleague of more than thirty years, who sparked the idea for this effort. To all these men go my very great thanks for their unfailing kindness, courtesy, and help.

New York, N.Y.
April, 1976

Sid Latham

Foreword

During the past dozen years Americans have become more concerned with their environment and an unknown word: ecology, has become a standard of our vocabulary. Hunters and fishermen have borne the burden of disdain although their dollars for hunting licenses, and taxes on sporting equipment, have helped pay for all those lovely parks enjoyed by millions.

Now there is a new trend in the outdoors; backpackers and wilderness campers. Youngsters, and even young families, are going into areas once thought to be the province of expeditions and hardy sourdoughs. The Cascade Range or Yellowstone in winter are providing new recreational areas in seasons once the domain of elk and moose.

As a photographer I've been fortunate, over the past thirty years, to work in the outdoors. I've traveled to many of the remote parts of the world on assignments and, increasingly, find more and more cameras being used. John Whiting, a former photo editor, once said, "Photography Is A Language," and, indeed, wrote a book with that exact title. Whiting was right; it is a language, almost a universal language, and the amateur is able to communicate with the professional with some understanding.

No matter how exotic the locale I've found cameras carried by foresters, geologists, helicopter pilots, mountain climbers, hunters, fishermen and, even one time, some officers of the Anti-Pirate Police in Borneo. In fact I was once marooned in a high mountain valley in New Guinea with two geologists for company. Torrential rains had closed the area and choppers couldn't get in from the base camp on the coast. For three days we read detective stories, played chess and finally got to photography. Both men had cameras and wanted good color pictures of soil samples for their reports. Another time, across the world, the problem was different, how to photograph the capture of an anaconda underwater.

Even among my friends at Camp Fire Club, a group of outdoorsmen who never understood the meaning of ecology because they were conservationists long before such verbiage became popular, not everyone is a hunter or fisherman. There are mountain climbers and fast water canoists, hikers and campers and even backpackers who swing a rucksack over their shoulders and continue their love affair with the outdoors. All these men derive pleasure heading out where the air is crisp and the sky a shade of blue seldom seen in the big cities anymore.

Over the years I must confess I've been concerned more than once with some simple query about photography. In retrospect some of those questions haven't been that simple either. What aspiring camera buffs want are simple answers to complicated problems and it isn't all that easy to reply, particularly if the man is a complete novice with the camera. Of course there are those enamored of the technical jargon of photography. These gadgeteers find all that gleaming glass and chrome fascinating and become so hypnotized they rarely consider the equipment must be understood before demanding it deliver fairly complex pictures. And then, of course, there are those many picture snappers (they can't be called photographers) who are perfectly happy with a record shot of a hunting trip or a slightly out-of-focus view of San Francisco harbor. In the majority are many, however, who truly seek better pictures. Clearer, sharper and more exacting results, a dramatic angle or exciting view. When they ask a question they expect a direct reply and the answer is really stored away for future use.

Those who devote time to travel, for fun or sport, often have quite different problems than the man who clicks a shutter nearer home yet, in many ways, some of these problems do overlap. How do I carry cameras on horseback? What exposure do I use for a beautiful sunset in Arizona and how do I make my skies appear black? Every sportsman, depending on his interest, also has a different set of questions. A friend of mine, Jack Samson, is a keen fisherman and will go after anything with fins. Whenever we've been on assignments together Jack always asks about films and filters, cameras and lenses. Over the years he has acquired a fair amount of skill plus a couple of Nikons with lenses suited to his purpose—and he's learned to use them well.

Tillman Brooks is another member of Camp Fire Club who simply wants to take better pictures. After a couple of years of serious discussion he turned up at the main lodge one day and

11

proudly opened his camera case. With a happy grin he pulled out a new Olympus OM 1, a wide-angle plus a zoom and telephoto. Each lens had a Skylight filter attached and, remembering an earlier conversation where I had explained why his color was blue, Brooks went whole hog; a Skylight on every lens. When I explained this wasn't necessary since the filters were interchangeable he replied, "Hell, they only cost a few bucks and what if I have to change lenses fast or lose one on a trip?" He was right, of course, since I had cautioned about the dangers of scratching or losing these delicate pieces of glass.

There are other men like Dick Ayer, Jr. who is practically a professional, not only for the quality of his pictures, but for his forthright attitude toward film. Dick is in the aircraft business, he buys and sells planes, and has occasion to travel to Africa a couple of times a year. While Dick swears by his Nikons, more importantly he brings an average of fifty rolls of film on each trip. "Africa is so great and the picture possibilities so tremendous how can you skimp on film?" is the way he feels about it.

These men, and others like them, are probably as responsible as anyone for this book. Not that I've become tired of answering their questions, but I've noticed the same ones being put forth. What's the best camera for canoe trips? Do I need a tripod and what film should I use? There is also a constant striving for more imaginative and striking results, not always successful, but the effort is made. If this book will help, even in some small way, to add a bit of drama to their pictures or stimulate the cameraman to see visions of beauty, if it adds a touch of romanticism to just one picture and if it helps to make the outdoors and our sports as exciting as they are then it will have served its purpose.

Sid Latham

CHAPTER 1

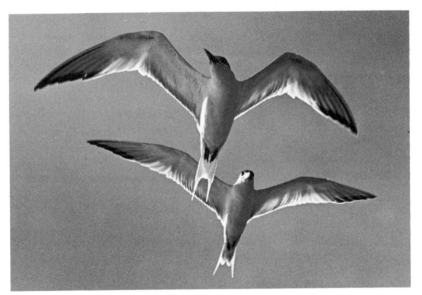

Introduction

The American sportsman, be he backpacker, mountain climber, hunter or fisherman or just a carefree traveler in a mobile home, is probably the most enthusiastic camera fan in the world. True, he may not be up to our Nipponese friends who continue to photograph Mount Fuji obscured by fog or mist, but almost everywhere he travels he lugs one or more cameras with him. Pictures are taken in bright sunlight and heavy overcast and, if he is particularly daring, even in rain. But what comes out of all this effort? Snapshots, and pretty sad snapshots at that. Almost everyone has a hidden drawer at home bulging with umpteen zillion snapshots, most are pretty sad and the rest are simply awful. All those wonderful pictures taken with such zeal that don't turn out quite as good as the wanted posters on the post office wall. Even on those infrequent occasions when pure luck brings them into focus, and the lighting is close to perfect, they are still wrong. Most of the people pictured or great mountains photographed or monster fish snapped never really looked like that and too many picture takers become embalmers of life rather than capturing that fraction of a second that really glows.

Good photographers, who have the skill to see beyond what is in front of them, occasionally make a picture that becomes more than a snapshot. The sky is blue and filled with glistening cumulus clouds, the mountain takes on form and a friend, wading in the fast-moving river, is caught with his line laid out in midair and body positioned with the grace of a dancing skier. Just viewing such a picture brings the scent of fresh pine to the nostrils and water coursing over rocks tinkles faintly to the ears. Suddenly the photographer has become an artist and taken a picture that has feeling, emotion, color and may even convey, however imaginary, a hint of sound and scent.

It may not be so in every picture, but one doesn't expect perfection all the time either. Not on every Canadian hunt is trophy game the reward nor a record marlin the prize each time a charter boat leaves the pier. But a photographer who thinks when he gets behind the camera will, more often than not, be rewarded with successful pictures. Pictures that are slightly more than casual snapshots, pictures that become photographs and may bring admiring comments when shown to friends.

But what is the reason for the outpouring of snapshots that gladden the hearts of those happy stockholders at Kodak? They are many, but the most obvious is a lack of practice with the camera. Perhaps it is because the camera is often thought of as a magic box. It is always there when needed and should work. With the skills of modern technology cameras work very well indeed. Modern cameras set exposures automatically, tiny diodes and transistors race with the speed of calculators (which they are) and soon there will be lenses that even focus by themselves, but there is one thing these modern miracles won't do and that is think for the photographer. That elusive human quality of deciding what to take must still be left to the man behind the camera. Only the cameraman can select his subject, compose the picture and

decide when to click the shutter. In spite of the tremendous technical advances those are still the photographers' decisions and this is where the average cameraman tends to fall down.

Think of the hours a sportsman might spend perfecting certain skills. If he is a skeet shooter the shells might pile about his feet should he have trouble at a particular station. Or a fisherman will surely spend some sleepless nights with an aching elbow trying to learn the double haul, but a photographer will seldom take a camera out for a dry run just to get acquainted with the controls. To master the skills of any sport or hobby a fair amount of time must be devoted to learning, but we are all occupied with other things and, sad to say, photography is often regarded as a secondary hobby. It is felt pictures will take care of themselves and it's more important to bring home a brace of birds from a South Carolina quail hunt than take time to perfect picture-taking techniques.

In truth I've even had friends ask me to load their cameras before leaving on a trip to Hawaii or Alaska. I must admit I've tried to shame them to no avail. After they go through a foot-shuffeling routine and a couple of sheepish looks I take pity and load the camera. When I ask what they'll do when it's time to change film I'm told, "Oh, one roll will do." I have to agree one roll will do nicely, for their holiday, the winter's skiing pictures and even next summer's vacation. One roll in a camera all year? Certainly, it happens all the time with the film constantly exposed to the extremes of heat and cold. And then when it's time to process the film it's usually dropped off at the nearest drugstore. After all that time why bother? The pictures are probably grainy, fogged from being in the camera too long and the results would better be stored in the mind than on film.

Unfortunately, most amateurs, and this includes many of our outdoor friends, don't take enough pictures to become proficient with their cameras. And the poor quality of photographs can't be excused by equipment either. With rare exceptions fine cameras abound: Nikons, Hasselblads, Leicas and Rolleiflexes. All the tools of the professional, yet skills with cameras can't match their ability with rod or gun. Taking pictures does demand some little skill, and taking good pictures, that are different, requires thought and some rudimentary knowledge. We won't kid anyone about that, but it isn't any more difficult than handling a canoe with enough proficiency to enjoy a quiet river trip or shoot a round of trap that will be reasonably rewarding.

As basic as it may seem the camera's instruction manual should be read thoroughly. The camera should be handled and the controls worked until it becomes second nature. Only when there is a thorough knowledge of the camera can thought be given to pictures. To learn to use a camera, film must be exposed—there is no other way. But don't go wild with the first roll either. Shooting too many pictures is just as bad as too few if there is no grasp of the basic fundamentals. No doubt films like *Z* or *Blowup* have sent hundreds of camera fans scurrying to the nearest camera shop in search of motors. Granted the protagonist looks pretty impressive zapping off film of all the bad guys, but in real life a professional using a motorized camera knows what he's doing and, more importantly, a client is paying for all that film and processing. But, if taking too many pictures is just as bad as shooting too few, how is the learning process accomplished? By thinking: think about pictures when planning a trip, think while packing equipment and think before taking any picture.

Do as the professional does when he has an assignment and make a short list of key pictures. This doesn't have to be a Hollywood shooting script, just a brief outline of pictures necessary to tell the story. And don't be too rigid either. After all it's only a guide. But if certain key pictures are listed, and even added to, a more successful sequence will result.

I know one of the most important lessons I ever had came the day I went to work for the now defunct International News Photos in New York some years ago. The fact I.N.P. hired me from *Life* magazine didn't cut much weight with my new editor, Ernie Prince. At *Life*, where film was exposed in a grand manner, I was pulled up short my first day on the job.

Prince told me I was expected to do a feature story with two rolls of 120 film (24 exposures) and 24 flashbulbs. After showing me a dozen typical feature stories Prince said, "Give me three pictures; a long shot to identify the locale, a closeup to show what is happening, and an angle shot to make it interesting. For the rest, shoot what you like." Even today, when I feel

Scott Bowie of Aspen Mountain Rescue shows the hardware of a well-equipped mountaineer.

16

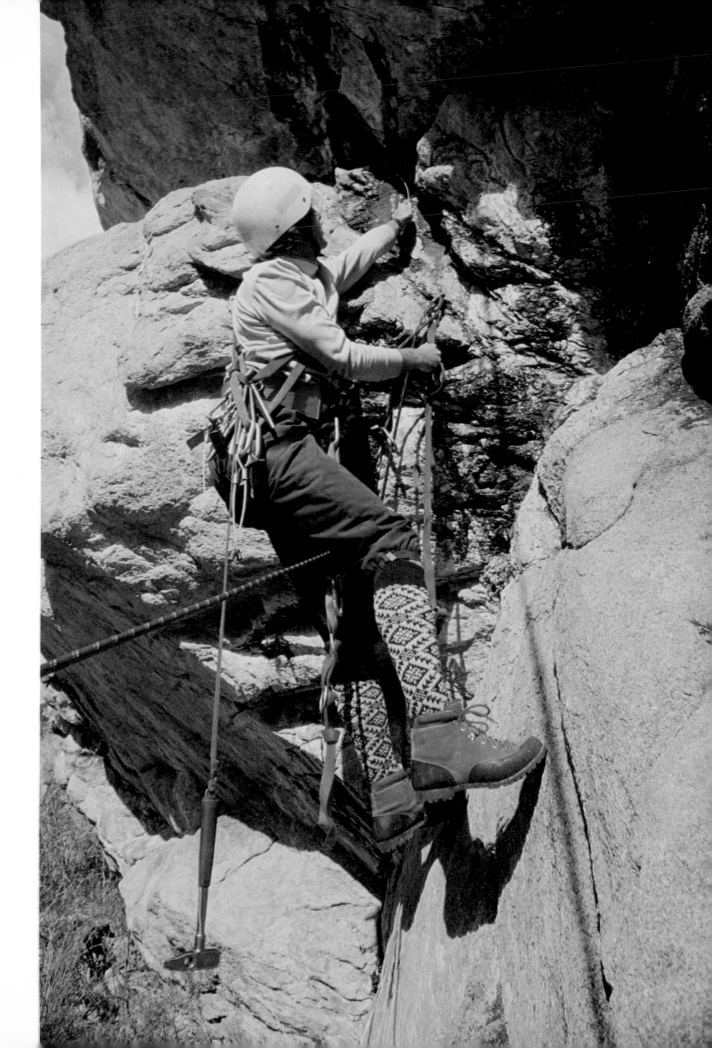

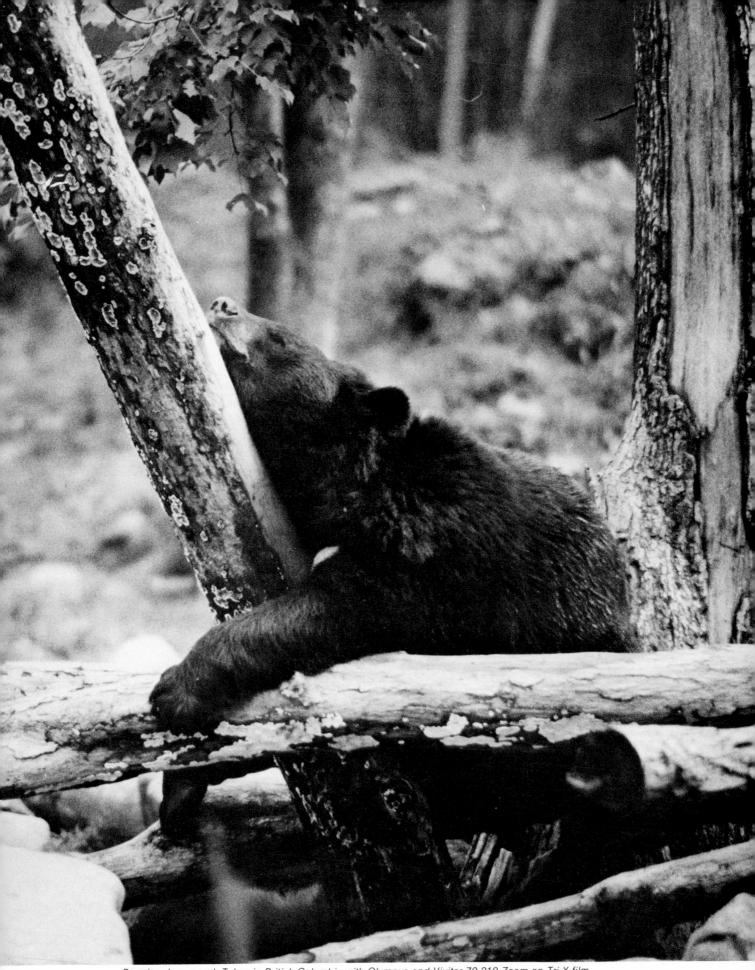

Bear in a lazy mood. Taken in British Columbia with Olympus and Vivitar 70-210 Zoom on Tri-X film.

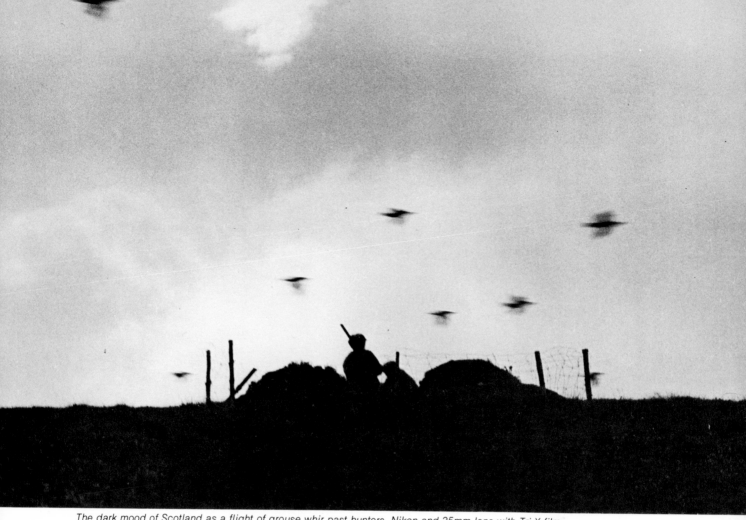

The dark mood of Scotland as a flight of grouse whir past hunters. Nikon and 35mm lens with Tri-X film.

I'm shot out on an assignment, or not certain what to take next, Ernie Prince's words come to mind and I usually pull out a few more pictures. It was good, solid advice and works just as well today as it did those long years ago. Three key pictures: a long shot, closeup and angle shot should be the main ingredients of any sequence and will help the amateur next time he's sitting by stream side wondering what to take next.

Of course the thought in any sportsman's mind, and I don't care if he is after a trophy moose in Canada or mule deer in Texas, is when do we find time to take all these wonderful pictures? Anyone expending time, energy and money wants to hunt, fish or climb mountains or whatever his pleasure may be. One can't hunt and fish at the same time, nor can one hunt, fish or take pictures at the same time either. Give it a try, but the results are about as satisfying as trying to lick a lollipop with the cellophane on. I won't say it's impossible to stalk an elk with gun and camera, certainly many have succeeded very well, but the hazards of spoiling a fine shot with the rifle or getting a second-rate picture are just too great a risk.

With the continuing rise in sporting costs, as with everything else, it's easy to understand the reluctance of any sportsman to lay aside rod or gun and pick up a camera, but there are many fine pictures, wonderfully exciting pictures, to be taken that are often overlooked.

Scenics of Wyoming's mountains or Arizona's deserts, closeups of flowers and strange rock formations, pack horses on a ridge and camp scenes, color shots of guides and companions, campfires and steaks sizzling over hot coals. All those pictures ready for a clicking shutter. Even enjoying the pleasures of a fine trout stream it isn't necessary to leave cameras back in camp. Bring them along for the day and take pictures of companions wading streams and casting a line and, when it's time for fun, set the camera aside—and fish.

Often, when I'm in some distant land on assignment, I've run into the same problem. My hosts usually invite me to try my luck with rod or gun and, I must admit, the temptation is great. But I always explain, diplomatically, I hope, when I get my pictures I'd be delighted to try my skill. Being in Scotland on the Glorious 14th of August (when grouse season opens) isn't easy to refuse a proffered Boss or Purdy. But with luck I'll have my pictures within a few

19

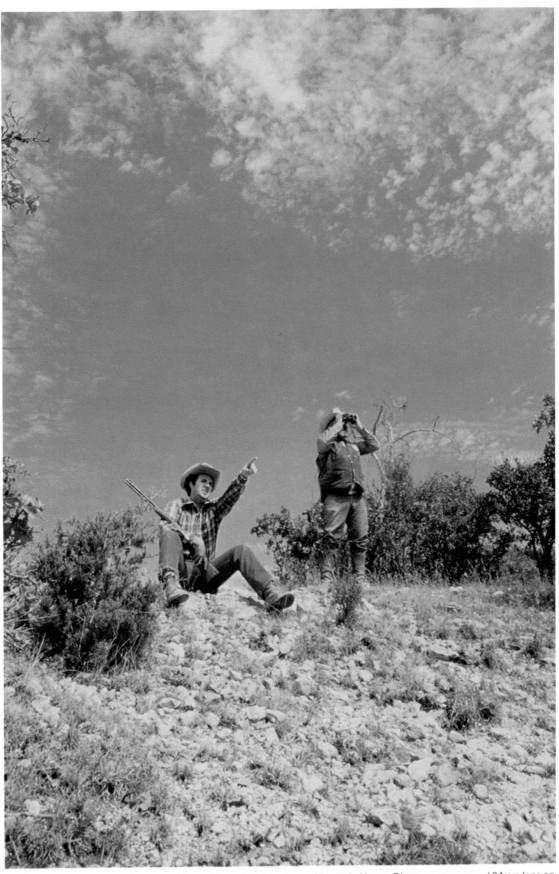

Hunter and guide searching for game at Texas' famed YO Ranch near Mountain Home. Olympus camera and 24mm lens on Ilford FP 4 film and skylight filter.

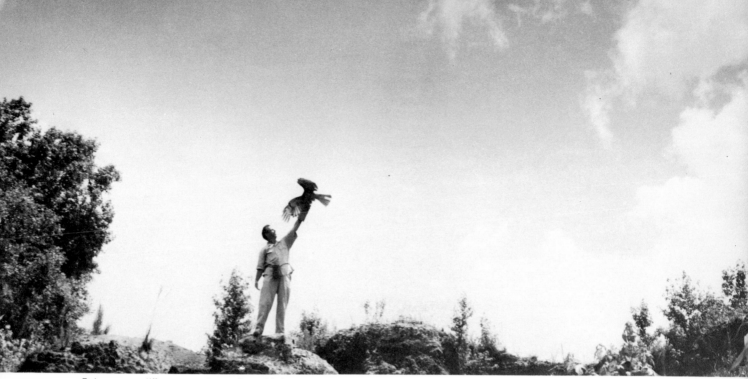

Falconer on cliff prepares to receive a bird.

days and the 16th or 18th can be just as glorious. The amateur cameraman can solve his problem in much the same manner; hunt or fish a few days then set a morning or afternoon aside for picture taking.

We've been talking pictures for awhile, but what kind of equipment should the outdoor traveler carry? Loaded with packs, guns, rod cases, tents and supplies, lightness is of the essence. No one will object if a huge tripod and a large view camera is lugged along (in fact many of the finest outdoor views have been taken with just such equipment) but the sportsman who wants to do everything on one trip must consider weight. First of all, few good pictures can be taken with an old Box Brownie so don't try. A well-made 35mm camera is the basic requirement (we'll get into cameras and lenses next) and a couple of lenses will add variety. Those with simpler equipment, Pocket Instamatics, for example, will be able to do some of what is discussed and shown, but not everything. There are limitations in equipment just as there is in the ability to use that equipment.

Even such mundane skills as loading and unloading a camera far from the comforts of home should be practiced until they become second nature. I'll wager most hunters can take a shotgun apart blindfolded, but can't change film the same way.

It may not be necessary to unload a camera with eyes closed, but at times there are situations that come darn close. I've had to change film bouncing along in a Land Rover, while keeping one eye on game, or chasing antelope herds while strapped in a helicopter flying over the prairies of New Mexico. Even with a couple of cameras on hand they always seem to run dry at the most crucial moment and it's necessary to take advantage of inactivity to reload. This is one of those seemingly unimportant skills that should be acquired by the most bumbling novice. It is important to at least grasp the basic skills before attempting pictures in some hazardous situation. Of course if one is already proficient consider it a plus and get on to taking pictures.

Frequently one of the most difficult tasks of the professional photographer is being asked to look at pictures taken by friends. We both use Leicas (or Nikons or Canons) and why aren't my pictures like yours? This has to be the moment of truth for the eager amateur. If he is a man of some skill, an airline captain or a surgeon, as a few of my friends are, then the reply becomes slightly more complicated. The obvious answer is to explain I would be hesitant in taking a 747 off from New York's J. F. K. airport or wouldn't dare remove an appendix, but that doesn't seem to fill the bill either. There is a strange psychology among those talented in another profession and we must return to the ''magic box'' syndrome for a moment. The camera is used for taking pictures and it should work. It's supposed to take superb pictures all the time, prize-winning pictures, masterpieces of color without thought or fuss. Oh? Well,

21

that's what it's supposed to do. What the eye sees the camera should record, but it isn't quite that simple.

Visual information is more readily accepted by the eye than the lens and this is where mistakes happen. The brain will exclude the extraneous and beauty truly comes to the eye of the beholder. A magnificent scenic offers visions of grandeur and a jumping trout excludes everything but what the viewer wants to see. Not so with the lens that doesn't have the ability to be selective by itself. Suddenly power lines pop out, power lines that weren't there before and a parked car jumps out of the bushes near the lovely stream. Unexpectedly, a cigarette butt is caught in a swirling eddy and, yes, that's a beer can reflecting in the grass. Suddenly those beautiful pictures don't look quite as interesting and selective vision has played all kinds of tricks. The mind eliminated those annoying distractions, but not the lens; it can only reproduce on film precisely what it sees and, frankly, it sees a lot more than the human eye.

But how does that answer those who expect every exposure to be a rewarding picture? Very simply, they must learn to see once again, to look at what they see and examine the subject in a way they have never done before. The scene must be edited in the mind and, if necessary, walk about and pick up debris and police the area.

Some years ago, while doing special still photography during the filming of *Lawrence of Arabia*, one vast scene with hundreds of camels, horsemen and an old railroad train covered many miles of desert. After each take half a hundred men moved onto the desert with brooms and swept the sand clean in readiness for the next take. Of course this is an extreme situation and no still man is expected to move across the countryside with a vacuum cleaner, but the photographer's eye must be made aware of extraneous material that will jump out of the picture like a stick in the eye.

Another question that often arises is the difference between an amateur and a professional. Hopefully a man who earns a living with a camera has learned his lessons well over the years and is able to reach back into his mind for all those little tricks that help in many picture situations. In addition the pro *makes* pictures rather than *takes* pictures—and there is a differnece.

Not infrequently the working photographer may be tired from a long plane ride and so

The difference between the same shot in color and black and white, plus the use of flash to open shadows. Camera on tripod, one second exposure on meter, 22B (blue) flashbulb fired during exposure. Flash in tent triggered by photo eye.

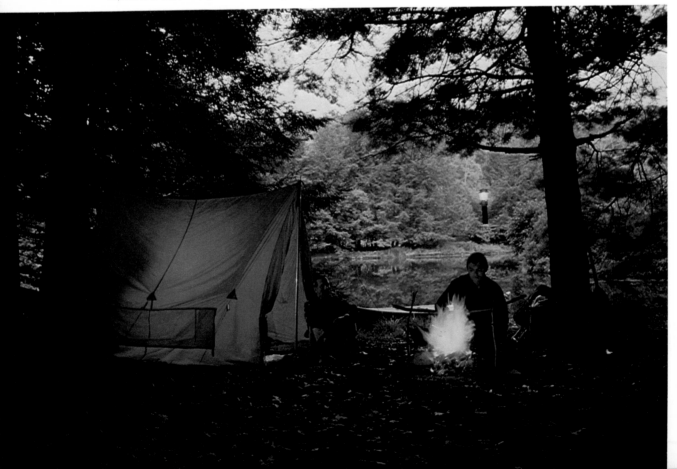

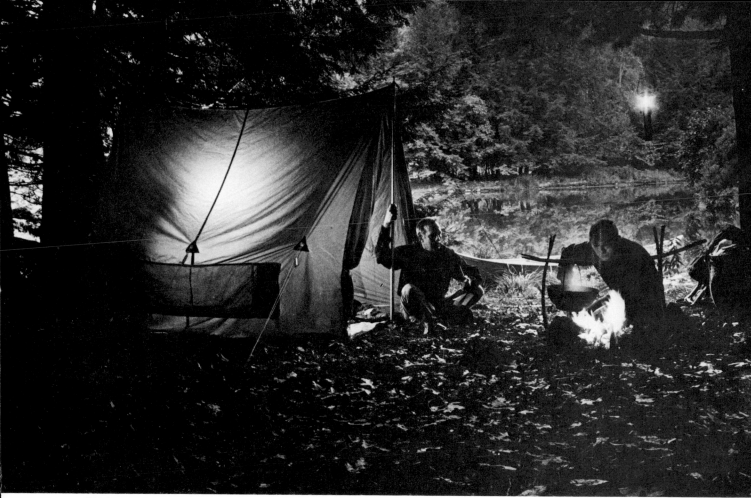

Black and white is reasonably effective with flash and short time exposure.

Same setup as top picture except no flash was used. While fireplace throws some glow onto faces, it isn't sufficient to light properly. All pictures taken with Olympus camera and 24mm lens. Lens setting ran between f.5.6 and f.11.

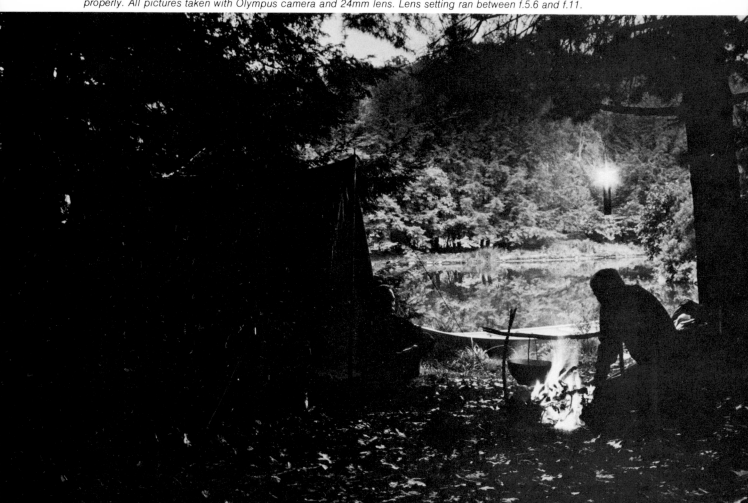

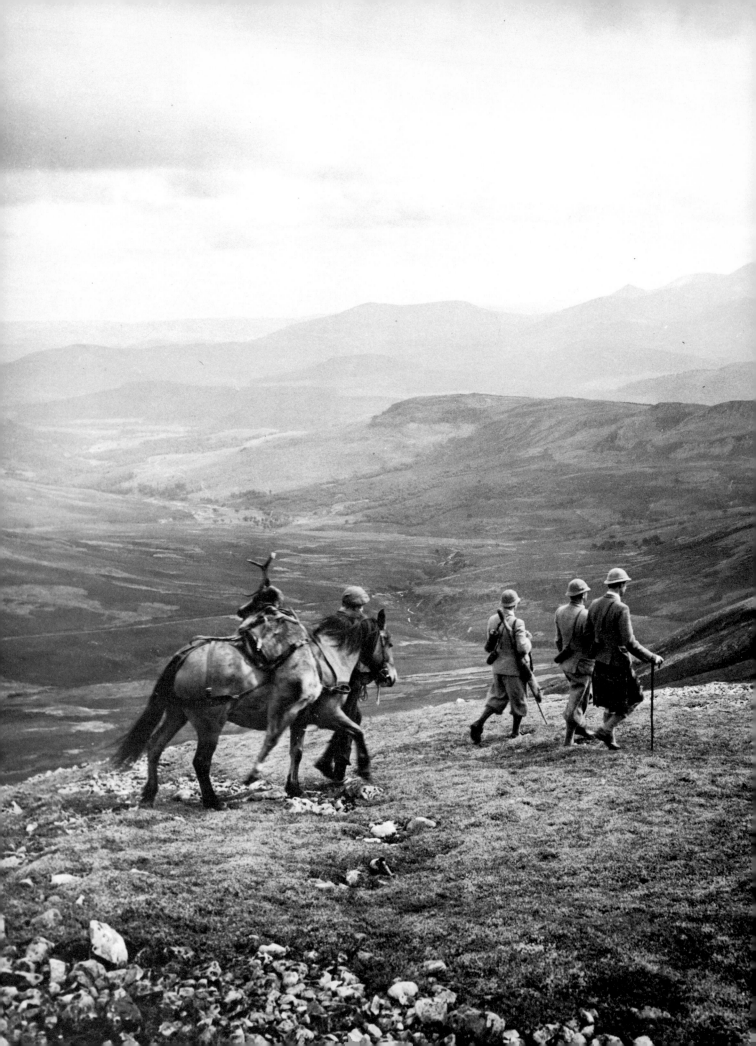

groggy his brain feels like soft ice cream, yet he is expected to get right to work and come back with fine pictures, interviews and all the captions. The amateur, on the other hand, has no such pressures pushing him on. There are no deadlines, he can rest until he feels like taking his camera out, and there is no concern with clients. If it rains he loafs and if the sun shines he heads for the beach. Being a professional photographer also demands many skills picked up over the years. It's often necessary to don scuba gear for underwater pictures, sail a boat, fly a plane, ride horseback for hours at a time, repair an outboard motor, shoot a gun, handle a fly rod and even toss a diamond hitch; and how about setting a Malay tiger trap? All these plus a hundred more forgotten bits of lore with the least, it sometimes seems, of being a good photographer.

In the outdoor field clients assume an expertise on the part of the photographers they hire and demand they cover an assignment with maximum skill, minimum expense and return with good, frequently great, pictures that tell the story. All this proves exactly nothing except—the all-important differences when the professional isn't able to take pictures *he makes pictures* —and that difference is what we'll try to show. The difference between moving a few feet for a better angle or view, how to frame a scene for more impact, the use of small electronic flash and all about shutter speeds to show the flames of a campfire.

Taking interesting pictures isn't all that difficult; it means thinking about the picture to be taken and a willingness to expend a few extra frames of film. I don't mean *great* pictures because these are often the result of tremendous planning or simple luck and one of my favorite pictures was just that: luck alone.

On assignment at Invercauld Castle in Scotland to photograph a stag hunt we had five days of driving rain. Finally, in desperation, I suggested we move onto the moors and try a stalk. Earlier that morning the gamekeepers reported a fine herd of stag on the far side of the deer forest. We all bundled into rain gear and headed out for the hunt. By now the steady rain had diminished to a heavy mist and, from a photographer's point of view, added a tremendous mood to the moors. The light was soft and I didn't have to be concerned with shadows. Fortunately, after a long stalk, Captain Alwyne Farquharson, Laird of Invercauld, brought down a magnificent stag. The ponies were brought up by the gillies and the stag roped on.

As the hunting party started down the hill I watched their progress from a short distance away. After a half dozen exposures, none exactly what I wanted, everything suddenly seemed to come together. The mist began to rise and the fog slowly lifted. The entire valley opened to view and it all said hunting in Scotland. There was the Laird striding along in kilts, the gillies leading the pony and the vast panorama of the Scottish deer forest lay before us. Everything was perfect, hunters and game caught in that precise instant of time. I don't recall how many pictures I had taken, probably no more than eight at the most, but one particular shot said it better than all the others and if it proves no other point it is this—keep exposing film.

The other extreme of exacting work with great preparation was that done for a number of gun catalogs for Winchester. There are few things more difficult to photograph than blued steel. Roundness must show in the barrel with a long highlight along the side. Fine walnut stocks must have detailed grain showing and the exposure meter runs the range from pitch black metal to darkened wood, the hills beyond and blue sky above.

Most of the photography was done on location in the West: Wyoming, New Mexico and Arizona, all researched previous to location shooting. Pictures were taken when the sun was just right, usually morning or late afternoon, large reflectors were used to open shadows. Guns were carefully cleaned of fingerprints and coated with a dulling spray. A light meter was used to read every portion of the picture and then, with everything in readiness, a Polaroid color picture taken. After careful checking by client, art director and myself, and minor adjustments made to a safety or sling swivel, the exposure was made.

The camera was a 4X5 Linhof mounted on a large Gitzo tripod and three sets of exposures were taken, two on the meter, two one stop above and another pair one stop below. Why so many exposures? As a professional photographer didn't I know what I was doing? Yes, I did, but the continual variables of exposure, shutter speeds, film speeds, processing and those mysterious gremlins of photography demanded this added insurance. Film has been

Stag hunting in Scotland. The Laird of Invercauld leads the hunting party across the moors. Rolleiflex camera and Tri-X film.

The Macro lens is an important accessory for any photographer. It works with ease and allows such pictures as these closeups of flowers or logs. 55mm Macro on Nikon with Ektachrome X.

scratched in loading or processing, one exposure may be more to the liking of both the art director and engraver and, to be perfectly candid, not every exposure is on the nose even with the greatest of care. Again, we come to the film-is-cheap theory. Considering the cost of such a project: meals, lodging, transport, car hire, shipment of a couple of hundred guns around the West, plane charter, film, processing, weekly paychecks for a dozen people plus research time and the photographer's fee and we've toted up a heavy bill. I've mentioned this to show that taking pictures is a serious business with a great deal of responsibility riding with the photographer.

This is not to deny when someone says, "Gee, it must be fun traveling the world and getting paid for it" you don't have a twinge of pleasure. I know few photographers who would disagree, but the pressures are still there and while the tourists are lolling about the beaches of Jamaica the photographer is getting filthy at the bauxite mines many miles inland, or sitting, as I once did, with a beautiful model at Negril beach with a broken helicopter for company. It only took five hours to fly a repair part in from Kingston and in the blazing Jamaican sun that isn't much fun—even with a bikini-clad beauty for company.

I trust I've made my point about the pleasures and problems of being a professional photographer. Many of these trials and tribulations can be lifted from the shoulders of the amateur camera buff. Going into the outdoors should be fun and pictures taken for delight and pleasure.

Throughout this book, however, I will continually repeat, expose film and take pictures. At the risk of becoming redundant I will also insist film is cheap, too. The more pictures taken, the sooner the novice photographer will become familiar with the camera. Only then, only when there is a glimmer of understanding of what lenses and other tools can do, will there be a move toward better pictures.

CHAPTER 2

Camera and Lenses

Among the many difficult decisions facing the new camera purchaser is what to buy and how much to spend.

But anyone devoting time to the outdoors must also contend with another factor: weight. When most of us talk of outdoor photography we really mean warm weather, balmy days with gentle breezes and a hot sun beating down. But there are other days spent in the outdoors many of us often forget. Days with cold crisp winds, heavy packs tugging at aching shoulders, the fatigue of fighting through snow drifts and the weariness of clambering over wet, icy rocks. Packing into wilderness areas can be tiring any time of year and each additional pound can add to the torture. Tents and sleeping bags, provisions, clothing and guns make heft and bulk important considerations.

For those who drive to permanent campsites in National Parks or meander about in a mobile home all those extras of photography; lights and tripod, lenses and extra film can be carried along without too much hardship.

But added to the weight problem of cameras is also sturdiness of construction. How many rolls will be run through in a year? Five a month or five thousand? Granted fine miniatures have become smaller and lighter, they have also become more delicate and fragile. The carefully machined parts have, in many instances, given way to stamped pressings and plastic and what will satisfy the amateur won't stand the gaff of a globe-girdling cameraman.

What is the ideal camera for the outdoor traveler, a camera that is small and light, has a range of lenses covering practically any photographic situation and still packs in a modest space?

Let's consider what is required. The camera should be compact in size and tough enough to survive a fairly hard life. It should also have a wide range of available lenses because nothing else will eventually satisfy the user in the long run. Naturally this means 35mm and while all modern cameras work very well indeed, there are some that are smaller and lighter, and work better than others.

This will not be a complete rundown of all the photographic hardware on today's market. It would be impossible with the continual introduction of equipment and the information is already available in the many buying guides, photo magazines and large camera shops.

Before we get into cameras I wouldn't negate the fact there may be those who enjoy working with larger film sizes or derive great pleasure from composing a picture on a bigger groundglass. For those who favor the Rolleiflex, a Hasselblad or the Mamiya RB 67, bring them along. I own all three yet wouldn't consider toting them on my back all day. They are splendid cameras and take sharp, crisp pictures, but they are too darn heavy and the added weight of film magazines, lenses and all the bits and pieces that go onto a camera wear me out thinking about it.

For those readers who may wonder what cameras I use; they are Nikons. I have five bodies

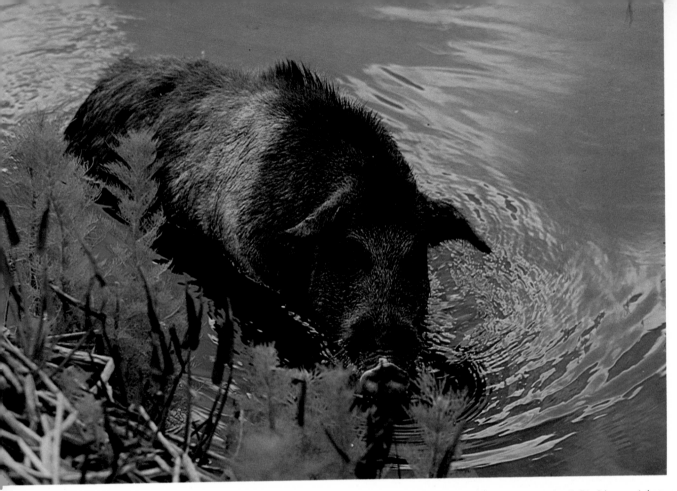

With hunting sequences, particularly with fast action, a motor is a must. These pictures of boar hunting in Florida were taken with a motorized Nikon and 35mm wide angle. Ektachrome X film was used with a skylight filter.

with a variety of lenses ranging from Fisheye to 500mm mirror reflex with a couple of special lenses in between. In spite of a vast array of other cameras in my cabinet the Nikons cover the bulk of outdoor assignments. They are sturdy beasts, take hard knocks and have stood the rugged climes of the Arctic and jungle for quite a few years. They are not the lightest of cameras and two others deserve serious consideration. One is the Olympus OM-1MD (for motor drive) and the other the small Leica CL. Both are crafted to professional standards and neither should be considered an amateur's snap-shooting camera.

They are, however, quite different cameras. The Leica CL is a rangefinder type camera. It takes the meter reading through the lens with the CdS cell swinging to the side for the exposure. The OM-1MD is a true SLR (single lens reflex) camera with metering visible in the finder. Both cameras are built in Japan so we're even on that score. In fact the Leica has all the data available to the viewer's eye; bright frame shutter speeds and a battery test indicator. It is ahead of the Olympus on that score. If we consider weight and size, within a matter of ounces and inches, we're really separating salt from pepper and the prime consideration, greater lens availability, is won hands down by the Olympus OM-1MD.

With over thirty excellent lenses from an 8mm Fisheye to a 1000mm mirror reflex plus automatic macro lenses, an automatic bellows attachment and a lightweight motor drive, the Olympus offers a greater opportunity to grow with the equipment.

For those Leica owners who are fortunate to have a batch of M series lenses, the CL will accept the 28mm Elmarit above serial numbers 2314921. The 50mm Summilux f/2, 35mm Summaron f/2.8, the 50mm lenses used on the M5 Leica, 90mm (except 90mm Summicron f/2), 135mm lenses (except the 135mm Elmarit f/2.8). Even for someone who already owns a Leica it's easily seen the CL presents problems with its "will and won't" acceptance. The currently available lenses, the new 28, 40, 50 and 90mm will allow the user to take a wide variety of subject matter, but what of the long telephotos for game photography or, the other extreme, macro lenses for tight closeups? There is no information available from Leitz as to

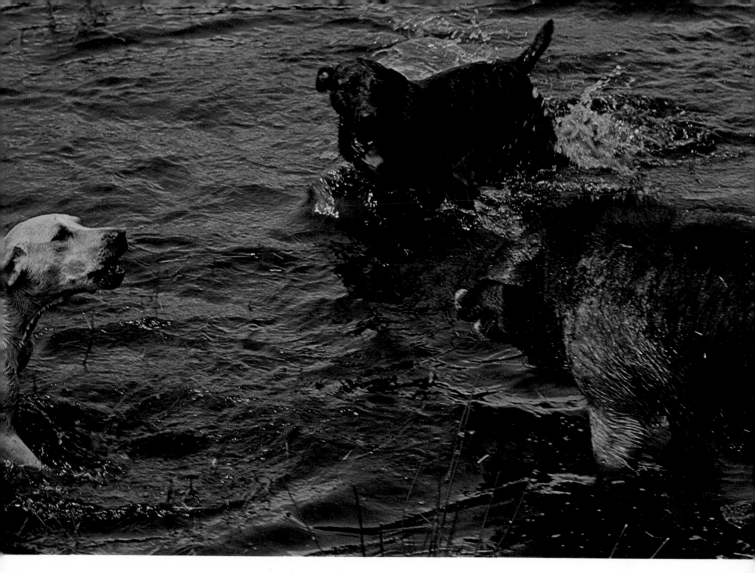

future plans and I feel the camera would be a poor gamble for the present. If the serious amateur is considering the purchase of a new camera I would favor the Olympus OM-1MD; if slightly more weight is no problem then go with Nikons.

As to the metering systems on cameras, we've all read of spot, averaging or center-weighted. Some cameras even give a choice of both; they are all good and yet all have inherent weaknesses. No meter can be all things to all men nor can they solve every picture problem to complete satisfaction. Even the newer automatic cameras may present difficulties. It depends how the user holds the camera, reads the meter, rates the film and other variables. The secret, if it is that, is to test the equipment thoroughly by actually taking pictures under varied conditions and comparing results with the meter reading. Keep notes on this, it helps.

Of course any meter can only give a normal exposure reading, but frequently the normal exposure isn't always the best. That's why it's important to bracket exposures—more on the minus side than the plus—because underexposure by one-half stop can often make a picture more dramatic, particularly in color.

Assuming a good 35mm camera is already owned don't 'dump' it because something new is introduced. Nikon recently came out with a new model and I'm certain it would be nice to have. No doubt some interesting tidbits on the latest model would be a convenience, but that doesn't mean the older models won't work well. Of course all lenses still fit the later model and that's one advantage of purchasing a system camera outfit right at the start.

Now that we've settled on cameras (hopefully), what of lenses? Here we find a bewildering array of glass and chrome. At the 1974 Photokina, a huge trade show held in Germany every two years, over 90 new lenses were introduced. The obvious question is why so many and what can they do? To answer the first part one would have to include several factors: (1) computer technology has speeded up the time required for calculations in glass design. (2) Improved

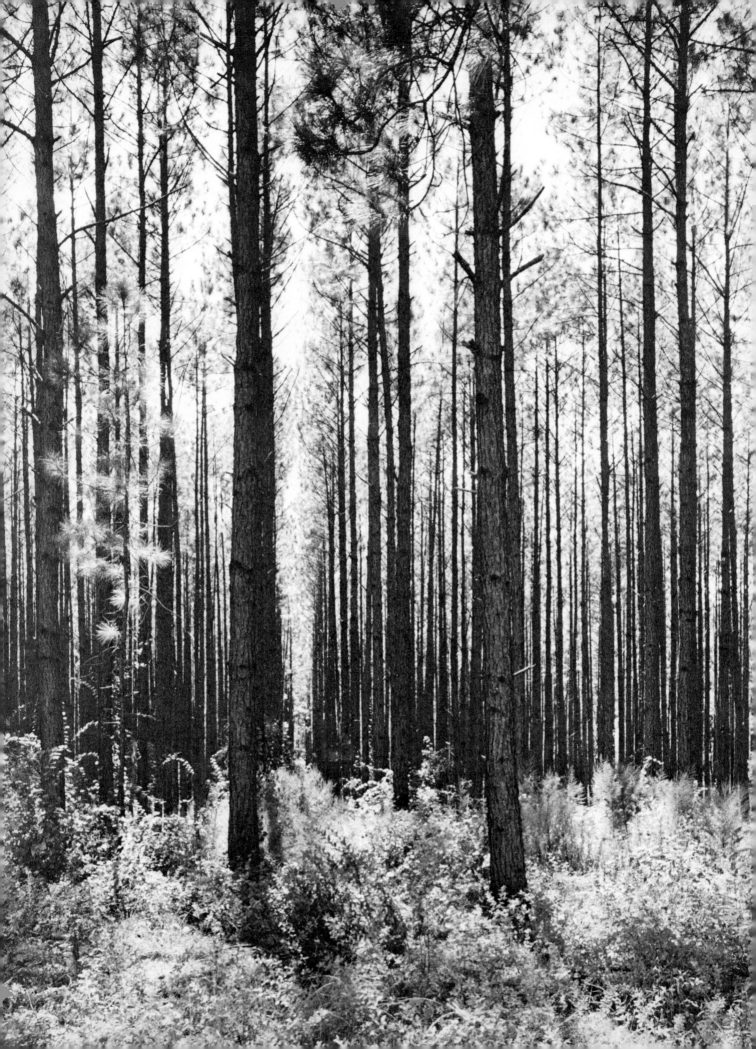

optical glasses are now possible with the inclusion of rare earth elements in the formulations. (3) Tremendous advances in manufacturing techniques; and (4) an expansion in the market-place.

The last factor, what can they do for me, is almost entirely due to the tremendous popularity of the SLR camera.

The SLR's allow the camera to become an extension of the photographer's eye. He can see through the lenses while composing and focusing, and changing lenses, with different optical characteristics, can extend and amplify vision—and that is the answer to the second part.

In spite of this vast offering of lenses, to simplify matters they can be divided into five basic areas: the normal lens that comes with the camera, usually a 50mm or 55mm, wide angles (including fisheyes), telephotos, zoom lenses and the macros for closeups. The term "normal" is rather an arbitrary definition. Actually a normal lens for a 35mm camera would have a focal length approximately equal to the diagonal of the negative. For optical and mechanical reasons normal lenses aren't made to this precise specification and anything from 45mm to 58mm may be considered "normal" for the full-frame 35mm camera.

Let's take these lens types one at a time and explain what they do. The normal lens that comes with the camera could be considered the workhorse of all the optics and will take many of the pictures required. Most of these lenses have fairly fast speeds (they permit photography under low light levels) and while many consider the normal lens limiting in its creative ability they have been used for memorable images by many noted photographers.

WIDE ANGLE

Wide-angle lenses have a focal length that is *shorter* than normal and they 'see' wider since they compress more into the picture. The least that can be said of any wide-angle is that it is frequently an overworked gimmick lens and, if not handled with care, distorts the visual truth of what is seen with the eye. All that is true but wide-angles, properly used, are the wave of the future and add excitement to any picture. How wide an angle is needed? That's akin to asking how long a blade is required on a hunting knife. It depends upon what the knife will be used for and the same can be said of a lens.

In the early days of 35mm photography there were only the 28 and 35mm lenses and they were considered pretty wide stuff indeed. The 28mm had a fast (?) f/6.3 speed with the 35mm beating that by a hair. Not quite the speed demons of today's available-light buffs.

Now wide-angles begin at the extremes of 15 and run through 17, 18, 20, 21, 24, 28 and 35mm and many have fast f/1.8 or f/2 speeds.

The 35mm is considered the *normal* wide-angle by most but there are others who prefer the 24mm.

The most common use for any wide-angle is to enable the photographer to take pictures in a confined situation where walls can't be knocked out or get more in the picture when it's impossible to back up. To a professional like Bob Isear, a top-ranked New York-based cameraman, wide-angles have a different use. "Things become more interesting when they are distorted. I don't use a wide-angle for covering more space, but to give me exaggerated foregrounds, abnormal vision and project the viewer into the picture."

Asked what lenses he prefers Isear answered, "If I had to work with only a few lenses I could manage any assignment with a wide-angle, 24 to 28mm, and a slightly longer lens ranging from 85 to 105mm. The macro would be a useful lens to replace the standard 50mm that comes with the camera."

Care must be taken with the extreme wide-angles, the 16 or 20mm in particular, since they distort and distend, giving what might be called a falsified perspective, and the difference in size between near and far objects is greater than normal. But what of the practical side of the wide-angles?

Consider the close confines of a fishing boat. I once covered a deep sea fishing story off Cat Cay in the Bahamas. While this was a comfortably sized boat, around 40 feet, the area of interest—cockpit and fighting chairs—was pretty tight. All the action aboard had to be

A PC or Shift lens is important in keeping lines of subject running straight up and down. A 35mm f. 2.8 Nikon PC lens and Ilford FP 4 film in this shot of woodlands.

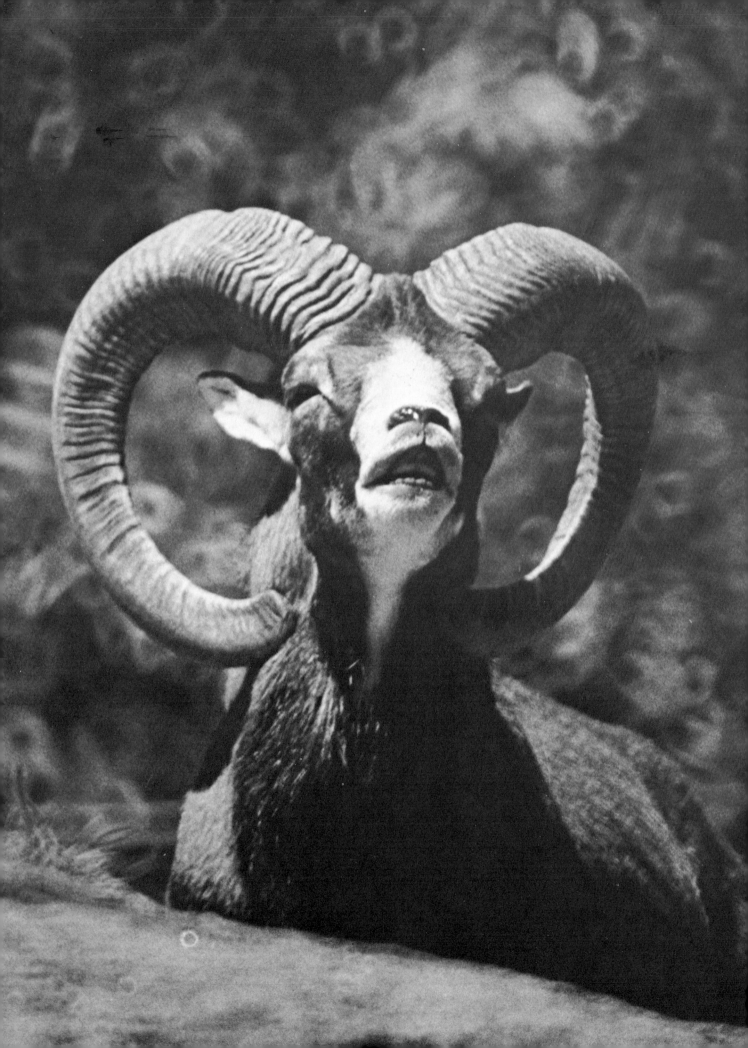

The 24mm lens gives a wide view and exceptional sharpness from foreground to background. Nikon and 24mm with Ilford FP 4 film and deep yellow filter.

photographed with both the 20mm and 24mm wide-angles. Certainly other cameras were at hand with long lenses for jumping shots of fish, but the bulk of the work was handled by those wide-angles. Now if a forty-foot boat can be cramped, how about a canoe? Sitting in the bow seat, a friend fighting or landing a bass can be photographed quite comfortably with the 24mm or 35mm lens and it is the ideal lens for such action.

The wide-angle must be used with care and one result of careless usage is wide empty foregrounds. An expanse of sidewalk or leaf-covered forest land contains nothing that adds to the composition of a picture. There is one special lens that will help overcome this; it is the 35mm PC or Perspective Control lens. It permits a lateral or vertical movement of the lens much in the manner of a view camera. This allows the lens to be moved off-axis to bring treetops or buildings into the frame. Thus, if there is a gain in the tops of tall timber, or mountains, it brings more interest into the picture and eliminates the emptiness of the foreground.

Wide-angles will enable the cameraman to become tricky with perspective, but it must be remembered while photographic rules are made to be broken, as are all rules, it should also be considered if the aesthetics are a conscious act or an accident. The purchase of a wide-angle should be approached with care and caution. They do require some skill and the beginner would be safer with the 35mm (wide-angle) and advised to tread slowly on the acquisition of the more extreme wide lenses.

TELEPHOTO LENSES

Tele or long focus lenses are those that have a focal length longer than normal. These can be classed as medium long, 85 to 135mm, in length, 180 to 500mm and the Big Berthas from 1000mm and up.

Corsican ram poses for a portrait with Nikon camera and 500mm mirror lens. Small doughnut effect in background is typical of this type of lens.

The basic reason for any photographer to use a telephoto lens is to make a bigger image of some distant subject. The advantage of such long lenses in sports, nature or dangerous action (wild game, for example) is obvious. The medium longs are favored by many photographers for portraits since they give a more pleasing perspective, permit shooting from a comfortable distance without seeming to shove the lens into the subject's face and fill the frame nicely with head and shoulders.

As with all things photographic there are certain rules to bear in mind with telephotos too. While the image is magnified with subsequent increase in detail, the longer the focal length the greater the magnification, but the shallower the depth of focus.

Remember the compression effect of pictures showing rows of buildings that have no depth or traffic jams in which cars appear to be sitting atop each other? That's one effect of long lenses.

There is a gain in all this, however, since the shallow depth of the lens makes them fairly easy to focus accurately, it also allows distracting foregrounds and backgrounds to be thrown out of focus and concentrate attention on the subject. But there is danger in all this; very long lenses, those from 180mm and upward, will be difficult to hold and the longer the lens the greater will be the magnification of heat waves and mirage. It's like looking through an 8X or 10X scope on a rifle. With a rifle this can be overcome by holding steady, but that's only half the battle with a long lens. Hold it steady, sure, but how about pictures through all that wavy stuff combined with haze? Filters will help (and the Filter chapter will offer suggestions) but the longer the lens the more difficult it will be to take good pictures under less than perfect conditions.

In selecting a telephoto we must pose the same question we did for the wide-angles. How long a lens should be used? To those who have specialized needs the longest may not be sufficient, yet an analysis of the needs may be of help. As an example a skeet-shooting friend, Rod Risley, who enjoys photographing birds asked my advice. Since he was able to set up feeding stations and keep his subjects at controlled distances the 300mm was ideal. He could peer out the windows of his home or sit on the porch and take pictures to his heart's content. Were he going to photograph birds in Florida's Everglades or the rain forests of the Hawaiian Islands, where conditions may not be ideal, longer lenses might be required.

For the nature enthusiast who wants to photograph wild game the first choice might be the 200mm at the minimum with perhaps more pleasing results obtained with the 300mm. Anything longer would be nice to have but not really necessary except for photographing Dall sheep in Alaska.

TELE EXTENDERS

There is another method of reaching out with lenses and that is with tele-extenders, a supplemental type of lens, which doubles the effective focal length of the lens on the camera. A 105mm, for example, will become a 210mm with the use of a 2X tele-extender and a 200mm will give the magnification of 600mm with a 3X extender.

These gadgets give fairly satisfactory results and they are not expensive, usually around $30, but they are not a cure-all for a proper telephoto of the correct focal length. The tele-extender is really an extension tube with various groups of minus lens elements. The better ones will have an automatic feature enabling the use of the camera's built-in metering system, but there are a couple of inherent weaknesses in their use that should be understood before buying one. One is their lack of sharpness and the other is the loss of light. The lens must be closed down considerably so there is both a light loss and a working speed. This can be partially overcome by using a faster film in the camera, but the light loss in the microprism focusing screen does make it extremely difficult to view easily.

Admittedly there have been some excellent results with tele-extenders, but sharpness will suffer and effective apertures will be extremely small. I've never been happy with the results I've gotten, but I won't deny anyone the pleasure of experimenting. After all that's what photography is all about.

A lens that should be used sparingly, but it can be effective with carefully chosen subjects. This picture of forests was taken with a Fisheye on a Nikon. The internal yellow filter was used with Ilford FP 4 film.

CATADIOPTRIC LENSES

If weight is a consideration, and it should be packing equipment into high country and wilderness areas, then the mirror lens is well worth considering. Imagine being able to shoot with a small handheld lens giving 10X or 20X magnification over the normal lens? How is it done? With mirrors; I'm not kidding. Well, that's part of the answer, but these mirror lenses are based on catadioptric design principles used in astronomical telescopes and originally were conceived by a Russian designer named Maksutov.

In conventional lenses the light travels a straight path. In the reflex or mirror lens it doubles back and forth through a system of mirrors which is why they are often called "folded optics." This folding of light leads to a remarkable reduction in size and weight compared to other lenses of similar focal length. The Nikkor 500mm f/8 mirror lens provides a ten-time magnifi-

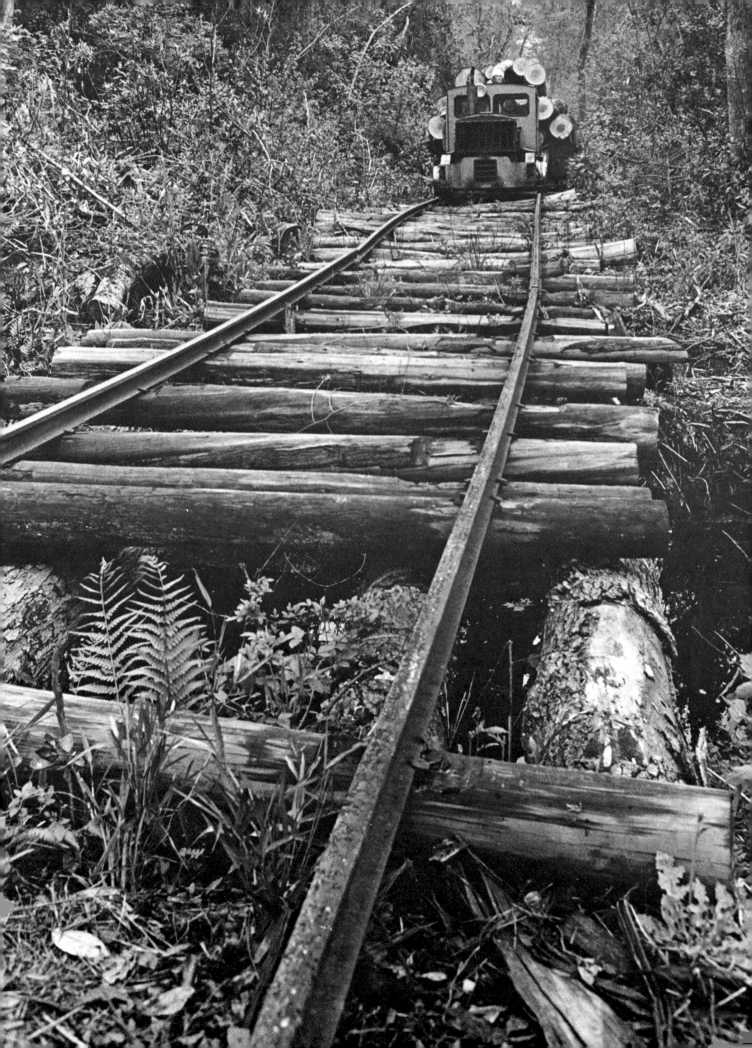

The same subject photographed with the 500mm mirror lens showing the compression and distortion of the undulating tracks.

cation yet weighs only 2.2 pounds and measures a small 5½ inches in length. The lens focuses to a close 13 feet and includes five filters that fit inside the lens mount keeping them small.

Perkin Elmer designed some even smaller. These are true "solid-cat" designs and will be distributed by Ponder & Best under the Vivitar Series 1 designation. There will be two with f/8 apertures, a 600 and 800mm with fairly close focusing capabilities. They weigh about 3½ pounds, are three inches in length for the 600mm and around 6½ inches for the 800 mm. There will also be a 1200mm f/11 at the same length as the 800mm. These are interesting lenses due to recent advances. They have good interior baffling and old-fashioned (all to the good) silver surfacing rather than the widely used aluminizing.

In spite of the small size of these lenses it isn't as easy as that to make comparisons. A quick look will show that, basically, the only asset an all-glass lens might have is the ability to close the diaphragm down for more depth and exposure control. With the mirror lens there is only one opening and it remains constant. The meter reading is taken by pressing the stop-down button on most cameras and exposure controlled by the proper shutter speed to match the constant opening. For the beginner, however, the mirror or catadioptric lens isn't the easiest piece of equipment to use. With a regular tele the more the diaphragm is closed the sharper the image becomes, but the mirror lens, working at one opening, may present difficulties.

Now an exciting new lens has appeared in Germany and may well point the way for design improvements in other mirror optics as well. This is the Goema Katoptar. It is a 500mm f/8 mirror lens with a *circular iris* that can be stopped down to f/45. It is an unusual lens to look at

How lenses change perspective. An old logging train in the swamps of North Carolina pictured with the 24mm lens.

and to use. It resembles a cigar box, being square in design, and is pointed downward slightly more than 20 degrees in order to photograph something straight ahead. In spite of the unusual configuration, and method of use, the ability to close down a mirror lens opens up exciting vistas.

For the beginner, however, a mirror lens isn't the easiest lens to use. While the Katoptar offers depth of field, the speed may not be sufficient for many pictures. On a trip to Canada's eastern Arctic the mirror lens just wasn't fast enough due to short winter days and low sun. On a recent trip to Kenya it was more useful in bright light, but very early in the morning or during the dusk of evening the mighty mite was left in camp.

SPECIAL LENSES

Of particular interest to the outdoor enthusiast is the family of macro lenses (see also chapter 7). These permit exceptionally close focusing and take wonderful pictures of colorful flowers, engraving on guns or knives and all the subjects of the close-in world. If lenses are

The odd couple. Wild game obviously going somewhere in a hurry. Nikon and 500mm mirror lens with Ilford FP 4 film.

really the vision of photographers then the macro's come closest to the ideal lens. Since the superb resolution of these lenses remains virtually unchanged through their entire focusing range the lens can be used for general photography. The exceptional image quality, its flatness of image plane, high image contrast and excellent color rendition are especially suited for all subjects where the camera must be moved in ultra-close. If f/3.5 seems slow for a modern lens (with fast film?) then we're really nit-picking. The speed is sufficiently fast plus the fact these lenses have dual-helical systems built into the lens that permit continuous focusing from infinity to 1:2 (one-half life size) reproduction ratio. There is an adaptor ring that comes with the lens that allows it to focus as close as 1:1 or life size. One nice thing about macro lenses is the automatic lens diaphragm (for proper exposure) remains operative throughout the entire range of focus except when using the M-2 ring.

Basically no mental gymnastics are necessary and no nuisance factors of measuring from the film plane to the front of the lens or spinning compensator dials are required for the correct exposure. There is, of course, nothing to prevent using additional extension tubes or

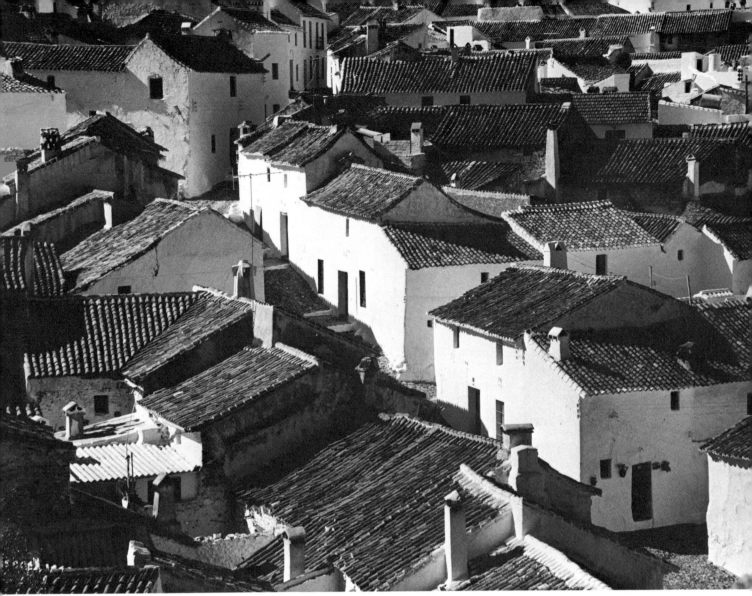

Housetops of a small Spanish village in the mountains above the Costa Del Sol. 135mm lens on a Nikon and Ilford F P 4 film.

close-up lenses in combination with the macro so many exciting pictures can be taken with this lens.

MACRO ZOOMS

A rapidly growing breed are the zooms. These are a reasonably new generation of lenses in which the focal length is continuously variable across pre-determined ranges. Originally they ran from slightly above normal to moderately long tele ranges (70 to 205mm); now they are available from wide-angle (35mm) to medium tele (85mm) and even longer. The advantage of any zoom, particularly to the backpacker, is the fact one lens will do the job of several giving a range of vision to the cameraman without a lot of lenses crowding his pack. However, offsetting such a decided advantage are a couple of factors: despite remarkable improvements in design and manufacturer, few zoom lenses will match the quality of a fixed focus lens and, secondly, zoom lenses still remain relatively hefty. In fairness, however, many of the modern lenses are marvels of design ingenuity, will deliver perfectly fine enlargements and won't prevent the projection of 35mm transparencies to at least 40 X 60 on a screen.

There is a certain amount of pleasure working with a zoom, precise cropping of the picture, for example, and the use of a zoom will cut down on some bulk. Another important point is the simplicity of filters—rather than a range of sizes for many lenses, one set will do nicely.

One zoom that should fill the bill for most tramping the outdoors, and one that would eliminate the macro lens in the beginning, are those with macro capability. Operating in two modes they function as a true zoom in the telephoto range; and also provide non-zoom focusing for closeups. For those who require a medium long telephoto plus moving in close for na-

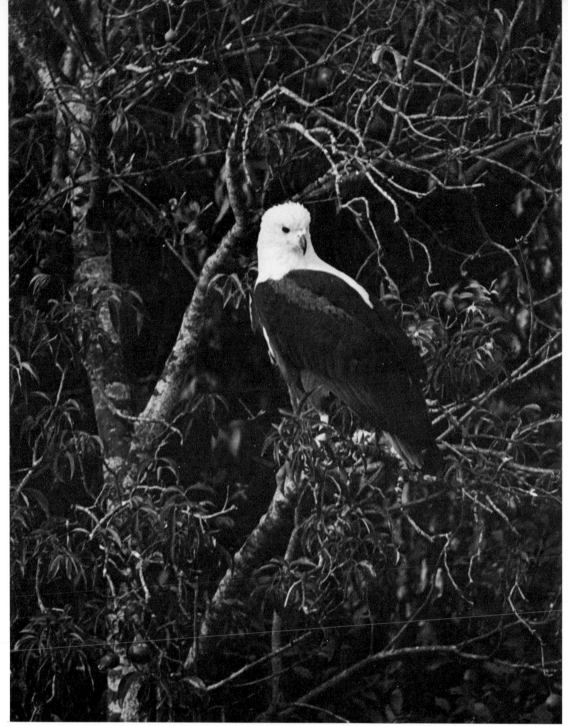

Nile fish eagle photographed in Uganda with Nikon and 500mm mirror lens on Ilford FP 4 film.

ture photography this is an ideal combination. The 70-210mm Vivitar Series 1 Macro Focusing Auto Zoom is an interesting lens. The macro feature is one-half lifesize and gives the tightest reproduction ratios of these lenses currently available. Actually the macro focusing is something of a misnomer since one-half lifesize isn't true macro, but these lenses permit reasonable closeups and for most work will get the lens in close enough.

In Uganda I carried one of the earlier Vivitar zooms (the Series 1 wasn't available) and it worked very well indeed.

In fact a morning's picture session taught me a lesson not to be too selective with lenses until becoming thoroughly familiar with the territory. Riding along in a Land Rover with two Game Scouts I had three camera bodies with long lenses attached. I was sitting atop the vehicle searching for lion and one camera had the 135mm, another the 200mm and a third the 500mm mirror lenses. Ready, I thought; not ready, I found! The first lion appeared like magic from the tall grass and was so near the car I had to fumble to undo the 135mm and attach a wide-angle. As the days went on, and I became more skilled in judging how close we could get

to game, I soon found the wide-angle and the zoom worked perfectly. Naturally there were times when the longest lens came into play. Along the Nile, just below Murchison Falls, swam great herds of hippos and huge crocodiles basked along the river banks. To photograph these primitive monsters as well as closeups of Nile fish eagles, egrets and cranes, the longest lens (500mm) reached out to fill the frame and enable me to get tremendous closeups not otherwise possible.

Unlike Africa, where it is frequently easy to get quite close to game, North America presents a greater challenge to the hunter with a camera. Long stalks are more common where the nearest elk or moose may be across a river or meadow and it often takes hours of painstakingly slow movements to come within shooting distance of antelope with camera or gun. Anyone seriously considering the purchase of a long lens should give thought to the longer zooms and try to stay with those that give a maximum range of 200 or 300mm since these focal lengths will prove the most practical. The photographer's personal needs and budget limitations are the only factors that must be faced in the acquisition of any new lens.

KEEPING THE CAMERA STEADY

Earlier we said telephotos aren't easy to hold even under the best of conditions. It requires practice in breath control to squeeze a shutter without having the picture blurred. High-powered lenses will magnify a heartbeat, but by bracing against a tree, log, rocks, a pack or anything that will give support, you will be aided in keeping the camera steady. Beanbags are excellent and many nature photographers carry them in a pack.

But a good solid tripod is still best. They provide a rock steady support for shooting many pictures and while they may appear to be cumbersome they are worth the effort in obtaining sharp pictures. I don't mean those cheap, fragile gadgets found in most camera stores, but something sturdy and solid. My preference is the Gitzo, a tripod made in France. It is used by many professional photographers and comes in a wide range of sizes . . . and prices. A good tripod isn't light and while the smallest Gitzo will fit comfortably in a pack it will still weigh around five pounds.

There are some other accessories that will help steady a long lens and one is the unipod. A canelike affair that pulls out giving, in effect, a single tripod leg. Shoulder stocks are another that will help and the more modern ones are crafted of aluminum. Belt pods are good, but most are usually a harness affair with too many straps to be of real help in getting a camera into play fast.

One important thing to bear in mind is the proper method of fastening a tele-mounted camera onto a tripod or supporting device. Simple, just screw it on, but if a long lens is hanging from the front of a small 35mm camera there is a lot of weight waving in the breeze and the slightest air movement, or inadvertent touch of the lens or camera, will set the lens bouncing up and down. With many long lenses, 200mm and upward, there is usually (but not always) a tripod mount on the lens itself. If this is the case fasten the lens onto the tripod rather than the camera. It will give better balance and help eliminate vibrations. There are a number of other devices available that will support both camera and lens and completely eliminate movement. One is the Questar Camera Cradle that is used with telescopes. Unfortunately it sells for about $100 and the price may be prohibitive for the casual snapshooter. A beanbag will do just as well and be easier on the wallet.

Before we begin to summate all this equipment let's talk of two other pieces of gear that may be of interest to the outdoorsman. One is the Nikonos II camera by Nikon. While it is already famed among skin divers and underwater cameramen this excellent 35mm may be of interest due to its ability to withstand the hazards of climatic conditions, and few appreciate that it may be used on land, too. The Nikonos II is a small, compact camera that is sturdily constructed and it will take a lot of hard knocks. Without a protective case it can be dunked in water; it takes pictures in the rain, bounces around in slush and snow and is impervious to dirt and dust. The camera is a self-encased wonder that can be washed off in the nearest mountain stream after use. It is an excellent piece of equipment that will undergo the hazards of a canoe trip or sit in a duck blind all day in the driving rain without harm and still take pictures. However, before my enthusiasm for the Nikonos sends the reader dashing off to buy one allow

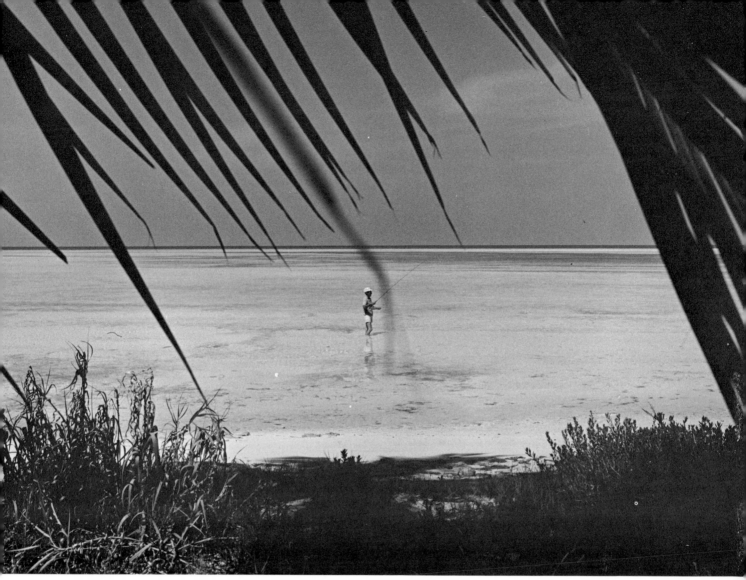

Florida Keys. Nikon and 35mm lens. Ilford FP4 film and medium yellow filter.

me to temper my praise with, as they say, the bad news. In spite of its ability to weather adverse conditions, the camera should not be regarded as a prime camera. For one thing it has neither rangefinder nor a built-in light meter. The selection of lenses is very small, with some specially formulated for underwater use only, but it does come with a superb 35mm wide-angle as the main lens (it even takes sunshade and filters) and if the user is adept with a light meter it will give excellent results for which Nikon is famed. For those who already own a good 35mm camera the Nikonos can be a worthwhile addition that will enable the cameraman to take pictures under all conditions.

MOTORS

Camera motors, especially those of the last decade which are reasonably trouble-free, have proved a valuable aid to the nature photographer. They may even be fitted with wireless controls that trip the shutter from great distances. This, in combination with the latest auto focusing lenses, makes an ideal combination. But sophisticated equipment is never cheap, and motors, radio controls and the rest can cost upwards of a couple of thousand dollars. Aside from their sequential capability there are times when shooting with one hand has an advantage. Mountain climbing is a good example. Holding a rope with one hand or fist jammed into a rock fissure will let the motorized camera user take pictures under less than normally secure conditions. Yet motors are noisy and the keen ears of game will swiftly pick up the whirring and clicking of the camera innards banging away. In the silence of the outdoors it can be an earth shattering experience to see a herd of zebra explode with the first sound of a motor.

The motor, in spite of these handicaps, can be a worthwhile investment when used properly.

Quite often the tendency with a motorized camera is to set the frame speed too high and run through a roll too quickly. When the negatives are inspected, usually about every fifth or eighth frame is selected with the others a complete waste. When analyzing motion in certain sports, fly casting or skeet shooting, there isn't the radical change of position one might expect, and practice with a motorized camera will soon enable the photographer to correctly judge what frame speed per second should be used.

Not everyone will regard a motor as an absolute necessity and a well-exercised thumb can still keep the film moving fast enough for most needs.

CABLE RELEASE/SUN SHADE

There are also two minor, but important, accessories that should always be carried in the camera case. One is a cable release for those slow-speed pictures where a camera is set on a tripod or even balanced on a log. The other is a proper sun shade to prevent side light flaring onto the lens and causing ghost spots across the negative. Both these small lightweight items can be had for less than $5 and will help improve the capability of the camera. In fact, should a cable release be forgotten (and it's happened to all of us), the camera's built-in self timer can also be used to trip the shutter.

EQUIPMENT CHOICES

With this tremendous abundance of equipment what lenses are most important? With the camera there is normally a 50mm lens that can be used for the majority of picture taking. A wide-angle, either 24 or 35mm, will give a different perspective and permit group shots, interiors and dramatic angles with their great depth.

I like the macro lenses very much indeed, but would suggest a zoom with macro capability since this will eliminate one extra lens to tote around. Certainly nothing longer than 200 or 300mm should be considered by the novice photographer. The super-long lenses are difficult to use and experience will be the best teacher.

For all these photographic goodies what should one expect to pay? Buy the best, spend as much as possible and in today's camera market that can be quite a lot. The finest 35mm with one lens (Nikon 2 or Leicaflex) will parallel the price of a top-quality Perazzi shotgun. There are also excellent medium-priced cameras, with built-in meters and all the latest advances, for less than a third the top dogs and there are many cameras costing even less with up-to-date advantages. Unlike motor cars, where the difference between a Rolls-Royce and a Volkswagen is obvious, the difference in cameras is not so glaring and many less-costly models are leaning hard on their higher-priced brothers. Not everyone shoots a Krieghoff or Perazzi; many are delighted with the Browning Superposed and quite a few are enthralled with Remington 1100s as well.

Don't look for real bargains, however, since quality can deteriorate swiftly with unknown makes. Stay with reputable and well-advertised brands. Even cameras that have been in the closet a long time shouldn't be discarded too quickly. If very old, they may bring prime prices in the growing photographic antique market. A few years back I disposed of some old Leicas for the estate of a friend and the good lady was very happy with the prices her late husband's equipment brought. Other cameras can be checked by a reputable repair shop to determine the merits of restoring them to order.

Perhaps the most important lesson to learn is not to be handicapped by inferior equipment. Cameras that are difficult to use or lenses that won't deliver sharp pictures should be sold or traded off. Professional photographers are always upgrading equipment and the keen amateur should do the same. Once a good camera and a variety of lenses are acquired learn to use them well. Get into the outdoors and take pictures under every conceivable condition. It is the only way to learn.

Luck plays a big part in animal photography. Driving along a game trail in India, the tiger was spotted sitting on a rock watching the Land Rover move slowly closer. Due to dim light in the jungle the camera was loaded with Tri-X film. Picture taken with a Vivitar Series 1 Zoom 70-210mm. Picture taken at longest focal length.

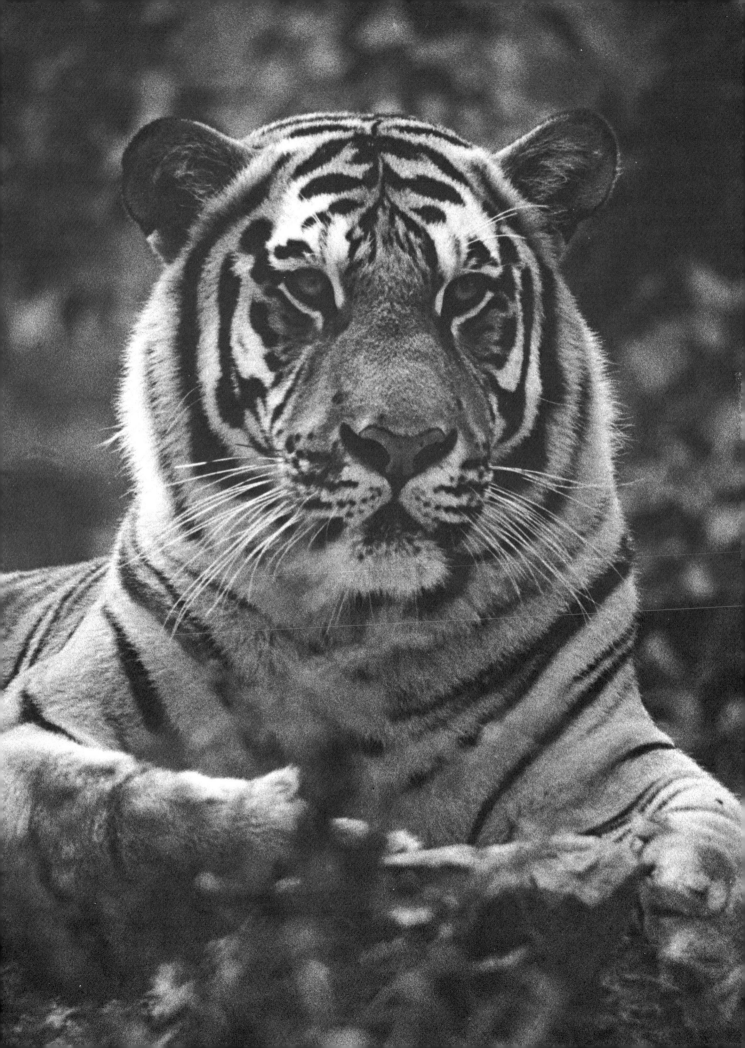

CHAPTER 3

Films

There were times in this rather complicated world when choosing a roll of film to take color pictures was a real snap (no pun intended) but the present revolution in films has complicated matters somewhat. Many of the old standbys are being phased out and newer emulsions introduced to make, hopefully, life much easier. In the process, however, it has delivered a couple of hard knocks to photographers who were comfortable with these older films and find they must learn all over again.

What are the reasons for these changes? Chemical improvements, for one, and more latitude for another. The old Kodachromes were considered "right on" films which meant the exposure had to be on the nose. Now the latitude has been increased radically and the forgiveness factor is greater. In fact newer color films will be introduced by Kodak into 1977 and the user will find the color rendering will be more faithful and accurate.

Ektachrome G is a new 8mm movie film that may be used indoors and out without filtration and, it is rumored, there may eventually be the same type available for still photography. It will still require filtration under extreme situations of light; fluorescent, for example, but will open new worlds for the amateur's camera.

Not everyone is happy with the new Kodachromes and a recent survey of members of the American Society of Magazine Photographers offered the following comments: definite color shift with electronic flash, film is lower in contrast, it goes green in bright areas, variations in developing and many more. Kodak's response is new learning techniques will be necessary with the new film, but they feel it gives more honest reproduction of color. Actually this is nothing new with the introduction of any film and problems always arise until the manufacturer shakes out all the bugs.

Let's face it, when a particular film has been used for many years the cameraman becomes familiar with it; knows exposure and proper filtration. Naturally when it's removed from the market he panics and the learning process begins all over again.

While many pictures are taken on negative stock destined to be turned into wallet-sized prints, the advanced amateur or professional will usually select a transparency material for the bulk of his shooting. The pictures are clearer, sharper, offer better color and can be projected. And no print can be as brilliant as a well-projected slide. In spite of what may eventually come out of this temporary confusion one film won't do everything so don't try.

COLOR FILMS

Even at best color films can be confusing so let's dig into that medium first. At present there are about nine emulsions from four different manufacturers to choose from. These are all daylight films and we'll get into the indoor types later.

These films range in speed from ASA 25 for Kodak's new Kodachrome 25 to ASA 500 for GAF's 500, the highest speed color film on the market. The first thing to consider, before se-

lecting any color film, is to ask what it will be used for.

Taking pictures, obviously, but what kind of pictures and under what type of conditions? Dim light, bright light, overcast, portraits, etc.? Is the film to be pushed to gain speed and how much gain is required? If we walk before running the best probable choice for the majority of picturetaking under well-lit daylight conditions is Eastman's Kodachrome 25 film. As their designation implies, its speed is ASA 25 and it is an excellent choice for most subjects. The film's overall quality is excellent with colors that are pure and bright. If more speed is required then Kodachrome 64 would be the choice. For the purest blues of all color films Ektachrome X (ASA 64) is excellent. The latter is the film I use most because there is more control in processing. With the Kodachrome films, once they are exposed there is no leeway allowed for pushing a stop or so. With the Ektachrome films (all types) the photographer may have a six or eight-inch strip (or a frame from 120) cut from the roll and processed first, then decide if he should gain or lose speed and how much. A third film that I use, and like, is Fujichrome. A Japanese film, it has an ASA 100 rating and that extra dash of speed is a pleasure under dim light. It may also be processed by any laboratory that does Ektachrome film.

But the question arises with the introduction of these new Kodachromes, are they the same as before? No, they are not, but this is true of all newly introduced films and they will eventually settle down fairly steady.

All the films discussed would be excellent choices for general purpose photography under most outdoor situations. The slower films would be best for those areas where light is extremely brilliant; Caribbean beaches, the high mountains of Utah, Colorado or Wyoming and skiing. The fast emulsions, High Speed Ektachrome (ASA 160), GAF 200 and 500 will work better under low light situations. The GAF 200 does have a tendency to be somewhat on the green side with that tint apt to pervade most dominant colors. The green is fine in the GAF 500 but a brownish tint seems to intrude on the reds and skin tones. With High Speed Ektachrome a pinkish cast will be seen in clouds and perhaps even the blue sky. Nothing is perfect and many people believe (poor souls) that a particular color film will act exactly the same under the same situation. But color sensitivity changes according to length of film storage before or after exposure, processing and exposure.

Color films present a more confusing picture than their black and white brothers. There are so many that do different things at different times that it is often difficult to make a choice. Unlike black and white films that may be used indoors or out, with artificial light of all types—electronic flash, fluorescent, tungsten or flash bulbs—color film must be used with the correct light source. This means outdoor rated color films in daylight and indoor films with their proper light. Also, unlike black and white films, color is rated for the light under which they will be used. This is called a Kelvin rating and if daylight films are shot indoors there will be a reddish cast unless the film is corrected with the proper filter. It is simpler, therefore, to match the film to correct lighting and most of the problems are solved. But back to this Kelvin business for a moment. Daylight color films are rated for around 5500 degrees and while daylight varies up and down this scale a bit, depending upon the time of day, 5500 degrees approximates ideal daylight. Moving indoors color film is known as Tungsten film and comes in two types; Type A to be used with 3400K lights and Type B for 3200K lights. Incidentally, these lights may be purchased at any camera shop and are relatively inexpensive. The Type A film is Kodachrome with an ASA 40 rating. It is a beautiful film and, if the speed is sufficient for the subject, would be a first choice for indoor pictures. The Type B films are High Speed Ektachrome with a rating of ASA 125. This is the film to use under low light conditions; the circus, street scenes, or campfires. Type B Professional is a 120 film with an ASA rating of 32 and should be used for exact color reproduction.

As complicated as this may seem it isn't all that difficult if the proper film is matched to the correct light source. Of course Daylight films may also be used indoors; with proper filtration, blue flashbulbs or clear flashbulbs with an 80C filter or electronic flash.

One area of color photography the amateur doesn't usually understand is that dominant

The ability of Ilford to hold tonal range is best shown by these hunters portaging a canoe. Olympus and 16mm lens.

51

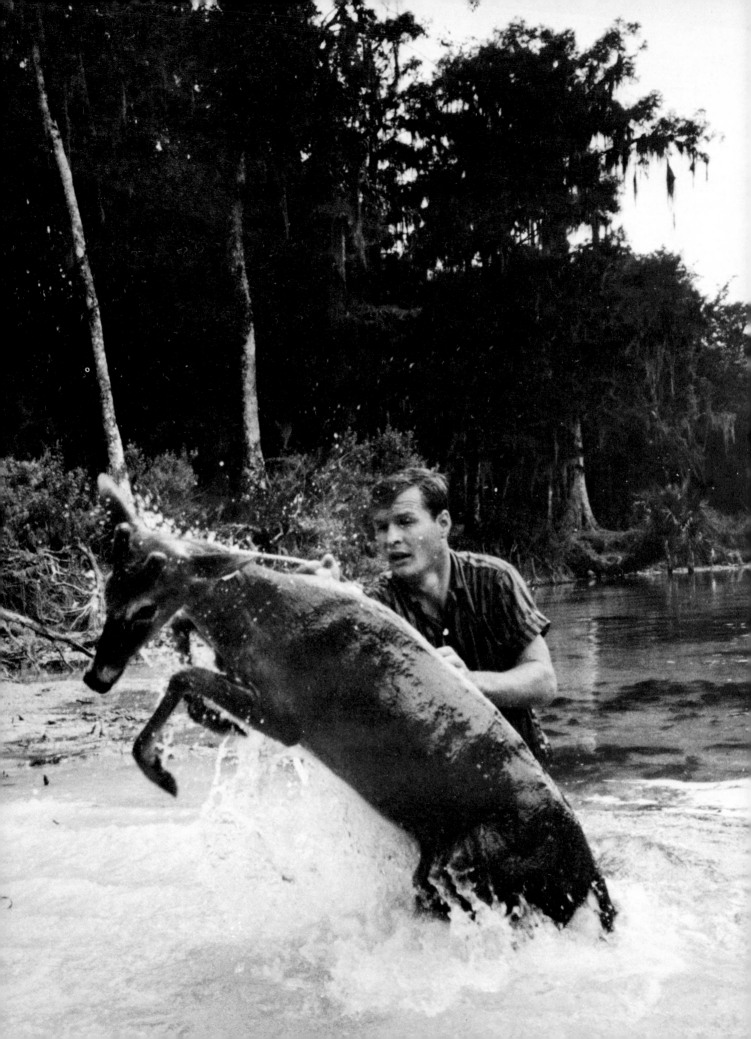

Bright tropical sun calls for a film that gives a full range of tonal values. Taken at Cat Cay in the Bahamas. Ilford FP 4 is ideal for such locations.

colors will frequently intrude on the transparency when pictures are taken indoors. Colored walls or drapes near the subject will often reflect on skin tones. This can usually be overcome by selecting a proper location before taking the picture. It is another reason why most professional studios are painted stark white.

It can even happen outdoors and care must be taken before arranging a picture near some red or green wall. Beware of colored beach towels or umbrellas since they may give a slight tint and should be watched.

With this seeming confusion of films the ideal would be one film that could be used both indoors and out. Actually, a number of years ago, when rangefinder cameras were the only breed we had, many photographers saw no reason for complicating an already tricky situation and Type A Kodachrome was used for everything.

When the camera was taken outdoors a salmon-colored conversion filter was slipped over the lens to correct for daylight and removed indoors. Ah! That's ideal and why can't we do that today? We can if the photographer will put up with a slight inconvenience. The Type A film, used indoors, has a speed of ASA 40; go outdoors with the conversion filter and its speed becomes ASA 25, exactly the same as Kodachrome 25 film. If that seems to be such a simple solution why aren't more photographers doing it? A fair and reasonable question and for the answer we have to go back to those rangefinder cameras. A rangefinder camera is just that, the subject is focused through the rangefinder and usually viewed through another window set a few millimeters off center and the filter made no difference to the eye of the viewer. With the advent of the SLR camera, where viewing is done through the lens, the deeper and denser filters become awkward to use since they distorted the scene and made it much more difficult

Part of a series of a deer capture taken near Silver Springs, Florida.

to stay in touch with reality. With the exception of the very pale light-balancing filters (discussed in the Filter chapter) anything placed in front of the lens for any length of time is going to interfere with a visual interpretation of the scene. However, if the photographer can overcome this handicap in viewing, it is a good way of taking pictures.

In the beginning it is best to select one film for outdoor photography and stay with it until the user becomes thoroughly familiar with it. Of course if there is any compromise on the use of any film it has to be on its availability. Can it be purchased in Richfield, Utah or Pahokee, Florida? And can it be processed easily as well? If many of New York's largest camera stores don't carry lesser-known brands it's a sure bet they won't be available in some small town drugstore.

Incidentally, should the photographer live in the hinterlands and not care to process his own color, it might be a good idea to become friendly with the local photo studio. Often arrangements can be made to have film processed and since the pro has an investment of time and money there is some assurance he will exercise caution.

Infrared films, both color and black and white, may be used by the amateur, but with exceptional care. The color emulsion is an amazing film and true color shouldn't be expected, but the results are startling to the first-time user and it may open doors for creativity in color. Filters must be used with both these films, a deep red with the black and white, and reds and yellows with color. A close look at the focusing ring on most lenses will show a small R or a tiny red dot. This is the infrared focusing mark and when using these films the lens must be racked to this mark for correct focus.

What kind of results can be expected? With black and white excellent haze cutting, black

A bow hunter at the YO Ranch, Mountain Home, Texas. Bright southwestern sun is akin to tropical lighting and calls for the same type of film.

Not all indoor color requires elaborate equipment. High Speed Ektachrome, daylight type, was used. A small tripod and a low shutter speed to picture this craftsman at the Orvis plant making a cane rod.

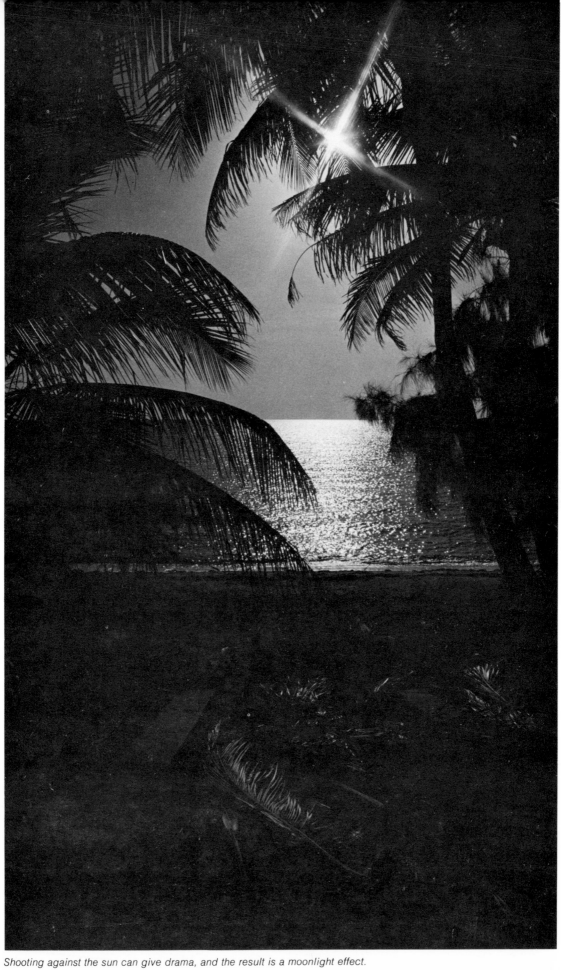

Shooting against the sun can give drama, and the result is a moonlight effect.

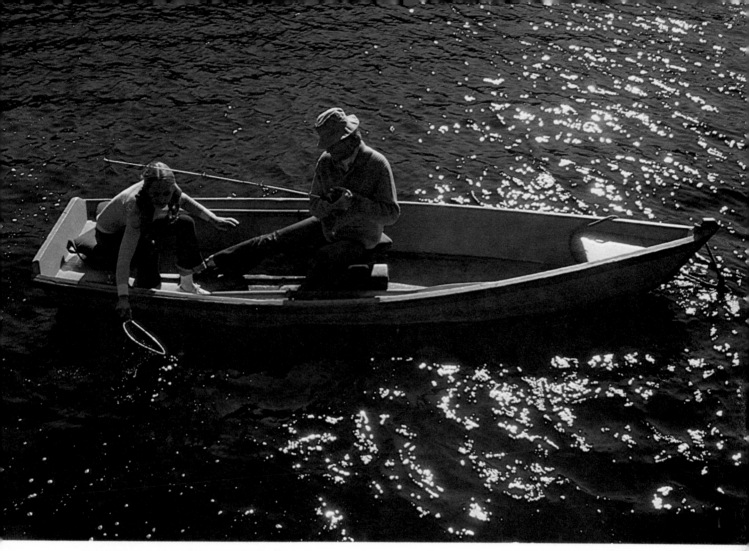

Backlighting can be particularly effective in color.

skies, silvery foliage and brilliant cloud formations. Color goes wild depending upon the filter used. Purples, yellows, greens and subtle variations. The ASA ratings of these films is dependent upon the filter used and the instructions enclosed with each roll must be read thoroughly.

With such wild results what are the best uses for these emulsions? Landscapes and aerial shots will show the most exciting difference between infrared and regular films. Aside from the scientific aspects; aerial mapping, criminology and medical, these films are widely used by advanced amateurs and professionals for bold effects in scenics and have occasionally even been used in fashions.

The two kinds of indoor color films, Type A and Type B, will cover practically all indoor situations and if an electrical outlet is available a small photoflood (of the proper rating) bounced off a white ceiling will raise the light level. The Type B film is best for "available light" situations and, if the camera is held steady or set on a tripod, will permit cabin interiors by candle or lantern light. For more precise indoor photography the Type A film is excellent. With the correct 3400K lights it has the grainless quality of all Kodachrome films. It would be the ideal film to use for closeups of all our sporting toys and also renders excellent skin tones.

Tungsten films may also be used with clear flashbulbs and an 81D filter. The lens must be opened about 2/3rd stop and the flashbulb wrapper will give the correct guide number for the bulb used. An 81C filter will give slightly less warm results and may be more pleasing.

When we come to photography under fluorescent lights David B. Eisendrath, one of the great photographers and an expert technician, once paraphrased the Lord when he said, "When the Lord said let there be light he didn't mean fluorescent since they are the work of the devil." If it is so difficult obtaining a good transparency under troublesome lights, why bother? Well, most photographers are a perverse bunch and these unnatural lights have been introduced into the outdoor world in ever increasing frequency. Mobile homes have them as

57

Charlie Loughridge in his fishing shop at *The Ranch at Roaring Fork* in Colorado. Sufficient daylight flooded the shop through large doors and windows to give a natural effect. Ektachrome X film exposed at meter reading.

do many cabins and boats and even small portable lanterns are available to make the night's shadows recoil in ghastly hues.

The proper filtration for photography under fluorescents is detailed in the Filter chapter, but let's recapitulate quickly. The easiest way to solve the problem is to use High Speed Ektachrome Daylight Type film, place a CC30M filter over the lens (this is a gelatin filter) and rerate the film speed to ASA 125. This takes care of the filter factor and all that need be done is take the proper meter reading and shoot. This technique gives the best (?) flesh tones. Other suggestions will be found in the Filter chapter.

If it all seems too technical don't despair because we're not finished with color films yet. Thus far we've concentrated on the transparency type of film that delivers projectable slides. There are also negative color films that make up into inexpensive prints. Those prints that proud dads display on the slightest provocation.

It just might be possible there is a desire to take something more than boring prints so let's discuss the negative color material. Fuji Film has an excellent film called, naturally, Fujicolor. It is rated at ASA 100, the same speed as their slide film and is compatible with standard Kodak processing. Eastman has Vericolor II, a replacement film for the old Ektacolor (Kodak is always pulling something like this) and in spite of the older material being a sensationally successful film it was never really very fine-grained. Ergo, it had to go! With the grain problem the pros stuck to larger film sizes, but the new material, while being a vast improvement, still isn't terribly fine-grained. However, the speed is the same, ASA 100, so it's worth a try. Now when to use these films. Never use a high-speed film if a slower one will do. The quality and fine grain will be better and the color truer. But picture situations are seldom perfect and this is where faster films come to the rescue. High Speed Ektachrome will permit shooting in rain, haze, fog, deep in the woods and dozens of other situations where the light level is low. Under bright or brilliant conditions both of the Kodachromes might be the choice and for general all-around outdoor shooting I'd go with Ektachrome X. Indoors my preference is Kodachrome Type A and if I must cover an assignment under available light in color then one of the High Speed Ektachromes with proper filtration, depending upon the lights.

BLACK AND WHITE FILMS

Now that we've partially solved the color situation let's move on to black and white films. As with color they come in a wide variety of sizes and ASA speeds but we'll concern ourselves with 35mm and keep it simple. As with all films some will give better results than others *if they are used properly.*

For example it would be foolhardy to use an extremely fast film like Tri-X on some tropical beach with bright sun beating down. While it might be possible to get an exposure (even without neutral-density filters) the negative quality would not give maximum results in the print. While many photographers prefer a very fast film for everything I feel it is wise to fit the film to the subject. The results will be more satisfactory.

Let's take the slower films first because they will be more widely used than their faster counterparts. Everyone has his favorite and mine is Ilford FP-4, an English film of remarkable quality. Over the years I've recommended this film to many photographers, both professional and amateur, and they've been delighted with the discovery. FP-4 is, without exception, one of the finest films I've ever used. It is a medium fast film with a very workable rating of ASA 125. The negatives deliver beautiful prints with a tonal range that captures every nuance and shading from very white whites through grays to full rich blacks. It is an absolutely splendid film and I can't praise it too highly.

This is the film that should be used for the bulk of outdoor picture taking and if developed properly it will give astounding results.

A number of years ago there were a series of German films available that were famed for their exceptionally fine grain and superb quality. Manufacturered by Adox these were KB14, an ultra fine-grain film with an ASA rating of 16, KB17 at ASA 40 and KB21 at ASA 100. There were groans of dismay when they were taken off the U.S. market but now there is rejoicing because these excellent films are now being made in, of all places, Yugoslavia. The fast-film fanatics may wonder why the emphasis on slower films but the Adox material known as thin

emulsion base films, delivered fine grain and a quality unknown to modern available-light buffs. For huge enlargements with exceptional quality Adox will deliver memorable prints. Should there be some hesitancy regarding the rather low ASA ratings remember these films are to be used out of doors. Just for fun set the meter at ASA 40 and see how well this speed works. After all, color pictures are taken with slower films.

No, I'm not going to leave Tri-X out in the cold. It is an excellent film, but should be considered among the family of fast, high-speed films. It will give fine enlargements but, for the beginner, it must be used with a judicious hand. The speed of the film is ASA 400 for normal photography and it may be rerated to ASA 800 without too much trouble (advise the lab when the film is speeded up) and an experienced hand can even push it to ASA 1600 or higher. The reasons for rerating films are many. It may not be possible to get a meter reading under some light situations and if the film is pushed to a higher reading it will enable the cameraman to shoot. Special effects is another. Fashion photographers may rerate their film to ASA 5000 or ASA 10,000 and, processed in certain developers, have it deliver grain the size of marbles.

Of course this is controlled shooting and is the exact effect the photographer desires. A hunting trip is another good example. Game may only be found when light is low, in early morning or late in the day, and the low light may not give a satisfactory reading to enable the cameraman to take a picture. Under such conditions the film may safely be rerated until an exposure is possible. It must be remembered, however, when film is shot at a higher ASA index the entire roll must be exposed at the same rating.

The photographer who does speed up film to a higher rating must also remember that there will invariably be some sacrifice in quality. In fact, for most, shooting the ASA 400 is quite adequate and the amateur is seeking trouble with tremendous gains in speed. Recently Jack Des-

Backlighting can give drama and mood; pictures should be taken against the sun more frequently.

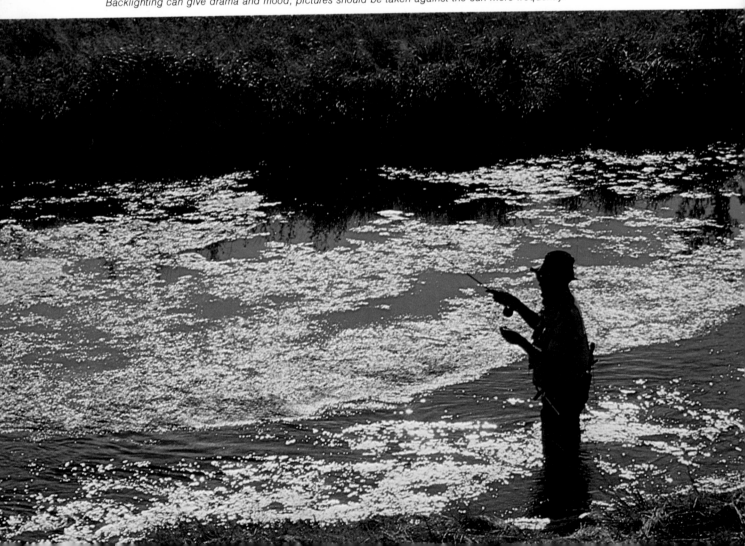

Youngsters from the Ranch at Roaring Fork take a rafting trip downriver to Carbondale, Colorado. Ektachrome X film.

chin, the former camera editor of the *New York Times*, showed me some enlargements sent him by a self-professed professional photographer. While the soft, out-of-focus prints could not be excused, the grain made the picture even worse. A covering letter proudly proclaimed that the film was rated ASA 1600. Both Jack and I wondered why? After all, the subjects were in a brilliantly lit office and the normal rating of Tri-X would have been more than adequate. This is one of the dangers of trying to emulate the professional when skills won't permit.

USING FILMS PROPERLY

A number of times I've said photography is experimental and nowhere does this hold truer than learning how to use films properly. Every camera has variations in shutter speeds, light meters and even how the meter is interpreted by the user. Added to the problem is the fact color films have minor variations in their stated speeds and each processing laboratory (including professional outfits) will vary from day to day. The laboratory may run the film late in the day, and technicians do get tired, perhaps the chemicals have had too many rolls run through and the film may be slightly slower or faster than indicated and it will all add to grief.

Perhaps the biggest problem of all, however, is that many beginners won't trust their equipment. In fact many photographers won't even trust themselves when it comes to taking pictures. Let's follow the average amateur and watch him expose a roll of film. He carefully sets the meter for the correct film index, slings the camera over his shoulder and heads for the great adventure. The first subject encountered he will take a careful meter reading, but won't believe it. The proper setting might be, say, f/11 at 1/125th of a second. Now, just to be on the safe side, the lens will probably be set at f/8. This, our friend reasons, will insure an exposure. Then when the roll is brought to the processing laboratory (assuming he is using a custom lab) he tells them, "Better add a couple of minutes to make sure it comes out." What he has done, of course, is add so much overexposure he'll be lucky if the negatives can be printed.

There is one very simple method of standardizing camera and film to insure success and

A young deer peering around a tree at the YO Ranch. 500mm mirror lens and Ilford FP 4 film.

that is to run a test roll of film through the camera. Select a roll of film, color or black and white, load the camera making certain to set the meter for the proper film speed and take a trip to the park. We're not going to concern ourelves with pictures, just exposure.

Assuming this is a 36-exposure roll expose one-third at the precise meter reading, another third one stop more than the meter indicates and the final third one stop less. Have the film processed normal and returned uncut, that is in one long strip. Everything being equal the test roll should have twelve exposures that are completely normal and right on the nose, another twelve that are a bit light and the final twelve somewhat darker. A close examination will show how exact the meter is and what meter adustments must be made for the proper exposure. With a new piece of equipment or new film I always run these tests. That way I know what each camera, lens and film type will do. Once the photographer becomes familiar with his choice of film, and can predict the results, he may then go on to other films . . . always running a test with the first roll.

Color, in particular, is a very personal thing and many cameramen may prefer a transparency that is slightly lighter or darker. Since each color medium has its own special characteristics it will also give slightly different interpretations of the same scene or subject. All color film is a compromise between the actual subject seen and what is captured on film. The best judgment of any color pictures are the flesh tones of a subject. In spite of a variety of tints in the human physiognomy, sunburn, tans or the white skin of redheads, we know the person photographed and subconsciously judge the colors before us.

A professional photographer who must match a particular color or fabric has a slightly more difficult time. But his problem is solved more by the engraver. If the transparencies are properly exposed the delicate variations will usually match quite close. Of course, the amateur needn't bother himself with inks, printing paper and exact color reproduction, all those variables that must concern a professional.

But don't let this testing become a bore. After all it's only one roll and will eliminate problems later. It also shouldn't discourage a desire for better color. There are millions of happy snapshooters turning out color pictures every day, but it is important the aspiring photographer be aware that bad negatives or color transparencies aren't the norm and with care it's just as easy to take a properly exposed picture.

Frequently many photographers don't have any frame of reference in order to judge their work with something better. Over the years they have seen so many poor pictures, usually from friends, the average under-exposed snap is accepted as a standard by which all other pictures are judged. Granted there are magazines to look at, but many feel these professional results are beyond their ability. Admitted not everyone is fortunate to have the wide choice of subjects offered a professional, but good exposure isn't that difficult to attain and many seemingly difficult pictures are solved in rather simple manner.

A friend once devoted quite a few weekends to photographing the interior of his cabin. While the color was exellent there was one thing that appeared beyond his skill. The view of the lake through the windows was completely washed out and he was unable to obtain a good transparency with a well-lit interior and a well-exposed exterior. I explained the best solution to his problem was to take an outdoor meter reading, then balance the interior lights to that exposure. Lugging both electronic flash and blue flashbulbs up on Sunday I proceeded to take the picture. The daylight exposure was the usual f/11 at 1/125th with Ektachrome X. Since my camera would only sync with electronic flash at 1/60th, we changed the reading to f/16 at 1/60th. An inexpensive flash meter was used and we clicked the strobes until the interior read the same as the exterior. Once we decided upon the proper placement of the lights we simply took the picture. We did the same thing with blue flashbulbs (to match daylight film) and used the guide numbers from the bulb wrappers. My friend was delighted with the pictures and, more importantly, is now an avid reader of photo books and magazines to learn other little tricks.

Another friend had a different problem since his efforts at taking campfire scenes were less than successful. The color was invariably overexposed and the pictures blurred from movement from both the camera and subject. I told him the first thing he would have to do is steady the camera either with a tripod, a rock or beanbag. Once that was done, to take a meter

A still life adds interest to any fishing series with an abundance of props and locations.

reading off the subject's face and tell them to hold still for a short time exposure. He was also advised to take the picture with both Daylight and Type B films and then decide which he liked best.

For something more elaborate he could have someone inside a tent flash a small bulb with the camera shutter on Time or Bulb. This would add realism and not overpower the naturalness of the scene. By now my friend was enthused and asked about stringing extension wires to the far side of the campfire. I told him he could do that, but should cover the bulb with an orange gelatin to cut down on the flash and add some drama to the subject. What I want to show is that a bit of learning leads to more enthusiasm and becoming knowledgeable about films will widen the scope of skills. Taking anything more than a simple snapshot demands taking the time to exert energy with lights, tripods and all the tools of photography. It also means knowing films and what they will do, and a willingness to expose more than one frame on any given subject.

FILM PROCESSING

With all these pictures now being taken should the photographer process himself, or go to a good professional lab? For the advanced amateur who has experience and the facilities it won't be a problem. Even the transition to color isn't too difficult. For those who are busy or don't have the desire or inclination (or space) to set up darkroom equipment then the only solution is with a good laboratory. For myself I don't have the time or energy returning from a lengthy trip with 30 or 40 rolls of color plus an equal amount of black and white to spend days in the darkroom.

Most professional photographers I know have their film processed in outside labs and if a

good one is selected the work will be excellent. How to choose the proper lab that will do careful work and deliver reasonable service isn't easy. The only way to guarantee consistent results is feed them a couple of rolls from time to time and see that the film is free of dirt, dust and scratches and properly processed.

In spite of protestations of personal service no lab that dumps 30 or 40 rolls into the tank at one time can deliver personal inspection no matter what they promise; fast developing time won't allow it. But once a good lab is found stick with them for they are as rare as a good auto mechanic or gunsmith. Not only is careful film developing of the greatest importance, but good enlargements are more than half the picture.

Too often I've seen badly developed film, scratched negatives and poor prints made by inexperienced youngsters. There are those with skills, however, who can craft a beautiful print with everything that is in the negative; men like Charles Reiche of Scope Associates in New York for instance. He's a master printer who makes prints that have awed many clients. For the amateur Charles says, "There is no substitute for a proper exposure. No magic in the darkroom can get a superb print from a poorly exposed negative. If the photographer is a rank amateur we'll set him on the right path. We'll advise what film to use, how to rate and expose the film and he'll learn."

Modernage Photographic Services is another New York-based professional laboratory that handles color and black and white for advanced amateurs and professionals. Harry Amdur, headman of this five-story building devoted to photography, explains, "There is a tremendous amount of skill required to develop film and make fine prints. Much of this is beyond the ability of the occasional photographer who may not have the proper equipment or large variety of printing papers at hand. The solutions used in color processing must be maintained at exact temperatures and often the amateur doesn't have, nor could he afford, the equipment."

Amdur continued, "The concerned lab, with conscientious technicians, is available to help the photographer take better pictures. After all, it's just common sense to help your customers."

Brown bear pictured in Wyoming with Ektachrome X film. Picture taken with Nikon and 500mm mirror lens.

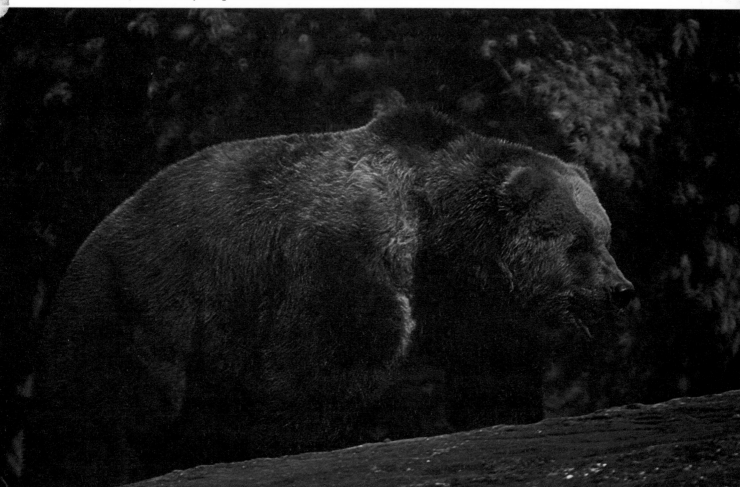

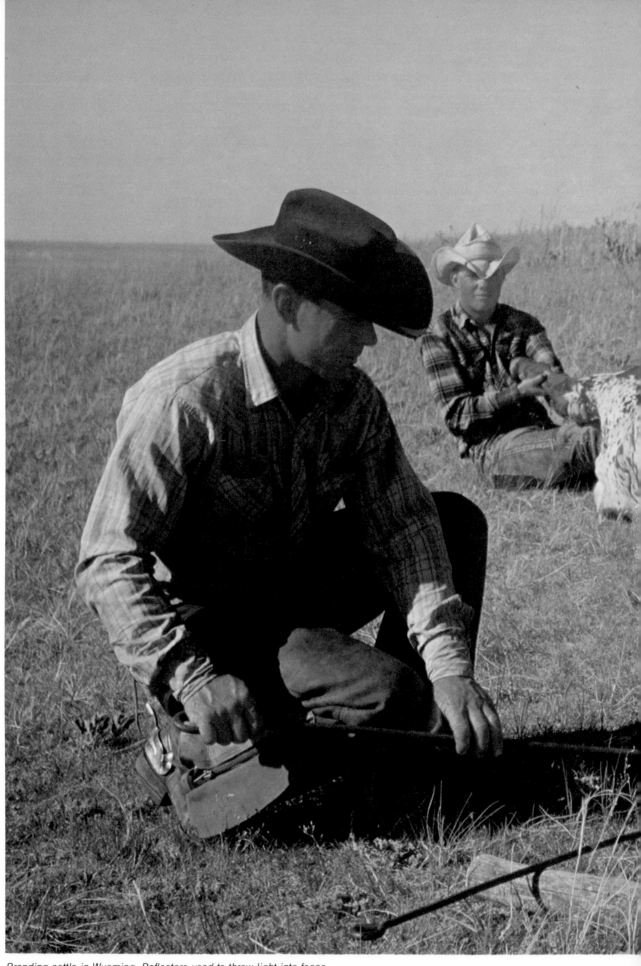

Branding cattle in Wyoming. Reflectors used to throw light into faces.

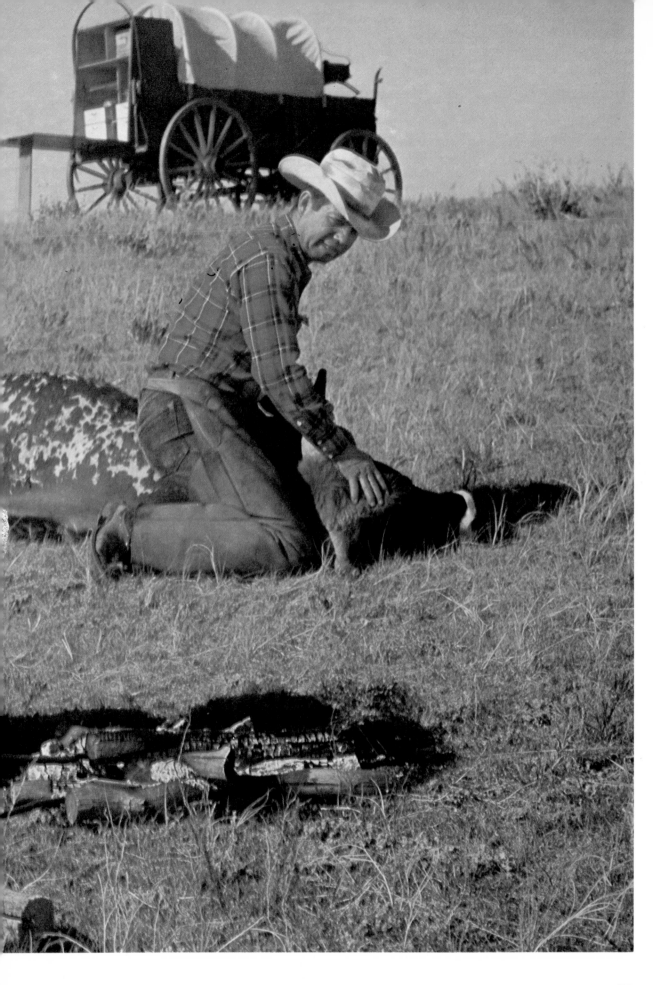

Patricia Anderson, who heads up Modernage's color department, is a young lady well versed in the complexities of color processing and printing. She has some solid advice for the color photographer. "All photographers should learn what filters do. There is nothing more annoying than looking at color slides with blue foliage. The proper filter would have warmed the scene and, it should be remembered, few such scenes are salvageable by printing. Unfortunately," Pat went on, "many clients feel the lab should perform miracles and we can, up to a point, but if the color isn't in the picture we can't put it in."

Whatever laboratory facility is finally selected, get to know the technicians and it will pay rewards. Advice and help are forthcoming because if the photographer improves it will make the lab's task that much easier. And it may even come as a surprise to the beginner to view a number of negatives and find the one that looks worst to his unskilled eye may well make the best print.

Whether the cameraman is shooting in black and white or color he shouldn't fear the latter in spite of many complexities.

As Pat Anderson summed up, "It is time we stopped thinking of color photography as a novelty. Something that stands aloof and alone in a special realm. We must treat it as something that is here to stay and is, after all, part of that medium that is, quite simply photography."

Colorado mountains pictured with a Nikon and 135mm lens.

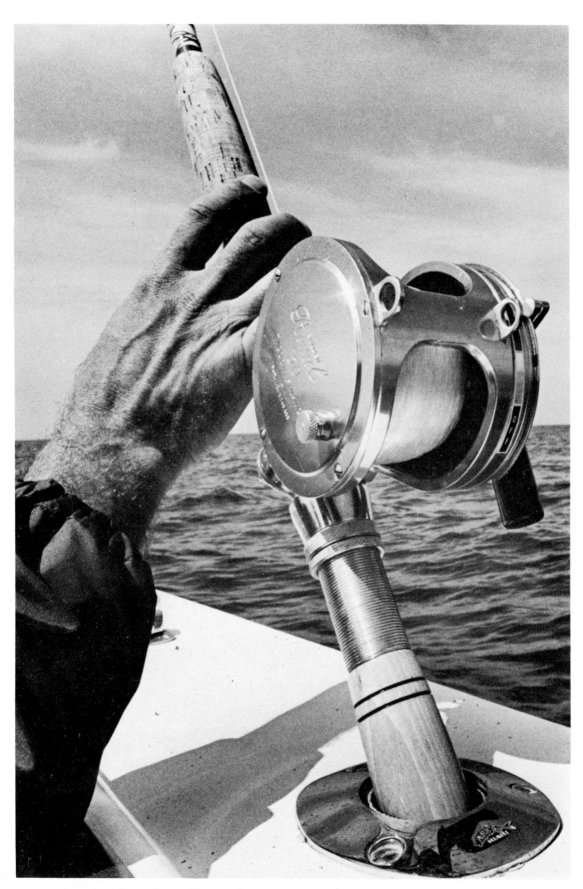

24mm wide angle at times offers a different point of view.

CHAPTER 4

Filters

What are those pretty pieces of glass and what do they do—filters?—scare people mostly. With the tremendous variety of films, and lighting conditions under which pictures are taken, filters do have a reason for being, but they have been poorly explained to the potential camera buff in the past. Almost every book on the subject contains a steady stream of scientific jargon. Granted it's pretty difficult to tell just what filters do without discussing such disconcerting terms as wavelength and millimicrons, but most outdoorsmen, and the majority of camera fans, are more interested in what the filter will do rather than why it works.

In a nation of some 78,375,000 cameras, only professionals and a few advanced amateurs have ever used filters. In fact *Consumer Guide* took an educated guess in their 1973 Photographic Equipment Report (the last year available for such figures) and stated that 95% of those who take pictures never have and never will put a filter in front of their lens. This is a great pity because the filter is probably one of the least expensive and most helpful photographic accessories available. It is an invaluable aid to better pictures and good filters, depending upon the size, cost around $10 or less. Certainly not a prohibitive expense considering the price of most items in the world of photography.

Many cameramen, especially professionals, regard filters as a way to gain more striking effects, correct color variations, balance films to their proper light source and, indeed, add drama to certain subjects. Filters are tools for better pictures just as a sunshade, light meter or a tripod are tools. They will enable the photographer to make better pictures and the proper filter will help the creative cameraman with the mood or effect of color or black and white. Filters frequently save poor pictures by adding a starburst to the scene or streaks of color across the subject, they will correct an off-color scene back to normal, exaggerate an effect and give drama and impact to pictures. Indeed filters are invaluable aids for better pictures and should not be feared.

What usually causes the most concern with potential filter users are the rather confusing filter factors. Those 2X or 3½X factors that must be used to compensate for exposure after placing a dense filter over the lens. But with modern through-the-lens metering systems on most cameras the factors may be completely ignored. Of course some technically minded folk may argue that's a simplified solution since certain meters may read more or less of various spectrums of color (giving slightly 'off' readings) and that could well be true, but I've used a number of cameras over the years and my advice is—put a filter on and shoot.

But how will the lack of filtration affect a picture? A perfect example is someone lugging enough equipment to Alaska or Africa to shoot an epic picture, but when the film comes back from the darkroom disappointment sets in. The transparencies have a definite bluish cast and the black and white is devoid of clouds. This happened to a friend who journeyed to Zambia for a month's hunting. When I was asked to view his color I inquired if he had used a Skylight filter. The poor fellow didn't know what I was talking about. With a clear atmosphere and puffy

At times a color filter can add an unusual effect to color film. This is entirely personal, but the photographer should experiment with these filters.

Polaroid filter was used for this beach scene in the Cayman Islands. Water appears more natural, sky is darkened, and clouds become more brilliant.

72

cumulus overhead the clouds, plains, and animals were a deep blue. It was a tragedy, really, because the photographer will only learn by asking or continue to accept poor results as normal.

To understand filters and what they do something must also be understood of film sensitivity as well. Be assured this is not going to become too technical, so read on. Basically the normal, human eye is sensitive to most colors. This isn't necessarily true of all black and white films, however. But in spite of the vast amount of monochromatic emulsions on the market most are of the panchromatic type. This is fortunate because this type of film does approximate the human eye. Since most photographers seek to record a subject accurately the choice of the correct filter will assist in the proper rendition of tones in the final print or more pleasing hues in a color transparency. Very often, by selecting the right filter, the cameraman can improve on nature or achieve wildly striking pictures which is what this is all about—improving pictures.

Before turning to filters themselves, and what to use when, let's learn a bit about the filter itself. A good filter is made from top-quality optical glass with as much care and attention as a fine lens. Filters for photography must be precise optical components to complement any precision lens system.

Many filters, particularly special effect or the CC (color compensating) series, are made from sheets of gelatin often sandwiched between glass and they do an excellent job, but in the long run may be affected by ranges of heat and humidity and will not last as long as those crafted from solid optical glass. Make no mistake, these all-gelatin filters, sold in sheets of various sizes to fit practically any lens, are manufactured to rigid standards. They are, however, extremely fragile and must be handled with great care. Why gelatin rather than glass? It's necessary because it's almost impossible to control the delicate color tones in the manufacture of glass filters. The gelatin types are primarily used for exacting color control. They will bring variations of film, under unusual lighting conditions, back to normal.

Another point of importance, often overlooked, is that an inexpensive glass filter will protect a high-priced lens. Dust and sand as well as salt spray and rain will be kept off the front lens element and that is a gain in itself. Even twigs or branches snapping back can damage a lens as well as an eye. That's one reason most experienced sportsmen wear protective glasses when shooting or fly casting. These hazards are about all the time and a fine lens must be protected from bumps and bangs. Now that we've given an excellent reason for using filters let's find out what they do.

Filters for black and white films are probably the easiest to use so—to begin.

BLACK AND WHITE FILTERS

Everyone has seen, or taken, a picture with beautiful, fluffy clouds in the sky, but when the picture came out those dramatic looking clouds had practically disappeared. A filter would have made those clouds stand out and, depending upon the density of the filter, could have darkened the sky just a bit or even made it black.

Although every filter manufacturer has a different nomenclature for his filter line we'll discuss them in simple terms so it may be more easily understood. The black and white filters range through tints of yellow, orange, green and red. There are others, blue for example, that accentuate haze or fog, and others for copying blueprints, various types of reproduction work and scientific photography. We need not concern ourselves with those because of the limited application. But getting back to important filters for general photography each range of filters, yellow, orange, green or red, is slightly darker progressing through the scale and will give different results. The prime interest for outdoor use, darkening skies, rendering more natural skin tones and giving more drama to a picture, lead to three types: yellow, green and the red series. The orange filters give nearly the effect of medium or dark yellows and make the picture even more dramatic.

For the novice who wants a few filters to make his pictures more exciting let's look at the yellow series. A light yellow will darken the skies slightly. This filter absorbs excess blue and emphasizes clouds. For more accurate tonal correction the next deeper yellow (called a Yellow 2 by Tiffen) produces greater contrast in clouds. The most dramatic of all is the Yellow

3 (Tiffen), a deep yellow for strong cloud contrast.

The green filter is an ideal outdoor filter for obtaining pleasing flesh tones and renders more natural landscape or flowers. In fact the green might be called a foliage filter since it renders these tones so well.

Orange-colored filters darken the skies somewhat more than the deepest yellow. They will render blue objects, such as water or marine scenes, more dramatically. Red filters are perhaps the most dramatic of all and give striking effects. The deep red (Tiffen 25A) will create almost black skies and give "moonlight" scenes in midday (with slight under-exposure). Used with infrared black and white films, the contrast is even more noticeable. Trees and foliage turn white, skies darken and it will cut through fog, haze and mist and is excellent for distant landscapes.

These black and white filters, when properly used, will give startling and bold results and, with care, may also be used with color films for special effects. The orange makes an interesting effect filter when shooting a sunset in color. The reds, yellows and greens may also be used if it is understood there will be a complete cast of the chosen color over the entire transparency.

When using any filter for the first time it makes sense to vary the exposure slightly to learn what effect over and under-exposure will do and how it will affect the film.

Before moving on to color let's discuss one other filter that may be used with both emulsions. This is the Polaroid filter and it is the *only* filter that darkens skies with color film without changing the color values of other tones. Kodak calls theirs the Pola-screen, Tiffen a Polarizer and we'll call it a Polaroid, as do most professionals, to simplify matters.

For the camera loaded with either black and white or color the Polaroid will reduce or eliminate reflections off water, darken skies with emphasis on clouds and cut down the brilliance of certain highlights. Basically, what the Polaroid filter does is eliminate reflected

Rainbow filter shoots a spectrum of color across the picture. Filter may be rotated until the desired effect is achieved.

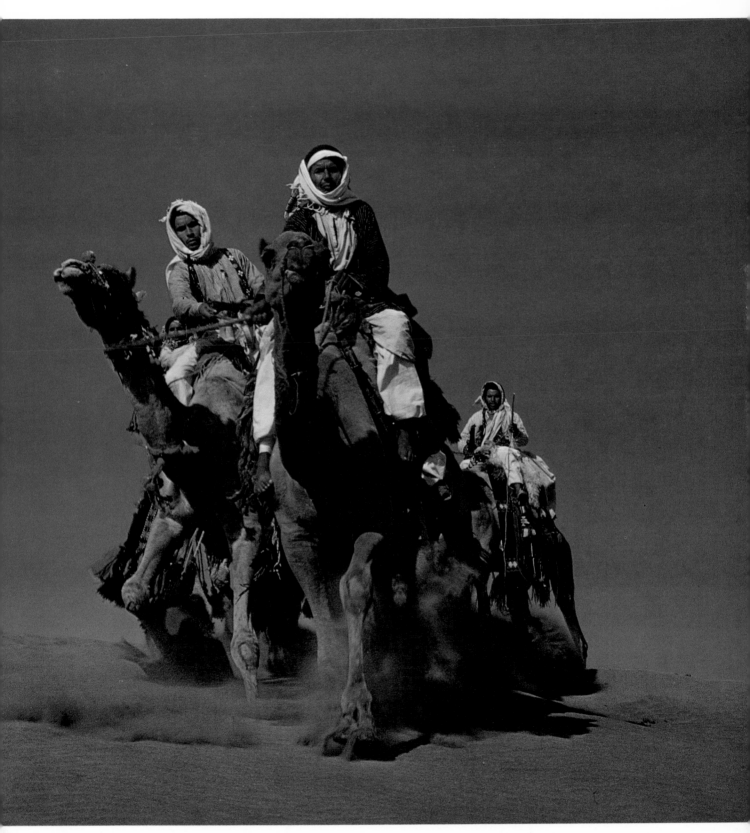

Camel Patrol pictured in Jordan. 35mm lens was used on a Nikon and low angle selected to add drama.

light off ordinary subjects such as leaves, flowers and any other colorful object permitting the color saturation to come through in the transparency. This means more brilliant color as a result. For fishermen it is a blessing since light dancing off water or surface reflections destroy the ability of a lens to picture what is under the surface.

The Polaroid filter isn't a cure-all; it must be used correctly and with care, but when it is the results are striking. Its use is dependent upon the direction of the sun and its distance above the horizon. Usually a 45 to 70 degree angle will suffice for effective elimination of reflections. In use the filter is placed on the lens and slowly rotated while viewing through the finder. When the desired effect is obtained the meter reading is made and the picture taken. It's as simple as that. With through-the-lens metering no filter factors are necessary and the meter will compensate by giving the correct exposure.

At the seashore it will give a more natural appearance to water and the usually haze-free skies will turn a deep blue. It is also excellent for snow scenes where it will also darken skies and help reduce glare off ice and snow. Some caution is advised since the Polaroid is not applicable to every subject and it must be used with discretion. A simple rule: best results are achieved with the sun to the side or right angle to the camera. The poorest pictures are those taken with the sun at the back or facing the camera.

Light is the prime mover in photography and the most important use of any filter, at least for neophytes, is to darken skies, render flesh tones more naturally (although this is of secondary importance) and achieve more dramatic impact.

But don't be confused with the profusion of filters since it isn't necessary to own every one. Not only would the effort cost a small fortune, but the opportunity would seldom arise to use every filter listed.

Filter sizes can be troublesome particularly if there are a number of different manufacturers' lenses used on the same camera. Fortunately most modern lens makers, and Nikon is a good example, have standardized the lens size so one filter will fit all Nikon lenses from 24 through 200mm. Should the photographer not have a system camera available a little thought and planning will save money in the long run and eliminate aggravation. The trick is to fit filters to the largest lens and resort to step-down rings to adapt them to other lenses. Agreed the larger size filters are more expensive, but it's still cheaper to buy one ring than filters to fit a half dozen different lenses.

What make filters to buy and which can confuse anyone. Try to get those recommended by the camera maker. A quality outfit isn't going to shortchange anyone with bad filters to be placed over high-priced lenses and Tiffen, Hoya, Harrison & Harrison and others are famed for the quality of their product.

In spite of some 30-odd filters available for black and white photography many can be eliminated as very special jobs that won't concern the average photographer. However, the choice is still slightly complicated by an individual's artistic sense. I would suggest for the first time filter buyer that a Medium Yellow and Deep Red be the only filters used in the beginning. They will immediately improve pictures. The Polaroid should also be obtained since it works as well with black and white as it does with color. Later a Green and a Medium Orange may be added as the photographer learns what filters do. Incidentally, there is one time where filters won't do anything for black and white pictures; on dull, overcast days the only thing they add is prolonged exposure.

COLOR FILTERS

Taking pictures in color presents more complications than the simpler black and white films. First of all no color film reproduces any subject or scene with absolute true accuracy. There is always some distortion of color depending on the emulsion used, how the film is stored, how soon it is processed after exposure and many other variables. Color may pick up a color cast depending on the surroundings and exposure. Outdoors, if the sky is very blue or the picture taken at high altitudes it will have a bluish cast unless a Skylight (or warmer) filter is used to warm the scene. The same may happen at sea level, the sea shore for example, and filter correction is needed there.

As we said in the chapter on Films the easiest method of obtaining good results with color

emulsions is to match film to light source and half the battle is won. Otherwise filters must be used to correct the color.

Another problem the average camera fan probably hasn't considered are color-corrected lenses. One might assume that all modern photographic lenses are color corrected, and so they are, but many fine lenses, even with modern technology, will run 'warm' or 'cool' and this will have a pronounced effect on the results. This is of great concern to motion picture cameramen and if one lens is used for all filming (highly improbable) the results won't be objectionable. With still cameras, assuming the transparencies will be used in slide shows, rapid changes of slides taken with those 'warm' or 'cool' lenses will be objectionable and won't allow the viewer to adapt to rapidly changing color values.

Some years ago Kodak gave a slide demonstration to a group of professional photographers. The entire show ran about twenty minutes and the colors were magnificent. At the end of the show, however, the first slide shown was again flashed on the screen quickly followed by the last slide and there were gasps of amazement from the audience. The pros had been taken in and what Kodak had done, of course, was assemble a set of slides with changing color values, but had introduced them so gradually the eye was able to adapt. If those two slides had not been projected in that manner the abrupt changes would have offended the viewer and made it difficult to watch the show.

Another variation affecting color can be light transmission of the lens. It might be safe to assume that every lens set at, say, f/11 might be the same as every other lens set at the same opening. Unfortunately, that isn't the case. Glass will give different light transmission, diaphragms are not always calibrated the same and minor differences of lens mounting may cause light to act in different ways. All of this will affect exposure. About now it may be fair to wonder if there are so many problems with color photography does anyone ever take a good

Portage glacier reflecting in the still water.

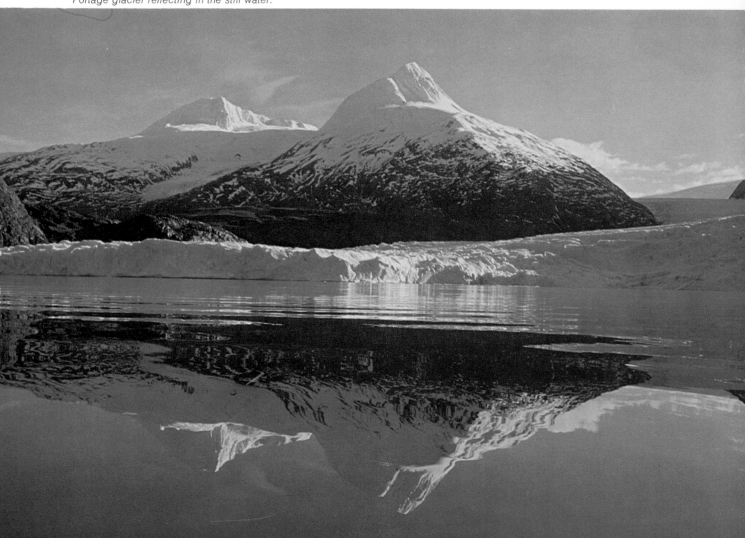

A lone hunter rides the ridge in Wyoming.

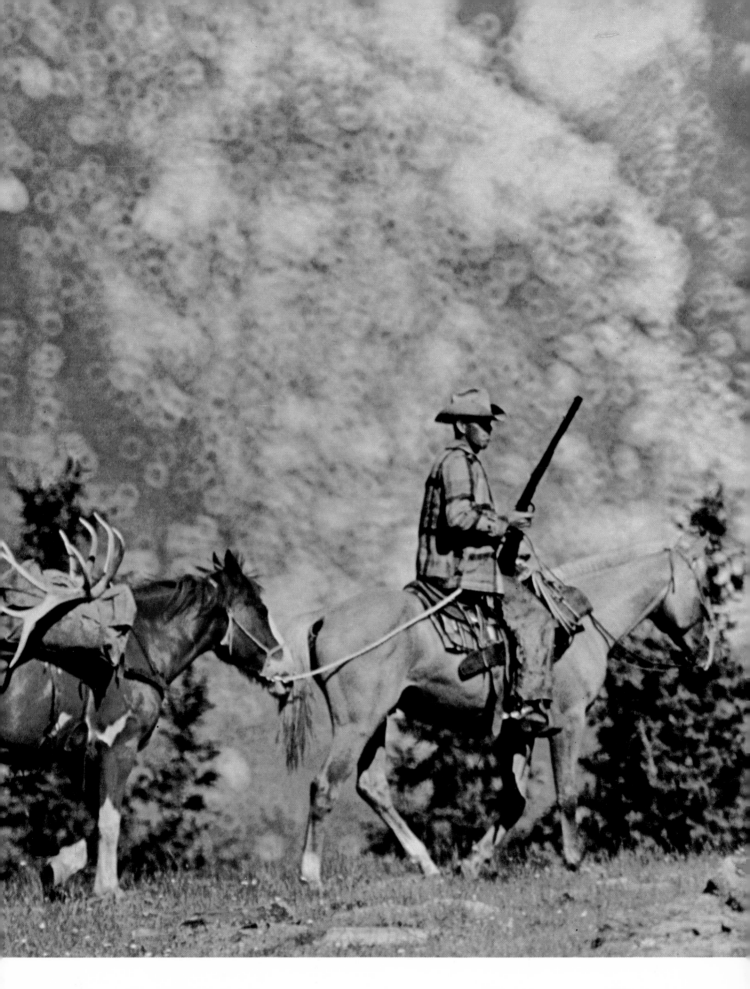

overleaf:

Famed western painter, Peter Hurd, in his ranch studio at San Patricio, New Mexico. Available light and Tri-X film.

color picture? Yes, of course they do. The results are all around in magazines, calendars and posters. To some degree many of these problems have been self-cancelling. Warm sunsets taken with a 'cool' lens or a winter scene improved with a 'warm' lens. Others have been corrected when the picture was taken and that means filters.

Earlier we said that color film must be matched to the proper light source. This is fairly simple when Daylight films are used since the Skylight filter will suffice for most outdoor photography. Daylight is probably the most commonly used source for millions of pictures and daylight films are balanced for the proper Kelvin temperature of daylight.

Don't let the term, Kelvin, be upsetting since it is only a standard of measurement for color temperature and expresses the spectral energy distribution of light. Simply explained, light is composed of rays of different wavelengths. Short wavelengths appearing as blue-violet and long wavelengths as reddish light.

The light emitted by incandescent bulbs, those used in most households, explains why pictures taken indoors with Daylight films usually have a reddish cast. With black and white films this makes little difference, but color is more critical since the appearance of a colored subject differs according to the type of illumination used. The eye may compensate to some extent, color film does not.

Daylight color films are balanced for daylight photography and are rated about 5500 degrees to 5800 degrees Kelvin. Artificial light films are rated 3200 degrees for the Type B films and 3400 degrees for Kodak's Type A emulsion. If the proper film is used with the correct light there will be no problems.

Where the photographer usually goes astray is trying to take indoor pictures with Daylight film or vice versa. This is where filters become necessary.

Taking color pictures, however, should be kept simple since a perfect match of film to light isn't all that difficult.

Let's stick with Daylight films for a moment. The easiest filter to use is the Skylight. It is practically colorless and requires no filter factor. Use it at all times outdoors since it reduces blue, adds slight warmth to the scene and is excellent for open shade. For more control of this blue cast the Tiffen Haze 1 or Haze 2A are ideal for mountain, aerial and marine scenes. They will both add slightly more warmth than the Skylight. Usually these filters will take care of outdoor pictures under the most extreme conditions.

There is an old saw about never shooting color too early in the morning or late in the afternoon. Pictures taken at these times, it is said, could be too warm or cool. Fine, at times an off-color transparency will often give spectacular results. Should there be no desire for brave (?) experimentation then the CC gelatin filters will correct such lighting situations back to normal.

Front lighting is still best for flat subjects, but this type of natural light soon becomes dull and monotonous if used too often. In spite of an emphasis on rules and being precise when exposing color, the best color frequently results when these rules are broken. Shadows are created with side lighting and back lighting will give the highest contrast. If there is water in the pictures, and this is important for boating enthusiasts and fishermen, this type of light provides brilliant highlights and sparkle—and underexposure, by one stop, will often result in a quite dramatic effect.

Some of the best times for taking color pictures are hazy or overcast days and, not infrequently, even when it's raining. Most amateurs will leave their cameras at home unless the sun is shining, not so a professional who realizes the light is at its best at those times. A soft blending of light without shadows, it produces delicate flesh tones and many subjects ranging from still lifes to scenics are enhanced by the beautiful light of an overcast day. Woodlands become fairylands without harsh shadows and the only filter needed is the Skylight.

If this doesn't give sufficient correction, and only experimentation will tell, then the Haze 1 or 2A should be tried.

The best way of becoming skillful with filters is to run a series of tests under controlled conditions. This should be done with both color and black and white and will pay dividends in the future. Load a camera with film, try color first, and take a couple of exposures without any filter outdoors on a clear day. This will tell if the lens is 'warm' or 'cool.' Now shoot a couple of

Sioux from Rosebud Reservation in full regalia. Hasselblad camera, FP 4 film and yellow filter to darken sky. Large reflectors were used to open shadows on face.

frames with the Skylight, a few more with the Haze 1 and 2A. In fact with a 36-exposure roll it might be a good idea to run the test with all available lenses. Shoot these tests preferably with Ektachrome X film and have it processed and returned in one strip. With luck everything may be normal. Quite often a slightly 'warm' lens is preferable and gives more pleasing results.

Before leaving for a holiday it would be nice to know exactly what film, cameras and lenses will do. Very often filtration for color is nothing more than a Skylight filter; it's that simple.

Where color photography becomes more complicated are those times it isn't always possible to match the right film to the correct light. Normally the photographer needn't be concerned with these filters, but should a situation arise when a particular film is loaded and the lights aren't right these few filters may help.

Filter	Film Type	Lighting	Use
80A	Daylight	3200 K	Converts daylight film for use with 3200 K lights
80B	Daylight	3400 K	Converts daylight film for use indoors with this type of light
85	Type A	Daylight	Converts this indoor film to daylight
85B	Type B	Daylight	Converts Type B indoor film to daylight

For those who desire a system of filters that will correct every conceivable color situation DecaMired filters may be the answer. While they may be pretty complicated to understand, their advantage is that they are the only filters that can be used in multiples and will never become outdated regardless of films introduced or changes in light source color temperature.

Quite simply, ordinary light-balancing or conversion filters cannot be used in combination because of their effect on color temperature. On the other hand DecaMired filters affect the same amount of color temperature change at every point in the scale and may be used singly or in combination. There are four filters in each series, Red and Blue, and these eight filters will cover any application of any color film to any light. The theory behind DecaMired filters goes into color temperature (Kelvin), the quotient of Mireds and dividing the color temperature into one million to obtain DecaMired values. For the greatest accuracy a color temperature meter, calibrated in DecaMireds, is highly recommended. While all of this may be too complicated for the sporting photographer, I have been asked about these filters often enough and felt some mention should be made.

Another series of filters used are those to cut down the light when it is too bright, particularly if the camera is loaded with fast color or black and white film, and the lens can't be closed down sufficiently for an exposure. It may also be difficult to calculate a synchro-sunlight exposure with electronic flash and Neutral-Density filters come into play. These are exactly what the name implies, "neutral," and they reduce the light without changing its inherent quality. This is done by the filter slowing down all wave lengths to the same degree and they may be used with all films, both still and movie, to achieve the correct exposure. They are also an aid in diminishing the depth of field when desired. There are ten neutral-density filters available that allow 80% to 10% of the light to pass. As with all filters the factors may be ignored with a metering camera.

FILTERS FOR UNDERWATER PHOTOGRAPHY
It is not our intent to explore all the underwater equipment available nor catalog the wealth

of cameras, lights and scuba gear for the skin diver. Our interest is filters and we will confine ourselves to that area.

The first problem the underwater photographer encounters is the effect of water on simple, ordinary sunlight. Underwater visibility is affected by tides, wind, storms, surface conditions, algae, drifting sediment and, in fact, what body of water is being jumped into. At all times underwater photography is subjected to light conditions from above and the problem of optical properties of the water scattering light in all directions.

The color spectrum of film is also affected by even the purest and clearest water, and will filter such strong colors as red, orange and yellow, allowing only the blues and greens to penetrate. Considering the topside difficulty of taking pictures in rain, fog or mist, diving under the sea will give some appreciation of new problems to be met.

It is true the deeper the dive the more problems faced and staying a comfortable fifteen or twenty feet beneath the surface will solve many filtration problems, but not all. Going deeper will only make the task more difficult and it's unnecessary to attempt great depths since even

Buffalo on the range. Such pictures add to any travel sequence.

many wrecks and reefs are fairly near the surface.

Let us consider what might be the ideal situation for underwater. Some lovely, sloping beach in the Bahamas, Hawaii or the Florida Keys would be ideal. The white sandy bottom would reflect light upward. The surface would be calm and there would be no clouds or overcast. The sun should be striking the surface at about 30 degrees.

Once under the surface it would also be calm with no recent storms casting particles of sand or algae about. Under such ideal conditions all the cameraman would have to do is dive in and begin taking pictures. Think so? Think again. If black and white film is used a medium yellow filter will be required for greater contrast and with color it's necessary to put back the reds that were absorbed by the water.

The two effects that have to do with light and water, and that cause havoc with underwater photography, are the scattering of light and the absorption of light. Scattering is just what the term implies: a redirection of the light and it will have an effect on exposure. The absorption of light is the more troublesome problem. It is caused by algae, heavy salt content of the water, silt and sediment. When the water is cloudy or milky it is useless to attempt filtration and a waste of time trying to take pictures. Lie on the beach and soak up the sun.

With black and white film a medium yellow filter will help overall contrast. While there are some photographers who use red or blue filters, they will not increase contrast, but only darken vast blue areas of the ocean. Under clear conditions a medium or light yellow are the best for contrast control. As with surface conditions the filter must be used correctly. If a metering camera is used, with sufficient controls to change the diaphragm or shutter speed underwater, then it may be used as it would on the surface—with filter placed over the lens and readings taken directly. Should the popular Nikonos II be used, which doesn't have a meter system, then the filter factors will have to be used.

With color film any daylight type may be used underwater, but with color the problem of color loss arises. Water filters out the color of sunlight coming through the surface (water is one big filter) and the deeper the dive the greater the loss of the red end of the color spectrum. At 15 or 20 feet red is hardly visible, yellow is retained until approximately 60 feet, and beyond these depths all that is left are the blues and greens.

Now loss of light through filtering, particularly in an environment where light intensity is already low, may seem a pretty heavy price to pay, but it can be worthwhile near the surface or in bright areas where a slight increase in exposure permits the picture to be taken. For available-light photography, from the surface to around 20 feet, a CC20R, a red series filter, is recommended. It will give reasonably true colors as seen by the eye. Yellow or orange vests and colorful air tanks will reproduce in fairly natural tones. Below this depth, say from 20 to 40 feet the CC30R, a deeper red, is more suitable. These color correction filters will give the transparency more natural hues.

It should be noted, however, there are certain limits to filtration in underwater photography. Too deep a dive and there is simply no red left. The other danger is overfiltration of some simple subject where either excessive or improper filtrations completely spoils the picture by making colors unreal.

As with any filter suggestion these hints can only approximate. There is no way any two people will agree on an ideal situation. And, in fact, color correction frequently means two different things. With color under water we may safely assume, to a few degrees, anyway, the transparency should reproduce with reasonable accuracy what the cameraman has seen. While beautiful photographs have been taken with electronic flash or flash bulbs even these pictures, taken at great depths, still will not be what the diver has seen. Deep blues, greens and blacks abound and while a brilliant flash of light will reveal the true color of coral or tropical fish, it will still look black to the diver once the lighting flash of light is gone.

Any time a camera is taken below the surface of water, be it lake, stream or ocean, filtration is required and is a matter of great experimentation. Experienced underwater photographers have found these suggestions to be practical. In blue-green water the CCR red series, and in yellow-green water the CCM magenta filters.

While it may not be the most scientific solution, just dive under the surface with a small square of white tile. Hold the tile at arms length and one glance will usually tell the color cast

of the water, then filter accordingly.

FILTERS FOR AERIAL PHOTOGRAPHY

Now before this becomes a treatise on underwater photography let's move to the other extreme: the sky above. Taking pictures from aircraft, even large commercial airlines, isn't all that difficult. I've even seen some spectacular results with Instamatic cameras. Of course light planes will offer greater opportunities since they usually fly closer to the ground and, in many instances, are under the control of a pilot who may be willing to tilt and bank the craft for a better view. While professional photo equipment is expensive good aerial views can be taken with most any camera.

Haze, which is always present to some degree in the atmosphere, is the greatest hazard to successful aerial pictures. It tends to increase with distance and creates pictures of low contrast with black and white films, but it is reasonably simple to solve. Medium or deep yellow filters are the answer and greater contrast and haze penetration will result if a deep red is used. As with pictures taken on the ground the amount of haze penetration, and dramatic effect, will depend upon the deepness of the filter used.

For color photography Type A Kodachrome with a salmon-colored conversion filter often gives the best results. This combination absorbs much of the blue and ultraviolet scattered by haze. Should any of the daylight emulsions be loaded in the camera a Skylight filter may be used. While the Polaroid filter is excellent with either emulsion, color or black and white, it should be used only when flying in light aircraft where the door or window can be removed. Due to the effect of stress and strain on regular aircraft windows the Polaroid will pick these colors up and cause a rather unusual effect in the transparency.

FLUORESCENT LIGHTS

One area of filtration we hesitated to mention is photography under fluorescent light conditions. It varies so greatly, some locales even mix lights, that it becomes a problem of great technical expertise. Anyone discussing photography under fluorescent lighting (including this writer) should be listened to with a jaundiced ear, but listened to nonetheless, since successful pictures under these conditions can be a guessing game at best.

Every manufacturer of this devilish light source has a wide range of lights running from cool white through daylight. Each tube is slightly different even from the same company. For example, General Electric gives a series of filter recommendations to be used with their tubes. Another manufacturer will agree up to a certain point and then their advice suddenly swings away. What this means is that both are right and then the variables of color emulsion, voltage and age of the tube take over and give different results. There are a couple of fairly simple solutions, but don't attempt color pictures under fluorescent lights without filters since the transparencies will have a deep, green cast.

Tiffen makes two special filters for this type of lighting, an FL-D for daylight films and the FL-B for tungsten films. There are a couple of other ways of also solving this. Ektachrome X may be used with a CC20M filter. Rerate the film from ASA64 to ASA 100 and have it pushed one stop in processing. The results may be slightly more satisfactory than the high speed film since the grain will be less.

SPECIAL EFFECT FILTERS

Now we can leave the serious side of filters for a while and concentrate on what could be called fun filters. These are used for special effects and slight variables in exposure may be accepted because it sometimes helps the picture enormously.

The first is the Star filter offered by a number of manufacturers. This is the filter that puts a starlike burst of light around every highlight and will add a spectacular appearance to the picture, especially night shots. Incidentally, the Star filter, as well as other special effect filters may be used with both color and black and white. Another interesting and useful filter is the Rainbow introduced a few years ago. It sends a shaft of rainbow-colored light across the picture and is particularly effective with color. While not quite as striking in black and white it will still give a strong amount of cross light. It blossoms in color, however, and offers a particu-

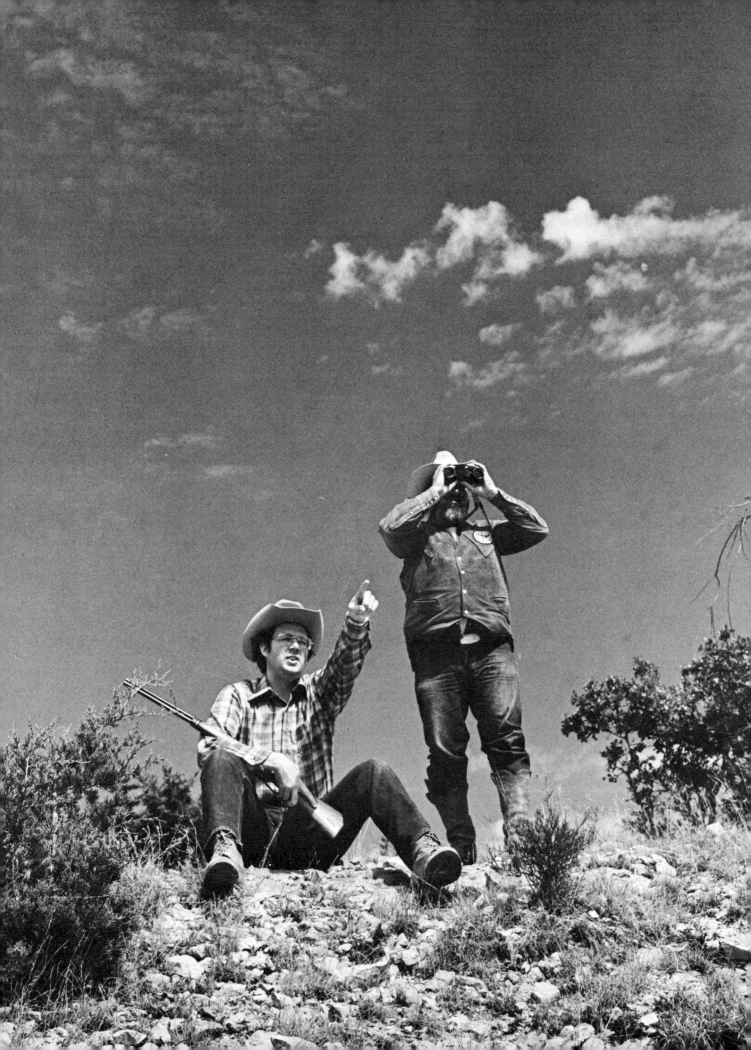

larly effective method of introducing color into a side or backlit subject. Try using the Rainbow filter shooting into the sun for really spectacular results.

Fog filters may also be listed in the category of special effect filters. Made by a number of outfits they come in various degrees of fog. Used at the right time of day, and under proper lighting conditions, they will turn any picture into a real London pea-souper. Fog filters range from a No. 1, which gives a slight amount of fog, to a deep No. 10 that makes any scene look like a refugee from an old Fu Manchu movie. It might be asked what use this filter could be to the outdoor photographer. Ever been on a lake or trout stream or even in the high mountains at dawn with fog or mist rising? Under these conditions a fog filter will add mystery; it will also diffuse and give a soft quality that is often desirable.

A fairly recent innovation is the introduction by Bierman & Weber, a West German company, of pop-art filters in glass. These are very special indeed and give a rose, purple and aqua tone to the transparency. The main difficulty with these filters is one of exposure. Be warned that CdS, and other cells, used in metering cameras don't have the same color sensitivity as color films. Certain cells may "read" colors more or less intense than the eye or film may perceive. The best control is to shoot a series of tests and begin to think in terms of what the picture might be, rather than what it is. It will contribute to creative freedom when using filters.

Should there be concern we're going too far afield for the requirements of the outdoorsman let's consider for a moment. Anyone who travels in the outdoors with any frequency has encountered spectacular sunrises or sunsets. And, quite often, those that are less exciting. How interesting it might be to pep up some of nature's duds, add to nature and dress up the effect. These pop-art filters will do just that, but they must be used with care since the results may be too extreme for every subject.

For the technically minded who want to delve into color and filters there are meters available that will give direct readings in Kelvin temperature and advise what filters to use. Bear in mind, however, this type of meter has nothing to do with exposure; it will only indicate the proper Kelvin rating of the light source and a regular meter, or the camera's meter, must still be used for the correct exposure. But for the exacting color photographer, amateur and professional, a Kelvin reading meter can be an invaluable aid.

What do these meters cost? Gossen makes a fairly simple one for about $100. Spectra offers one that will read all the color spectrum (including fluorescent), in the neighborhood of $600. Granted there are not many who will want to lay out that kind of money, but it's nice to know such aids to photography are available if needed.

As a quick reference, without the aid of a Kelvin meter, here are some average Kelvin temperatures found indoors. Variations of voltage, age of the lamps being used and occasional voltage drops may shift these levels.

Room lights in homes	2800
Photoflood lamps	3200
Photoflood lamps	3400
Warm white fluorescent	3500
Cool white fluorescent	4500
Daylight fluorescent	6500

Basic outdoor Kelvin temperatures:

Early or late afternoon	5800
Bright daylight	6000
Overcast daylight	6800

Minor variations in Kelvin degrees will usually make no difference in the rendering of color, but jumps of 100 or 200 degrees will certainly distort color as it appears to the eye and the transparency. Obviously, taking exacting color pictures isn't quite as simple as the film manufacturers would lead one to believe. While there are no easy roads to color control, a few inexpensive filters will help improve pictures to an extraordinary degree. The Skylight for color and yellow and red for black and white will give startling results and the addition of a Polaroid should be all the filters a beginning photographer requires.

Sportsman at the YO Ranch near San Antonio, Texas. Medium red filter and 24mm lens. Ilford FP 4 film.

THE CARE OF FILTERS

Although we've mentioned that filters are not expensive these pieces of optical glass are precision units and should be handled with care. Never get fingerprints on the surface and don't dump them in a camera case unless they are in protective cases.

Gelatin filters are particularly susceptible to any surface marks and should be handled with extreme care. Those gelatin filters that are mounted between optical glass may be treated as regular glass filters and cleaned with lens tissue and a few drops of lens cleaner. The pure gelatin are fragile and should be handled between sheets of tissue. The only way to clean them is with a good soft camel's hair brush. The surface must never be touched under any circumstances. A word of caution, never use eyeglass cleaning tissues or pads on any filter or lens. Most are silicone treated and will not only be harmful, but may cause minor abrasive marks on the glass or coating.

Filters should be stored in their individual cases when not in use, and never placed in sunlight or kept in warm areas. Heat will affect the color quality and cause changes in the dyes. With proper care and handling glass filters will have a long life. Filters showing abrasions, scratches or discoloration should be discarded at once. To continue to use them would only affect the quality of the picture. Even top-quality filters are not so expensive replacement will harm any photo budget.

In tropical areas it might be helpful to carry a small container of silica gel with filters. It will absorb moisture and give added protection not only to filters but lenses as well.

One of photography's great dilemmas is stuck screw-in filters or adapter rings. Trying to get them apart is worse than a Chinese puzzle. Fingers slip on the rims and no amount of huffing and puffing will get the darn things apart. Now a pair of plastic wrenches will work on 48-58mm thread sizes. It is one of those simple yet effective little devices that make one wonder why they weren't invented long ago. Known as the Kalt Lens Accessory Wrench Set it may be ordered from Kalt Corp., Box 511, Santa Monica, Calif. 90406. Enclose $1.95 and perhaps another 50¢ for postage. These wrenches are made of plastic and won't add too much weight to any kit. The first time a filter becomes stuck on the lens or the *&@+?/# rings won't come apart this little device will be regarded as the greatest boon to photography since the invention of the camera.

There are times when substitute filters may even be used. We've all left camp with filters in the duffle bag and it isn't always convenient to retrace our steps. Sunglasses (non-prescription) can be placed in front of the lens and work very well. Even Polaroid sunglasses will work. Just turn them slightly until the desired effect appears.

Filters, although they can even be a bloody nuisance to a professional, must be used if the amateur wants the best possible image on the film. No matter how organized the photographer may be he will eventually run into a situation where the wrong film is in the camera and it becomes necessary to compensate for the subject. If there is concern with the quality of color that's when having filters available and knowing how to use them is important.

Unless a photographer is willing to make occasional tests, and learn what filters do, he will continue to take the same dull unexciting pictures turned out by thousands of other amateurs.

Palm fronds frame a beach scene at Cat Cay in the Bahamas. Nikon with Ilford FP 4 and 24mm wide angle lens. Yellow filter to darken sky.

CHAPTER 5

A Few Hazards of Travel

With sportsmen going afield in all seasons and all types of weather some consideration must be given the safest and best method of carrying and protecting expensive photo equipment. Wind, rain, dust and snow are only a few of the hazards encountered. Bouncing jeeps and jouncing aircraft play havoc with delicate cameras and if care isn't taken the photographer can arrive at journey's end sans workable cameras.

A definite hazard for the peripatetic photographer is x-ray inspection at airports. In spite of judiciously placed signs that proclaim, "No Harm Will Come To Inspected Film," it is best to view the whole affair with a gimlet eye. In fact some recent signs now indicate film may even take ten inspections without harm. I don't question the necessity of these examinations since they have protected the traveling public from a world of crackpots, but stating that any x-ray inspection is safe is ridiculous. Granted one checkpoint may not harm film, but what is generally not known, at least outside the medical profession, is that any exposure to x-ray or fluoroscope is cumulative. What this means is a couple of stops en route, with a subsequent inspection at each reboarding, plus the return trip may add up to more than film can take.

When x-ray inspection came into being a few years ago much of the equipment could be categorized as old-fashioned and had to zap out a pretty high dose to make them effective. Recently a number of manufacturers have introduced quite sophisticated equipment employing electronic amplification of the image or highly effective scanning systems. The traveler should be warned, however, not all x-ray equipment in use is of the 'safe' variety. In fact Eastman Kodak recently ran some tests using a 64 ASA speed film with the safest x-ray equipment available (used at less than 15% of domestic airports) and reported that, "five exposures under ideal conditions produced a faint image." Obviously this is sufficient to damage any roll of film. In fact many of these so-called 'safe' machines offer the inexperienced operator higher level manual and repeat switch positions. None good for the traveling cameraman.

Overseas airline travel can also be hazardous since all international airlines must comply with local regulation. This can mean old-fashioned equipment may be used and 100 or more milliroentgens can be disastrous to film. All security officers will assure the traveler their equipment is safe, but very few will be able to specify if it is medium or low-level in dosage.

But what is the effect of x-ray on film? It adds unwanted density and on reversal film it takes away density. With color film it can easily affect each of the three color layers and cause color shift. What of checking film through as baggage? That's a greater danger than playing Russian Roulette with all chambers loaded. Some airlines x-ray all baggage, others don't and some won't talk. With all this expensive equipment installed to speed travelers on their way requests for hand inspection won't be popular, but regardless of assurances ask that the small packet of film be checked by hand. A new C.A.B. rule states that passengers may request visual inspection if necessary.

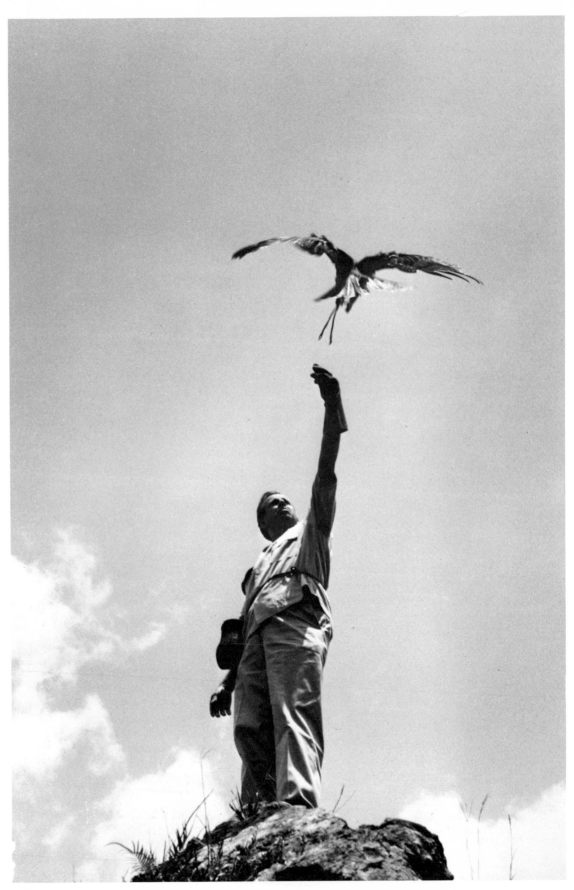

Falconer John Hamlet with a hunting falcon, near Ocala, Florida.

Fortunately for the inventive genius of man someone always comes forward to solve, or in this case thwart, certain obstacles. Something as simple as a bag has recently been introduced that will safely protect film and allow it to go through hundreds of x-ray checkpoints without damage to the contents. Stocked by most camera shops it is a large bag of tough polyester with lead foil, impregnated with barium, sandwiched between the puncture-resistant and moisture-proof plastic. Known as the FilmShield it will hold up to 22 rolls of 35mm film and provides a thermal barrier to protect film against extremes of heat as well. I have used these since they were introduced and haven't had a roll of film spoiled by x-rays. A word of caution: they should only be used for carry-on baggage and never in checked luggage. The contents of these bags show up as black on the monitor screen and cannot be identified.

If travel to a foreign land (and this includes our neighbors to the north and south) is contemplated, now is a good time to ask if cameras, binoculars, guns, tape recorders and all those other toys crafted overseas were registered with United States Customs? In spite of the sophistication of many travelers, few realize a Certificate of Registration is required for foreign-made valuables to simplify their return. Before leaving the country it's best to tote all those cameras and lenses to the nearest Customs office and ask for form 4455. In fact life will be easier if a duplicate list with serial numbers is brought along. On the return journey just hand it to a Customs Inspector and it will insure easy passage of those foreign items. The form used to have a short life, around five years as I recall, but now there is no limitation. There are still those hardy souls who believe in the sanctity of a sales slip or an insurance policy. Well, it can work sometimes, but an inspector can also present some formidable arguments against it and may even hold the equipment until it's proven they were originally purchased or taken from the country. I've lost count of the times I've cleared customs and I've always had this certificate with me. It's made the customs people happy, eased my equipment past their stern eyes and gotten me home that much faster.

While we're on the subject of air travel there is one other area that can bring surprises to the innocent. Short journeys don't usually affect cameras, but long hours in the air to, say, the Middle East, some far South Pacific island or Australia can loosen tiny screws of cameras and lens mounts. We've all seen pictures of a half-dollar balanced on the dinner tray. While this may be great for advertising it doesn't take into account the high-frequency vibrations of jet aircraft. These are the same vibrations that make a person groggy after ten minutes in the air and they also have a tendency to unseat screws. That's one of the reasons I always carry a set of tiny jewelers' screwdrivers and, after arrival, spend a few moments checking every screw in sight. I don't mean to imply I take a camera apart. That's beyond my comprehension and I leave such acts of daring to Marty Forscher and his skilled technicians. But tightening screws, checking connections and inspecting lenses thoroughly is one way of keeping equipment in working order. For example, a small dab of colorless nail polish on the threads will keep screws in place and a bulb blower for dust, a camel's hair brush, lens cleaner and tissue will keep lenses and filters clean. On long trips into rough country such a kit may often mean the difference between pictures and no shots at all.

Wilderness hunting conditions found in Alaska, British Columbia or our western states can be hazardous to the sportsman and his camera equipment. Admittedly not every hunt is done in blizzards or zero temperatures, but the thermometer can fall fast and high winds add to the dangerous chill factor. Frostbite can sneak up when the hunter doesn't even feel cold. Before such conditions strike is the time to consider what action to take.

As with humans many factors work on a camera under very cold conditions. Strong winds, sleet and snow added to subfreezing temperatures cause camera mechanisms to become tighter. Batteries lose their effective capacity and the viscosity of many lubricants decrease. The first hint of trouble may be a sluggish shutter or difficulty in winding. Some cameras are more susceptible to cold than others. The titanium shutter of the latest Nikon may, for example, keep working to well below zero while cloth focal plane shutters of other cameras will become stiff and slow the whole works considerably under lesser conditions. Cold weather also affects film and it may become brittle or break. Fast winding, or a motorized camera, can cause electrostatic discharges producing fancy little light streaks on the emulsion and it's a

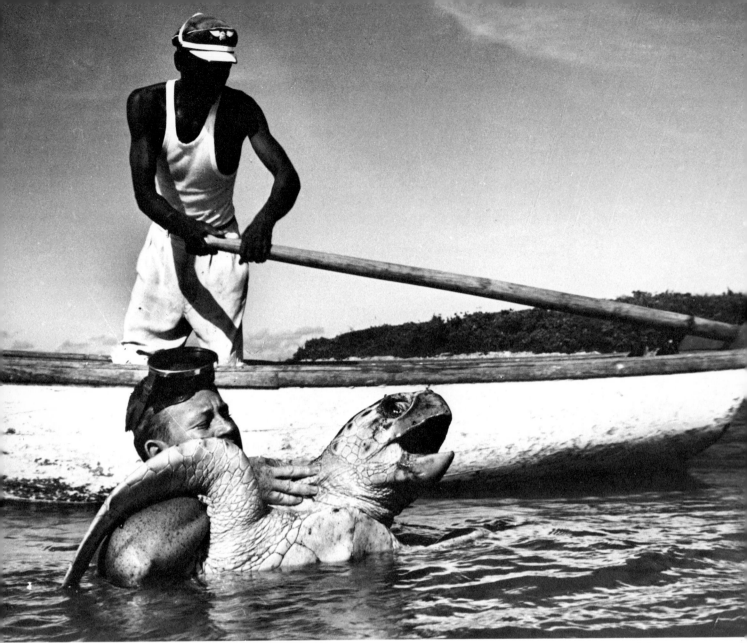

The capture of a giant sea turtle near Nassau in the Bahamas. Nikonos camera and Tri-X film. Fast film was used since underwater pictures were taken on the same roll.

hard lesson to learn after struggling through a picture session deep in the snowy wilderness.

Even on a clear bright day cameras should be protected, particularly when passing under a snow-laden evergreen. Ever touch a limb and have a cascade of snow dumped on your head? Don't try it, especially with cameras slung over a shoulder. I did up in Maine, and learned the hard way. And don't ever try to blow snow off the camera's optics. Breath contains moisture and coats the lens like a piece of crinkled cellophane. Again the soft, camel's hair brush should be used. Another professional stunt is to carry a stiff typewriter brush for getting snow out of the camera's crevices. Obviously, it should never be used on the lens.

And don't try to grasp the metal camera in sub-zero weather! I tried that once in Canada and left a choice piece of finger tip adhered to the base plate. When going into the cold for winter photography tape the metal parts of the camera with Gaffer or adhesive tape. It can be pulled off when the summer comes. Being prepared is a good policy. Batteries can be another source of problems. While many metering cameras use batteries, and it's a good idea to carry a couple of extra on any cold expedition, a selenium-cell light meter might be a wise investment. This type of meter doesn't use batteries and is added insurance in obtaining those tricky winter exposures. With all this don't assume film will react normally. Cold affects chemicals and may cause film to react slower. It makes sense, yep, again, to bracket exposures, especially with color film which is sensitive to extremes of cold and heat.

A hefty parka that will accept a camera in the pocket or between inner layers will help. Just yank it out prior to snapping pictures. Cameras may be taken from room temperature directly into freezing conditions for short periods of time. They should not, however, be taken into a snow storm. Snow and ice hitting a warm camera will melt and moisture collect *inside* the camera. As the camera temperature swiftly drops it could cause a freeze-up of the entire mechanism. If possible it is best to avoid exposure of the camera to such conditions for long periods of time.

For those going to Arctic-like climes for extended visits the best solution is to winterize cameras and lenses. Marty Forscher of Professional Camera Repair in New York is one outfit that has the capabilities for preparing cameras for cold weather service. The camera is cleaned and all factory lubricants throughout camera and lens are replaced with aviation lubes. Such modifications don't come cheap, around $60 per camera and $25-30 a lens with equal cost for dewinterizing. Such extreme measures aren't required for the occasional weekender, but anyone heading north of the continental 48, who expects to do sustained work below 20 degrees, might well consider winterizing as insurance.

The hot tropics don't present the problems of the Arctic, but there are precautions that should be taken to prevent damage to photo gear in hot, humid parts of the world. Fungus, dampness and humidity are the greatest dangers of the true tropics. I don't mean the semi-tropics of Florida or Hawaii, but rain forests and deep jungle, where the sun seldom penetrates. Such terrain as Southeast Asia or the great jungles of South America are famed for their camera-wrecking capabilities and precautions must be taken to keep equipment working. The first is keep the camera dry. Silica gel is the greatest aid and a camera wrapped in heavy plastic plus the dessicant in a small container will do fine. This goes for film as well. A step beyond is to pack everything in a box of rice. Rice is cool, often cold to the touch, and through its use a friend kept an old Leica going through two years of the South Pacific campaign during W.W. II.

Cracker tins are ideal for storage of equipment and sealed with heavy tape will keep out moisture. If there is difficulty with modern packaging purchase condiments in a jungle town where most items still come in tins. There is nothing wrong with plastic boxes either and it isn't a waste of space since they make excellent protective covering for packing fragile items for long journeys.

Deserts and beaches, even the most innocent California or Florida beaches, are insidious with the hazard of sand entering every camera opening. Make no mistake, even one grain of sand can put a camera out of action or scratch film if it goes into the wrong place. Cameras must be protected on the beach and they usually need no more than be kept in a zippered bag. Of course they should be set in the shade of an umbrella or beach chair. The real deserts can be rough. One time, working with the Desert Patrol in Jordan, we ran into a sand storm that drove sand like stinging sleet. Camels are desert-wise beasts and hunkered down with their rumps facing the force of the gale. The only thing to do is get down on the lee side of the animal, pull on sand goggles and wrap a kaffiyeh across your face. We rode out the storm in that manner; it lasted less than an hour, and when it was over we struggled up through layers of sand. The fine powdery talc clogged nostrils, coated grease-covered lips and dusted the camera cases. Although the leather cases, with zippered closures, were still securely fastened, a coating of fine sand had entered. Fortunately the ubiquitous plastic bags covering cameras and lenses had protected the contents. I doubt if every traveler is going to encounter such problems yet sportsmen who may find themselves in parts of the Egyptian desert on gazelle hunts, Somalia, the Northern Frontier District of Kenya or the Sahara could well encounter a big sand blow in the desert.

Much of East Africa resembles parts of our own Southwest, New Mexico and Arizona, and while altitudes can be high and clear the greatest hazard is dust. If cameras are kept in good aluminum cases, with rubberized lips that seal off the elements, valuable equipment won't be harmed. Foam lining will also aid in eliminating vibrations from bouncing vehicles and are an excellent method of transporting equipment over great distances.

While we've discussed the problems of dirt and dust let's consider the hazards of water. Taking pictures from boats requires more common sense than anything else. Even when the sur-

face appears calm there is danger lurking. Cameras should never be set where they might fall overboard. I've seen a couple of cameras take the deep six (not mine, fortunately) and some silly stunt, attempted by an inexperienced amateur, trying a wide-angle view while hanging over the water is a great crowd pleaser.

While the surface may be calm ground swells can build with great subtlety and cameras can go sliding unnoticed across smooth hatches and either take a swim or bounce hard on the deck. Neither action is conducive to the well-being of a precise piece of equipment. The same hazards are encountered with the swift passage of another boat that sets the craft rolling and pitching.

Sailboats should be boarded with respect by the aspiring cameraman. If it happens to be race day the deck can be as busy as Chicago's O'Hare airport at high noon. Even cruising the Out Islands of the Bahamas on a seemingly calm day can be tricky. While the boat may be cutting the water with ease continual tacking, with booms swinging and craft heeling, makes cameras candidates for damage. The safest place for a camera on a boat, at least when it isn't being used, is a shady spot below deck in a foam-lined case. It will be protected against sun, heat and falls.

One important precaution with a camera on or near salt water is a filter to protect the lens. A fine mist of salt spray can coat a piece of glass like grease and lens tissue should be used to wipe the filter clean. Otherwise there will be a great collection of diffused holiday pictures.

Fresh water can present as many problems as any other kind of wet stuff and equipment should be protected when it isn't being used. Canoes can be tricky stuff and I recall one trip with a friend on Saranac Lake in the Adirondacks when we were gliding along at dusk, one gunwale suddenly shipped water and under we slid. In fairness to us both I should mention we're experienced canoeists and over the years had put a lot of water behind us, but there is always a first time.

In small boats the best protection is an aluminum case that is completely waterproof. The case can be kept under the feet and a camera taken out quickly and put back just as fast when the picture is taken. I don't like the thought of a good camera hanging around my neck in any small craft. For that type of travel I much prefer the Nikonos II.

Lengthy pack trips by horseback won't present too many dangers and usually the biggest problem is how to pack cameras for safe travel. Experienced wranglers can fasten a case with a diamond hitch and it will ride securely. The problem is, however, that once cameras and lenses are well packed it might be difficult or impossible to remove what's needed without a long halt for unpacking. Since long rides are generally slow moving, without the wild gallops of Western films, it's usually fairly safe to carry a camera on the person.

There is little danger of falling off a horse, unless the rider is a complete oaf and in that event he shouldn't be riding.

One of the neatest methods of securing a camera is the use of the Kuban Hitch. A back strap affair holds the camera tightly against the chest and prevents bounce or wobble while riding. The camera may be lifted to eye level for use when required. Another handy stunt is to wrap camera bodies and a couple of lenses in foam rubber and carry them in a saddlebag. Most modern bags are sufficiently large and will take fairly bulky loads. Even a few rolls of spare film can be dropped in the odd corner. I went this route on a trip last summer in Colorado's Rockies and it worked out fine.

The dangers of automobiles are perhaps the greatest because that is the way most camera toters travel. Don't, repeat don't, ever keep a camera in the glove compartment or trunk. The excessive heat, concentrated in small areas, can spoil film and may even damage lenses. Again, the safest place, is a foam-lined case either set on the floor or on a seat, fastened with a seat belt to prevent banging during sudden stops. An air-conditioned car is all to the good.

Taking pictures outdoors in inclement weather a poncho or large slicker will give protection. Ducking under low-hanging pine boughs will keep rain off cameras for a few moments and, don't laugh, I know a number of photographers who use a small collapsible umbrella and it works admirably. The best umbrellas are white Mylar on one side and aluminized Mylar on the interior. In this way both protection and reflection can be carried. Another trick is to stuff the camera inside a clear plastic bag. With the mouth of the bag fastened around the lens

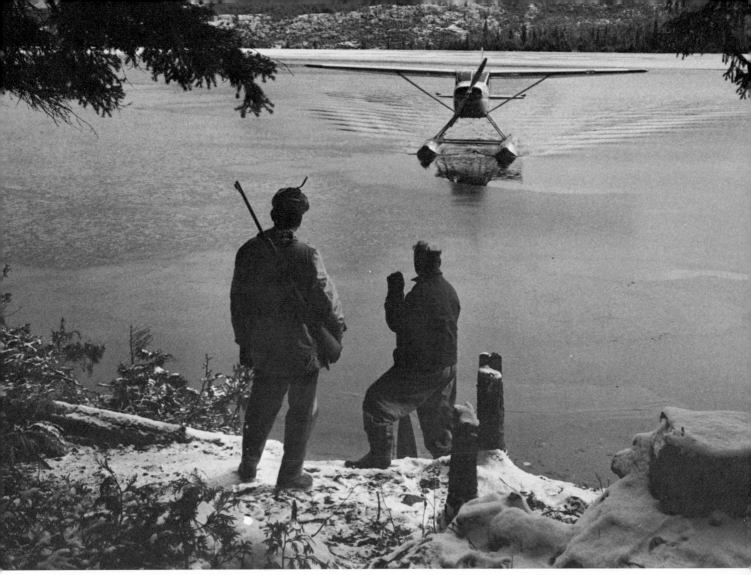

Jim Rikhoff, noted big game hunter, and Indian guide Elzer Wission wait for a plane to take them into wilderness country on a moose hunt near White River, Ontario, Canada.

shade with a large rubber band (and a filter to protect the lens) the cameraman can see and move all the controls and even take pictures in a monsoon.

In spite of my continual emphasis on a good aluminum or fibre case to protect equipment while traveling, these are not the most convenient cases for working in the field. They are ideal for carrying aboard aircraft, and a small one the size of a brief case can be easily stowed beneath the seat and are ideal for moving from point A to point B. But once in the field a small canvas bag to carry equipment is a help. One of the best, and I've carried one for years, is Abercrombie & Fitch's English trout bag. It has a couple of large pockets on the side, a removable rubberized liner and a wide web belt for carrying. At the present writing it sells for around $44 and is the best investment the outdoor photographer could have. It will comfortably carry a couple of camera bodies, three or four lenses depending on the size and a goodly supply of film.

Often when taking pictures outdoors it isn't possible to find a dry spot to set equipment on the ground. Having worked in Florida's Everglades and a few other dank and damp locales, I have some small experience in wet areas. Whenever it became necessary to lay the case on the ground I did just that. Sure the outer canvas became damp, and often wet through, but the rubber liner protected the contents and the bag performed yeoman service.

Good common sense is still the prime requisite for the care and protection of cameras. It's amazing how careless some photographers become and little wonder that cameras are stepped on when laid on the ground, kicked about or fall when hung from a dead limb. Photo equipment can take hard knocks and a professional may run as much film through his cameras in a day as does an amateur in a year. A couple of cameras hanging on neck straps

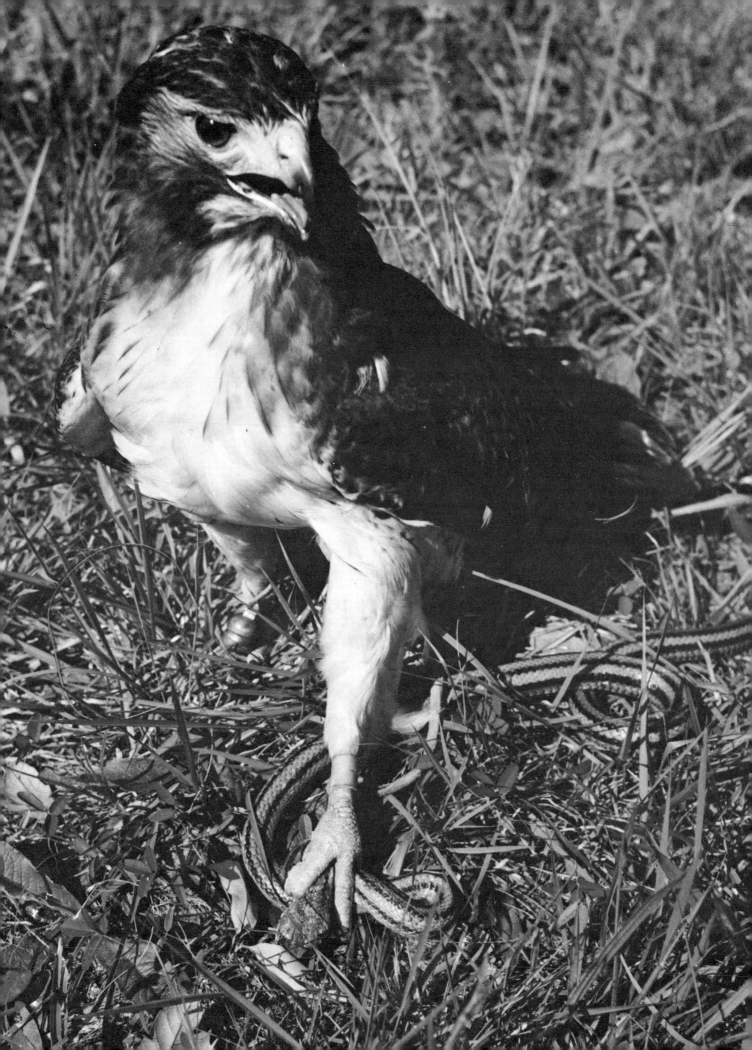

will jangle and bounce and give each other some pretty smart cracks, but good cameras are sturdy and will take much of this in stride. This does not mean that deliberate abuse is the order of the day. In spite of their ability to absorb considerable punishment cameras should be regarded as precise and sophisticated pieces of equipment. The modern camera contains hundreds of tiny screws, nuts and bolts. CdS cells for the light meter, miniature transistors that calculate exposure and tolerances that would frequently make a scientist weep. The one important thing to remember for the well-being of a camera is never force anything. If the camera doesn't wind or the shutter won't trip then first read the instructional manual, take it to a repair shop pronto, or reach into the case for another body. Cameras are intricate mechanisms and should be treated with a modicum of respect.

Aside from the safety of a camera in the field care must also be exercised when traveling to protect valuable equipment from temptation.

In thirty years of bouncing about the globe I've stayed in a wide variety of establishments ranging from some pretty deluxe jobs in Switzerland to a couple of flea-infested ratholes in North Africa and I must confess I've rarely had anything of value taken. However, I don't believe in tossing cameras around the hotel room either. I carry all my equipment in cases that resemble brief cases and they don't shout photographer at airports or in hotel lobbies. I usually try to leave the equipment I don't need in a case and place it atop the highest closet shelf. Some photographers chain their extra locked cases to a pipe or radiator, but I doubt if any of this will stop a determined pro. Best of all is not to advertise the fact that a goodly supply of cameras are living in the same room.

A fairly safe stunt is to place a "don't disturb" sign on the door when going out for a few hours. Occasionally the bed may not be made or towels won't be changed, but the tranquility is worth it.

The same order of prudence applies when wandering around the streets of a strange city. My equipment is placed in an airline bag. Everyone carries them and it doesn't stand out like a sore thumb. When taking pictures in tourist areas don't set camera cases on the ground unless a foot is hooked through the strap.

Granted all this may seem like an inconvenience, perhaps, but frequent and careful attention to equipment under extreme conditions will keep it safe and working for many years. It will help the photographer attain pictures even when nature is at its worst and the light-fingered are on the prowl.

Hunting falcon aggressively holds his catch. Rolleiflex and Tri-X film.

CHAPTER 6

The Sporting Eye

Many fine game pictures or scenics admired by amateur photographers are often taken by professionals with unlimited expense accounts and highly sophisticated equipment. This should not deter the enthusiastic camera fan because with a modest amount of skill, a lot of patience that really doesn't cost anything and a fair supply of film many of the same type of pictures may be attempted.

There is a fair sequence of order that will help and first of these is obtaining the correct exposure. Unless the cameraman is using an automatic-exposure camera (and even then) the meter, whether it be built-in or handheld, must be understood. No light meter will tell the user what combination of lens opening and shutter speed *must* be used; it will only advise what *may* be used. Confusing? Not really, since the photographer must decide what lens diaphragm (small or large opening) is desired to control depth and what shutter speed must be used to stop action or, conversely, give motion.

Example. On a magazine assignment covering the sports car races in the Bahamas, I was standing on a corner of the track with a couple of other photographers. The cars came zapping past burning rubber and turning into blurs of color as they took the turn. During a quiet moment one photographer turned and asked what shutter speed I was using. When I replied, "From 1 second to 1/15th," he looked at me in amazement. This was my choice since I wanted to give a feeling of movement to the pictures and everyone using a camera has to make the same choice. A meter will give a wide range of proper shutter speeds and lens openings, all of which will give a correct exposure, but what combination to choose for what effect must be left with the photographer.

Look at it this way. A shot of a running deer will require a faster shutter speed (to stop the action) with a resultant wider opening of the lens to allow more light for a proper exposure. However, there may be some who prefer to have a slight blur in the deer (to impart movement) and a slower shutter speed may be used. On the other hand game at a water hole, for example, may be more placid and, for depth, the lens could be closed down a bit and a slower shutter speed used for better exposure in dim light. Only experience can tell what shutter speeds should be used, but a general rule should be objects moving across the film plane will require higher speeds while those moving at an angle, to or from the camera, require less and those moving dead on to or from the camera even less. The lens opening, in combination with shutter speeds, give the correct exposure, but the photographer must decide what is best for the subject.

In high country or the shore, where the light is exceptionally bright, the lens may be closed down more with a correspondingly higher shutter speed. Of course this is also dependent upon the speed of the film being used. Don't forget: to obtain proper results the meter must be set to the proper film speed (ASA rating) and that setting used for the entire roll of film in the camera.

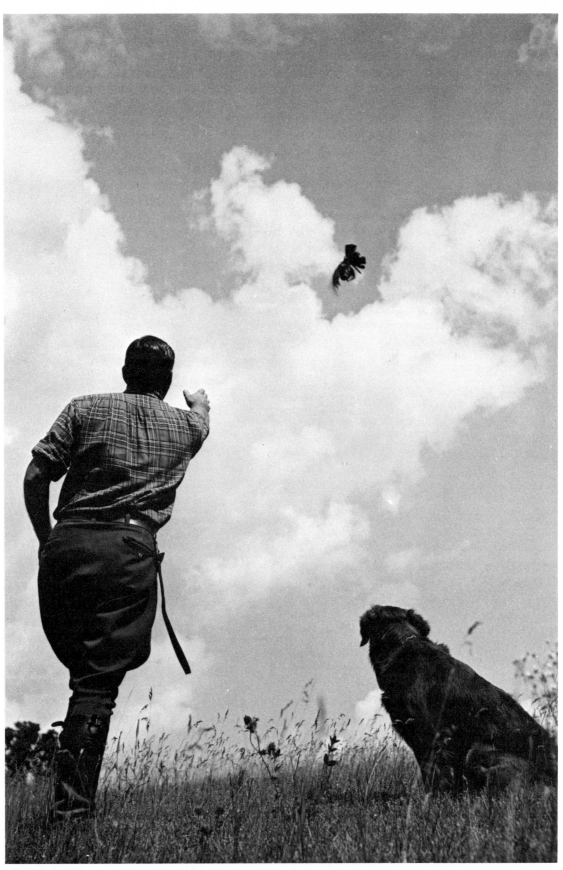

Orin Benson of Eagle, Wisconsin training a champion retriever Royal Peter Golden Boy. Low angle gives interest and drama to the picture.

There are some other basics and let's run through them as a reminder of the important factors in photography. Holding the camera steady will preclude blur or movement (unless it is deliberate) and will result in sharper pictures. Don't be careless with higher shutter speeds either since a jerky movement when squeezing the shutter can result in unsharp pictures. Sharp focus is a must although one can be less than exacting with the wide-angle lenses; they do have a tremendous depth of field. I remember Slim Aarons, one of our finest photographers, commenting on his first 35mm lens. "It's sharp from here to here," said he, pointing with a grand gesture from the end of his nose to infinity. But even a wide-angle should be treated with respect.

These are the most obvious concerns: correct exposure, steady camera and exact focus will help obtain better pictures right at the start. What to take, or when to snap the shutter, is better left to the individual peering through the camera.

The camera viewfinder is indeed a wonderful instrument and through-the-lens viewing (with SLR cameras) has helped many aspiring cameramen improve composition to a remarkable degree. The subject matter viewed, however, is often less exciting to others than the photographer who took the picture. Yet this is as it should be, since the subject of interest is so personal only the photographer can decide what he likes, wants to photograph and look at in the future. As pictures continue to be taken composition will slowly improve, horizons will be straight, distractions will be eliminated and pictures will slowly become more interesting.

Of course if there is a dramatic movement, a brown bear jumping out of the bushes, the decision to shoot or run is best decided by the fellow with the camera. Seriously, however, when confronted by any sudden action, shoot and then take a meter reading and try to compose for a second shot if there is time.

There are a couple of professional tricks that will help any cameraman in the outdoors. These were brought to mind in a recent conversation with two excellent photographers. Both Art Kennedy and Bob Olendorff are with the Bureau of Land Management in Anchorage, Alaska. Art was a former Navy photographer and is now Chief of the Public Affairs Office. He is a pilot, flies his own plane and takes excellent aerial pictures. Olendorff is head of the photo section and a fine photographer. We were having coffee in Kennedy's office and discussing photography as is the wont of photographers when they get together.

Both men work in the field much of the time and always have a camera set and ready. Art said, "When I'm flyiing I take a meter reading when I reach altitude, set the lens at infinity and keep the camera on my lap. That way I'm always ready for a picture and don't have to bother with shutter speeds or taking a new meter reading. Just point the camera and shoot." It makes sense since so many pictures are missed by bumbling and fumbling, by the time everything is in order the picture is gone. Olendorff concurs, "I've taken some of my best pictures just by having the correct meter reading and general focus set beforehand. On a trip up North last spring we cleared a rise and the river below us was literally filled with bear on a salmon-catching spree. They were so occupied they weren't aware of our presence. To play safe, however, I grabbed some shots and then settled down to take some serious pictures. But the first pictures were just as good as the rest. But if we had scared them the grab shots would be the only ones available."

Being ready to take advantage of situations is one way any photographer can get better pictures. Having the camera preset is important. If light conditions prevail for a reasonable amount of time take a reading and set the lens and shutter speeds for average pictures. By this I mean a lens closed down to at least f/8 with a shutter speed of 1/250th for color. With black and white film, say Ilford FP-4, f/11 at 1/250th will be close and keep the shutter wound. These are not hard and fast rules for exposure, but only suggestions for average situations.

Spectacular landscapes or scenics are always a problem with any photographer. Too frequently rugged snow-capped mountains become small rises in the transparency and blue skies give way to swirling, gray overcast by the time the photographer is ready to shoot. Longer lenses will help any scenic and the telephotos, that are so useful for picturing game, give more detail since they bring distant features closer to the photographer. These longer lenses are a tremendous help in photographing mountains and with bad weather faster lenses will enable the photographer to make an exposure under grim conditions.

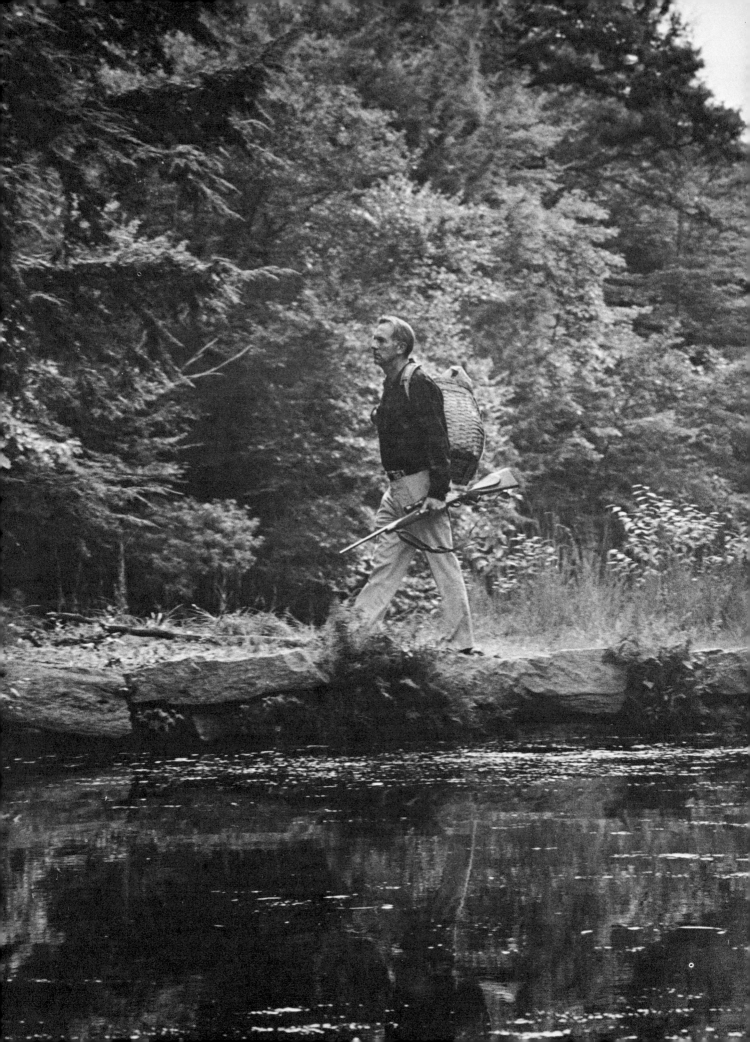

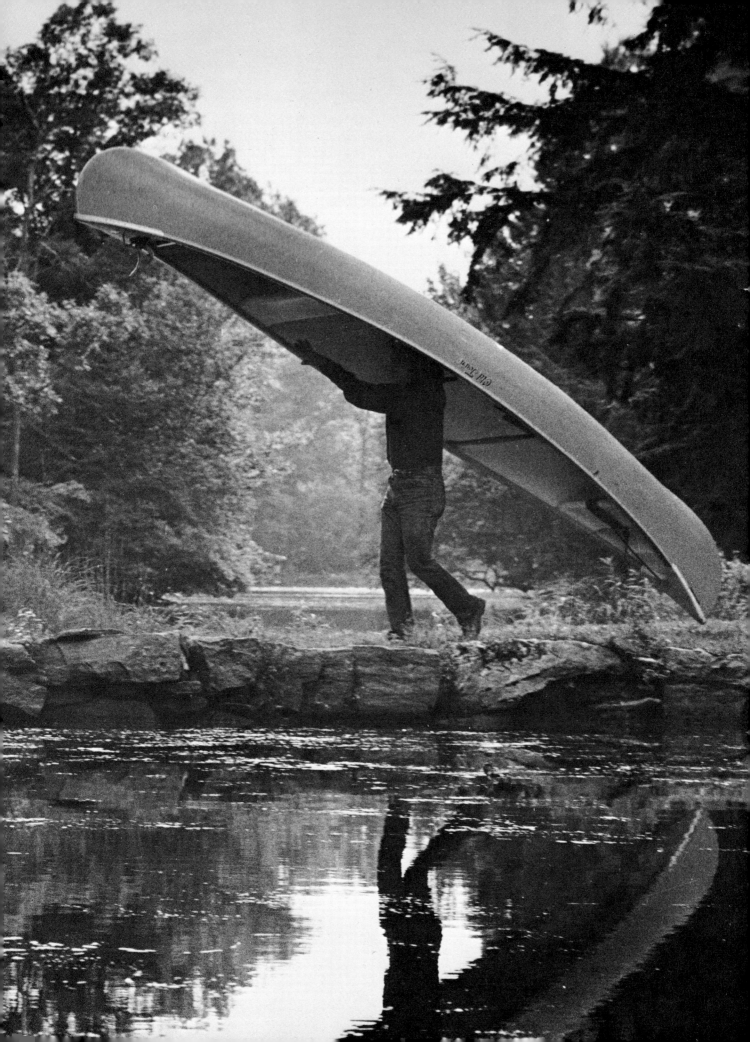

There is no way of predicting how the weather will act. On my Alaskan trip I was told, "This is where we make the weather and the only thing certain is that it will change within the next hour." I believe it! For three days Gil Hibben, Phil Lobred and I drove over a hundred miles to capture the beauty of Portage glacier. Three times my friends and I watched tons of aqua-marine glaciers breaking off and tumbling with great roars into the river—all in hard, driving rain. Finally, on the fourth day, the sun was shining, the sky brilliantly blue and the glacier ice shone like precious gems. It was a spectacular view and I worked fast not trusting the weather. Within an hour, however, I began to realize we'd lucked in to one of those rare good days and slowed the picture-taking. I used lenses ranging from wide-angle to medium telephotos, tried Polaroid filters and most everything else. The possibilities were remote I would ever return to this magnificent spot and I wanted to explore the picture possibilities to the fullest.

Will I ever return and should I take pictures although conditions are all wrong are questions everyone asks. It's a decision always facing a photographer in some part of the world. The sun isn't shining and the sky isn't blue. In fact quite the opposite may be true. I've encountered high winds, dark foreboding clouds, teeming rain and freezing temperatures from the Alps to the Olympic Peninsula and when I had to live with these conditions I took pictures.

A recent experience in Alaska is a good example. Another friend, Virg England who runs Muskeg Outfitters, a mountain-climbing shop in Anchorage, offered to drive me north to photograph some spectacular scenery. It wasn't the best of days when we decided to go, but it was the only time available for us both. As we headed northward toward Eureka in Virg's Land Rover the pale blue winter sky slowly disappeared to be replaced by gathering storm clouds. High winds blew swirls of glacier dust in the valley below and the lonesome land took on an ominous tone.

As we drove up steep grades, climbing even higher, some of the wildest and most spectacular scenery I had ever seen came into view. The Chugach Range, along with Mount McKinley and the Brooks Range, offer the most magnificent views in Alaska and this scene, only fifty miles from Anchorage, was striking. Now given a choice most cameramen would prefer to take glorious scenics under ideal conditions of bright sunshine and warm weather. Dark days and strong winds aren't conducive to leisurely picture snapping, yet these tremendous panoramas with grim skies can give enormous impact to a picture. This is the way the country is most of the time and pictures taken under such conditions will often show, more realistically, I believe, what the country is really like.

Often the less experienced photographer will wonder if the effort will result in a worthwhile picture, even if he had the skill to attempt such a shot under less than perfect conditions.

The answer is yes, shoot the picture and expose more than a couple of frames. Little tricks will help. Driving off the road I had the Land Rover turned broadside to act as a wind break. A meter reading gave the bad news of 1/30th at f/2, hardly an exposure to bring delight. But the vehicle was breaking the wind and I took a tripod from the back and set it up. This way I could give an exposure of ½ second between f/8 and f/11. I used a Skylight filter (for color) and took a number of exposures bracketing as always. To insure against heavy blue in the transparency I also took some pictures with the Haze 2A and UV (ultraviolet) filters for greater correction. They all came out well with perhaps a slightly better correction with the UV filter, yet all appeared as the scene did to the eye. I was able to record the view exactly as it was by making the effort. It is important to remember when conditions aren't as happy as we might like, good pictures can still result by trying the shot. Even if color film isn't as cheap as it was a few years ago, it has to be balanced with the costs of traveling halfway around the world.

Sunrises and sunsets are fairly easy to photograph, although overexposure in color will wash out the transparency to the point where it will resemble a high-key picture. The simplest solution is to point the camera directly at the sun (don't look through the finder too long, however), take a meter reading and shoot. As with all other efforts during the learning process, bracket exposures to insure success. Slower films will be better for such attempts since pointing the camera toward the sun will result in exceptionally high meter readings.

Elk photographed with 135mm telephoto and Tri-X due to overcast in the woods.

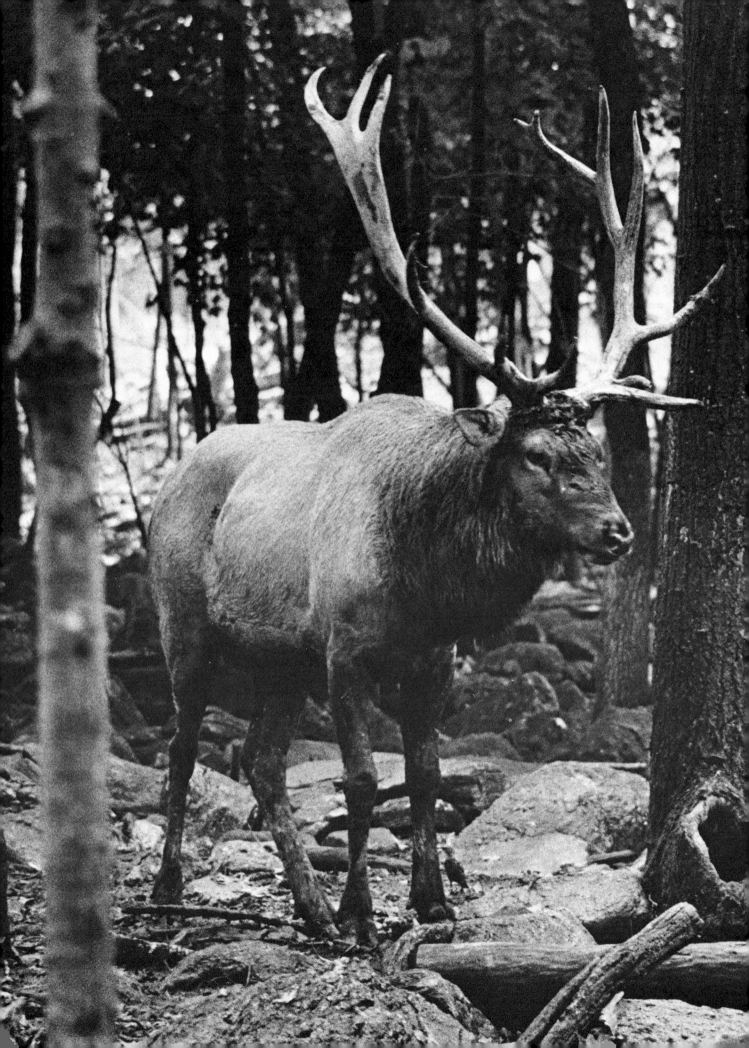

A subject in the foreground will add interest and a tall pine, large cactus or horseman in silhouette will add drama.

Earlier we mentioned subject matter is best left to the cameraman, but there are some compositional hints that will improve pictures. There have been volumes written, and untold thousands of students, have struggled through courses on balance and composition. A technical discussion can become pretty complicated so we'll just discuss a few simple rules.

The two most popular cameras and film sizes that will be used for outdoor photography, the 2¼ X 2¼ square format and 35mm, offer some difficulties in making enlargements to 8 X 10 or 11 X 14 prints. With these square format cameras such as the Rolleiflex or Hasselblad pictures must be composed on the ground glass with the added consideration of making a final horizontal or vertical print. Why? Well, unless the photographer is happy with square prints, 8 X 8 or 11 X 11, the only solution is to nip off a bit of picture from either side for a vertical or top and bottom for the horizontal. By nip I don't mean cut the negative, but cropping on the contact print.

While the square format, particularly with the Hasselblad, offers the user some pretty fancy equipment, the man who lugs cameras and lenses all day eventually turns to 35mm but will still face that important decision of taking a picture sideways or up and down.

35mm cameras are designed to hold and use comfortably and that means in a horizontal manner. In fact some people hold the camera just that way for a lifetime of picture-taking. Naturally subject matter should determine the camera's position, but most are too lazy or unknowing to give any thought to other than the one comfortable camera position. However, if we just look around we'll notice a strong influence of lateral thrust in our surroundings. Rooms, for instance, require a horizontal camera position as do many scenics or group pictures of friends. On the other hand portraits can best be taken with the camera in a vertical position as can tall buildings, waterfalls or giant stands of timber. Common sense should ordain the camera position as much as rules of composition.

There is another rule basic to photography that goes back to the ancient Greeks, and that is the Rule Of Thirds. One of the most basic of all rules is the fact the eye much prefers asymmetrical balance to the more formal symmetrical arrangement.

Imagine, for a moment, a picture of a sailboat. If the picture is horizontal the boat will appear more pleasing if it is moving toward the center of the picture from either the right or left-hand side of the frame. Visualize the same picture with the boat exactly in the center of the frame. Pretty disturbing, isn't it? With the boat we've divided the picture into vertical thirds, but it works as well by dividing into horizontal thirds too.

Want more ocean? Have the boat near the top. Prefer more sky? Then frame with the boat toward the bottom. This simple rule works as well with a person in the picture, mountain peaks or composing a still life. But back to the 35mm format for a moment. To bring enlargements to the more normally accepted 5 X 7 to 11 X 14 size a small amount of picture must be cropped off from either side of the frame. In composing black and white pictures bear this in mind and consider a tiny amount of picture as wasted frame. In color, where it's more difficult to crop the finished transparency, greater care must be taken when composing the subject through the finder.

Learning good rules of composition won't always guarantee good pictures, but once they are applied they will help the photographer overcome some stumbling blocks. But pleasing pictures aren't something that come by accident. Many photographers are born with the eye of an artist and, in fact, quite a number of professionals were illustrators or art directors before turning to the camera, but if there is an honest effort to acquire some modest training, a few afternoons spent in an art museum will do wonders to inspire the tired eye. Cubism, or old masters, no matter what style or period, the composition will be pleasing to the eye.

This is not a study of style or technique, it is simply to view the composition of fine art and apply it to photography. The same can be done with photo exhibits as well. Visit the picture galleries, read all the photo magazines, look at pictures and try to understand why certain ones appeal. Advertising layouts are a fine example of well-executed photographs and should

Two small electronic flashes work wonders with this trick rider. All hoofs are off the ground and high shutter speed eliminates background lights. Hasselblad camera and 80mm lens with Tri-X film.

also be studied for their merit. Simply looking at enough pictures will help the beginner frame and compose his own efforts in a more successful manner.

Practice with a camera never hurt anyone. If occasional moments are devoted to dry runs it will pay future dividends. Take the camera and lenses outside and select something simple to look at. A tree, a bush or even a barn door. Study it through the finder and try to select the most pleasing view. Change lenses and do it again. This isn't a picture-taking session, just a 'looking' session, but it will teach the simple basics of seeing, composing and arranging a picture to suit the individual taste of the cameraman.

While the rules never change, rules are also made to be broken, but the best rule of all is—if it looks ok, take it. Later, if the picture doesn't come out as expected, just toss it out.

An example of the type of picture we're discussing is the ordinary snapshot of some member of the family. The subject (or victim) stands awkwardly in the center of the frame. Shoulders droop, there is a fixed grin on the face and everyone, including the photographer, feels uncomfortable. Is there a solution? Sure, take a bit more time and arrange things carefully.

First of all, move into the shade to avoid the unnatural squint from bright sunlight. Lean the subject against a tree or fence, give him something to do with his body. Unlike professional models who automatically swing into another pose everytime the shutter clicks, friends are intimidated by the camera and need assurance and direction. And this is where the photographer's skill in composition and direction come into play. The subject must relax and have something to do with his hands and body. Talking will help and carrying on a conversa-

Small snake photographed in Florida's Everglades. 55mm Macro lens and Nikon camera.

tion will put everyone at ease. Give him something to do with his hands. If he's a pipe smoker suggest he light up and puff the pipe. For nonsmokers a fishing rod, or a gun will help. There are so many props used in the outdoors that any familiar object will help to establish a rapport and it will also add a personal note to the picture. The rules of composition (those thirds, again) play an important part in moving from the area of snapshots into the field of more pleasing portraits. And, once again, don't be afraid of exposing film. A lens slightly longer than normal, the 85mm, 105mm or 135mm, will give a more natural perspective and also throw the background out of focus and make it softer. Keep talking to the subject and keep moving, change camera positions and keep clicking. Take a dozen or more pictures and, if exposure and focus are correct, the results will be more than pleasing.

Quite often it may not be possible to control the exact framing of every picture—wildlife photography is one area—but generally an effort must be made to select the proper lens to eliminate problems later on. If the picture is taken in black and white then correction may be made in the enlarger, but shooting in color it's impossible to crop a transparency unless a duplicate is made.

Regardless of the difficulty of taking pictures under untried conditions there should always be a striving for good composition. Whether the frame has all those ingredients that make an interesting picture is something else again.

Now what to do with all those rolls from a trip? Should every shot be shown or set aside or tossed out? Admittedly it's pretty difficult for any photographer to throw out pictures, but a hard-nose attitude is best adopted when editing. There must be self-discipline and no matter the difficulty in taking a particular shot, if it misses—out it goes. To begin (and this holds for movie footage as well) out go all out-of-focus pictures, bad exposures, silly expressions and where the shutter was tripped at the wrong instant. Where the exposure was slightly off, set these aside for a second go-around. With sunrises and sunsets, buildings, general views and night or dusk pictures of cities where there may be some redeeming value set these aside as well. Now for a second editing. Begin by evaluating each slide. Does it have impact, interest, is it well-exposed and, basically, does it say something to the cameraman as well as a friend? There are no hard and fast rules, particularly where creativity comes into play and the individual may well feel the picture is important, if to no one else, at least to him.

Of course, pleasing composition and a center of interest are basic, but be ruthless in deciding what to keep and what to toss out. Pictures of a sentimental value can be kept in a private file, but any selection of photographs or transparencies that are to be shown to friends or presented in a slide show must have interest, action and impact. Quickly abandon poor images for they will only detract from more exciting pictures. I recall a slide show at a Ducks Unlimited luncheon in Colorado. The photographer had taken a wilderness canoe trip in British Columbia and showed well over two hundred slides. Many were absolutely magnificent views of mountains, fast races tumbling through ravines, wild game and spectacular sunsets, yet the impact of these wonderfully composed and exposed pictures was destroyed by the dozens of dull, trite snaps in between. A tight editing job, however cruel, would have made an exceptional slide presentation leaving the audience wanting more. Yet as the pictures, and photographer, droned on he lost the viewers.

It is important to remember that a blurred picture of an elk or a clearing where camp was made aren't of interest to anyone except the photographer. And while they may recall memories of an exciting trip they are boring for anyone else. Yes, editing pictures can be the most painful step in photography.

To develop a highly skilled photographer is beyond our scope, to bring out latent skills that are necessary to taking more interesting pictures, to understand what is before us and to look, perceive and grasp the ingredients of a picture, and bring them all together, is our main interest. Rules, all rules for that matter, can be dangerous because some photographers become so set in the learning process they rarely expand beyond that point. And a good rule for the average cameraman, who just wants nice pictures, if it looks fine, shoot it! As the photographer continues taking pictures light values, effects and the relations of color and balance will slowly emerge and the beginner will form some idea of what photography is all about.

There occasionally comes a time, at least to our sporting friends, when there seems to be nothing to photograph. Of course when trees begin to blossom and leaves slowly dress barren limbs a sportsman's thoughts turn to fishing. Mountain streams and distant lakes, high meadow country and the sweet, earth-laden breeze form a motion picture in the mind that keeps restless visions alive. With the crisp cool of autumn the pictures fade into the crunch of leaves underfoot and snow-covered peaks and roaring fires. The memories of a fine day in the field tug nostalgically when the gray days of winter descend. Winter, that twilight period when it's too early for fishing and too late for hunting. When all a man can do is clean his guns for the tenth time or tie a couple of trout flies that will probably never be used anyway.

But, at such times, an occasional thought should be given to taking better pictures. Every year thousands of sportsmen head out to rivers and streams whipping them to a froth. Coils of rope are tossed over shoulders in an effort to scale some higher peak and there are pack trips planned in search of some elusive trophy. The same thoughts should be given to improving pictures too. The camera should still be taken out for an occasional session, just as a fly rod is worked on the front lawn or a shotgun shouldered in a den.

This is not to deny that a camera may occasionally be taken out if some relative asks for pictures of the children, but it isn't this type of picture we're concerned with. It's an old, but true adage, "Practice does make perfect," and the only way to improve pictures is to continually take pictures. Film is still cheap enough and an extra roll or so shouldn't harm the most carefully balanced budget.

When a flushed grouse is rising isn't the time to fumble with focus or wonder about exposure. Picture stories that were once so popular with the weekly picture magazines are still an excellent way of depicting a trip and are not beyond the scope of the average cameraman. If the sequence is well done, it will have a beginning, a middle and an ending. As an exercise a story could even be told with just those three pictures. How many pictures are put in between should be left to the judgment of the photographer.

How should such a sequence be approached? By making a shooting script. By listing all those pictures that should be made to tell a story.

It isn't difficult, just give some thought to the trip. It will work as well for hunting as it does for fishing and even a journey to a foreign country might be listed in the same way. For simplicity, however, let's review a list for a fishing trip. This is the way it might read:

Picture

1. Photograph of fishing tackle artfully displayed on the tailgate of a station wagon. It will say fishing to the viewer and introduce him to the subject to follow.
2. A medium shot of the car en route showing the countryside to be visited.
3. Arrival at the camp or cabin and a couple of shots of friends unloading gear.
4. Medium closeup of building a fire in the fireplace.
5. The preparation of dinner.
6. Joking and eating around the table offer excellent opportunities for closeups.
7. Poker or chess after the meal, showing friends relaxing or working on tackle.
8. Perhaps a medium shot of the tent or cabin lit by the glow of lanterns or fire.
9. Early morning shot of preparation for fishing. Pulling on waders, checking flies, etc.
10. A canoe moving along a still lake will add drama to the series.
11. Someone framed in a stream with foreground of pine boughs to enhance the picture.
12. Closeups of tying a fly to the leader.
13. Sequence of fighting a trout.
14. Closeup of the catch using net or fly box as props.
15. Closeup of fish frying in the pan.
16. Medium shot of happy smile as the first bite is taken.

Here are sixteen pictures of a fishing trip. None difficult or calling for a tremendous amount of skill yet, as a sequence, it would be a memorable series of pictures for those on the trip.

These are the simple basics of making a shooting script. With a change of priorities it could

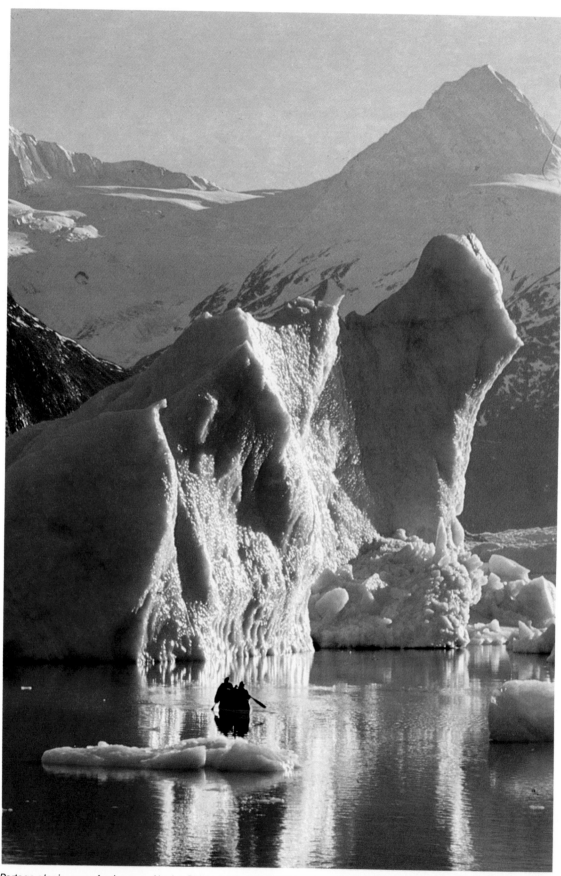

Portage glacier near Anchorage, Alaska. Phil Lobred and Gil Hibben brought the canoe in a truck in order to have a point of interest in the water. Ektachrome-X film and 24mm lens.

do just as easy for a hunting trip, running a river by canoe, backpacking in the high country or seeing the sights of New Orleans. Of course, as soon as a list is completed other pictures will no doubt come to mind and they should be added. Don't put any restrictions on the script because once on location other possibilities will constantly present themselves. It is only an aid, after all, to taking better pictures.

Naturally anyone taking such a journey wants to hunt and fish himself and often the bothersome nature of photography can be a bore. Taking pictures should never be a chore and if it is set the camera aside. Unfortunately, there is no easy way of bringing home good pictures without taking them in the first place. Tramping over hills and stumbling over rocky rivers can be tiring, too, and packing out a quartered moose can be the most exhausting task known to man. Discretion, even with tried and true companions, should be exercised and if there is objection to a constantly clicking camera keep it at low level.

Not everyone desires a sequence of events and considers such efforts boring to take and view. But even the photographer who isn't interested in a dawn-to-dusk report should still have the skill to take an interesting photograph that may cause a small stir of interest when shown.

There are many pictures that don't require the presence of another person and there are many still lifes and closeups around campfires—all within view of the cameraman.

Motorized cameras are an interesting method of obtaining pictures in sequence. They are especially helpful in taking instructional pictures or analyzing a friend's shotgun swing. They are excellent for aerial photography since they permit the photographer to concentrate on the picture rather than be concerned with camera controls. At first thought they might even be considered ideal for wildlife photography, and they are with very long telephotos, but frequently the first clank of the shutter will burst a herd of game like a hand grenade.

I recall one early morning in East Africa where a stalk had brought my guide and myself near a waterhole. Quietly I focused the camera and took a meter reading. When everything was set I pressed the release button and BAM!!! The zebra were off and running. Some even froze in mid-air. Even to my ears, in the early morning quiet, the camera sounded like a water pump running full blast. When the film was processed I found one excellent picture of those graceful animals drinking in peace and quiet then, suddenly, a scene that resembled a traffic jam on Friday afternoon. Very long lenses, 500 or 1000mm, can be used with motors since they keep the photographer a greater distance away from his subject. Lengthy stalks and staying downwind can help the nature photographer—even with motors.

For the amateur cameraman is the added expense of a motor really necessary? Let's put it this way. A motor is a nice piece of equipment to have on at least one camera. It will enable the photographer to do many things he could not otherwise do. On the other hand motors race film through cameras pretty fast and every roll exposed means additional costs for film and processing. For the rank beginner a motor isn't an absolute necessity. For the man who specializes in game, birds or other aspects of nature, and wants to use two-way radio control (an expensive and sophisticated concept) then a motorized camera is the only way to accomplish his goals.

What of the one-lens one-camera photographer? He is less handicapped than he thinks. Filters will enhance his pictures and a few dollars might go for a closeup attachment. An inexpensive tele-extender will double the range of his lens. All these items will run under $50 and make the camera more versatile. Beyond that is the imagination of the photographer and his experience with tools that will enable him to reach out to the limits of his creative ability.

With the constant brainwashing of the average photographer the rule of taking pictures with the sun over the shoulder should be disregarded. Many of the most dramatic pictures are the result of shooting with sidelight, backlight, early in the morning or late in the day. And if the color shifts off normal don't be disturbed. It can often add to a scene and make it more interesting. Change camera angle too. Don't constantly shoot from the same, dull eye level. Some years ago, when the Rolleiflex was popular, the continual use of the square format, combined with a waist-level finder, became known as "the belly button view." Every picture taken had the same "gut" angle, and they all began to look alike. To break the monotony photographers then moved to the "worm's eye view." Cameras were set on the ground, at

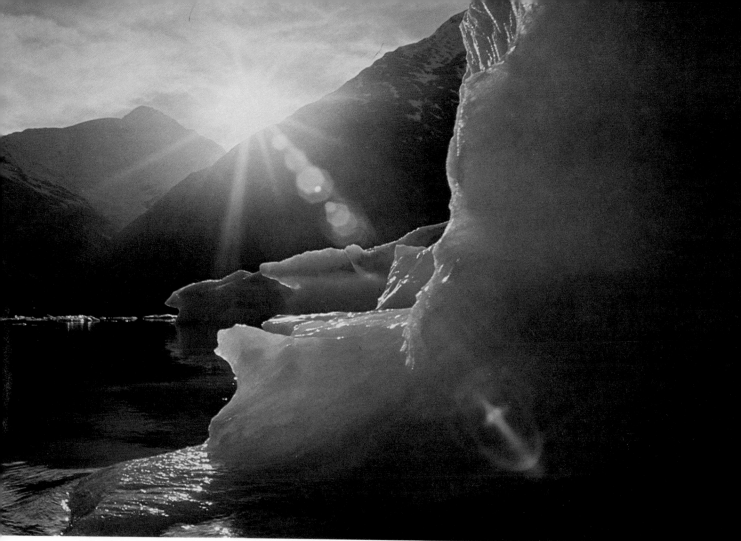

The same view should be explored for additional pictures. Portage glacier photographed from the canoe and against the sun.

water level and even in the mud. Again, every picture began to look alike, although this new and rather exciting view added drama to the subject. Following these soon overworked angles came the "ladder view" or high angle shot. Cameramen were clambering atop tables, ladders and even shooting out of high buildings. Soon common sense reigned and the working photographer realized he didn't have to dirty his clothes for every picture nor was it necessary to carry a portable ladder on every assignment. What did evolve from all this, however, was a realization the camera should be moved and there is more than one point of view for every picture.

Simply changing lenses will often give a different perspective and there is still nothing wrong with clambering atop a rock or even setting the camera on a shoreline to dramatize a particular shot. Learn to move the camera about and constantly search for a different angle to add interest and excitement to pictures.

It is also necessary to address the subject as well. Some friends have the greatest proclivity for clowning about in every picture or, the other extreme, becoming stiff and formal. Talking helps. Explain what is to be accomplished with the picture and don't be hesitant about directing them in a low, gentle voice. Not only are they happier about being let in on the secret, but frequently offer suggestions that help. Expressions can often make or break a picture and this is another of those small areas that should keep the cameraman alert. Naturally someone sighting through a scoped rifle at distant game would have a more serious mien about him and a frown on a rock climber as he reaches for a hold would help, but both would be out of place on a fisherman reacting to a strike.

Clothing can be another difficulty. Going into the outdoors doesn't necessarily mean looking like a hobo. Granted old clothing is comfortable and takes hard knocks in the rigors of outdoor living, but in this fashion-conscious world good-looking outdoor wear has made great inroads. Jeans, clean plaid shirts and bush jackets all add a proper outdoorsy note and should

117

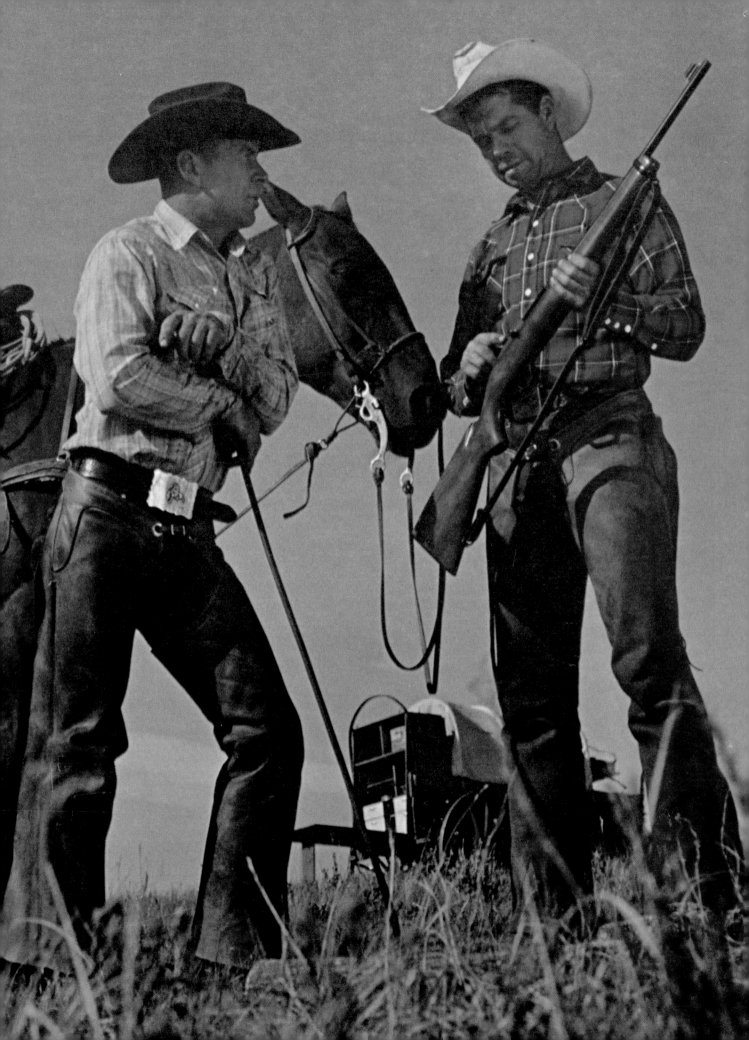

Sportsman scans the valley for game. Hasselblad camera, 80mm lens and Ektachrome-X film.

be utilized. Broad-brimmed safari or Western hats have become popular and protect the wearer from sun or inclement weather. However, they make picture-taking difficult by shading the face. The answer is to carry a small electronic flash to light up the face. The best method is to use a long tripper cord, six or eight feet, and move the flash three or four feet behind, and slightly to the side, of the photographer. It will open up shadows and the face, in deep shade, will be properly exposed.

The same technique can be used at the seashore or in ski resorts where the sun is extremely bright and high overhead. Although sand and snow will reflect some light upward toward the face it usually isn't strong enough to open the deep shadows around the eyes and a small flash will work wonders.

Earlier we mentioned the sportsman who may carry a camera, but is only interested in a couple of good shots without becoming involved in a picture sequence. Even those pictures must be given some thought. A pack trip into the out back country of Idaho or Wyoming offers magnificent vistas of mountains, but a camera simply poked at the scenery won't do much to bring home a striking view. While scenes of breathtaking beauty may be appealing to the eye, and the viewer is impressed with the grandeur before him, it all begins to diminish in a photograph. The photographer forgets that the trip has prepared him for all this. The air is clear, he is surrounded by jovial companions and has slowly become enraptured by his surroundings. In fact, some months later, he is prepared to swear his meals were prepared by

Cowboys near Cheyenne, Wyoming. Large foil covered reflectors were used to throw light under broad brimmed hats and into faces.

Under less than perfect conditions, pictures should be attempted. The results can often be worthwhile as is this picture of the mountain ranges near Anchorage, Alaska taken in dim overcast.

gourmet chefs, but we know different. The professional photographer, no less impressed, is aware, however, that something more than simply drinking in the scene is needed to benefit the piece of film in the camera. Mountains will diminish, they don't appear quite as high, the angle is wrong for a good picture and something has to be done about all those fine clouds.

A red or yellow filter will handle the clouds and often a longer lens will move the distant crags closer. A horseman placed in the foreground, or a craggy pine, will add foreground interest. In fact there are times when the use of a wide-angle lens will add visual excitement and give various planes of interest.

There are no hard and fast rules that dictate certain lenses for certain pictures. While a Macro is necessary for closeups or long teles are required for distant game, the selection of a particular lens should be left entirely to the aesthetic propensities of the photographer. Only he can make the final judgment of what the picture should say and whom it should please. Any given subject could be approached by six different cameramen and all would probably use a different lens, different shutter speeds and different films.

There are those times, particularly in outdoor photography, where adding to nature may enhance a picture. Filters for cloud effects are one means of accomplishing this, but there are other times when bad terrain, weather or conditions beyond our control may preclude too much fussing with the camera.

For example, I've had a number of fishermen friends ask why they can't capture the beautiful iridescence of a trout leaping from the water? Well, they can if they want to take the trouble. The proper focal length lens must be used, the cameraman and fish must be angled to the sun just right, the leaping fish must be out of the water long enough for an exposure (a motor is a must here) and a huge amount of luck will help.

Winning pictures like this are often staged, but the same can be done by any photographer. Here's one way of accomplishing this and if done with a modicum of care will result in a successful picture. A stiff wire, a straightened coat hanger is ideal, is forced into the fish from the

120

tail. The bottom of the hanger is twisted into a circle and placed underwater and held with rocks.

Perhaps the upper part of the wire may be curved slightly to give a natural position to the fish. Now the fish is above water with the tail underneath and hiding the wire. A buddy is placed just right with the line taut, assumes the expression of an excited fisherman and stands ready. Another chum is off camera, near the fish, with a large rock or bucket of water. When everything is set, camera focused and angle correct, a signal will have the water boy heave the water at the fish. If everything is just right, and the shutter squeezed at the exact instant, the results will look like a trout jumping and a cascade of water falling into the lake.

This is not to impugn the many splendid fishing pictures we've all seen over the years, but a certain amount of staging, faking, if you will, goes on and very often it's necessary if a location or situation won't permit more realistic action. In fact one time in Panama, covering an assignment on the Army's Jungle Warfare Center, one picture called for an advance scouting patrol to be framed by a snake slithering down a tree. We all know there are snakes in the jungle, but they are seldom seen. It's a remote possibility of finding one in the exact position called for or even having the soldiers positioned just right. The solution was simple; we caught a boa and tossed him in a sack until we found the right locale. Once we did everything was arranged and we got the picture. The snake? We let him glide back into the tangled underbrush.

Naturally many of the setups described may require too much preparation for the average amateur, but the world of photography is demanding and nowhere can the cameraman try his skills better than the outdoors. Even with the best of equipment, and the certain knowledge everything in the picture is correct, the only guarantee in bringing back good results is to bracket exposure. Any journey, no matter how near or far, shouldn't preclude the expenditure of a few extra dollars for a modest supply of film.

In unfamiliar surroundings or unusual lighting conditions there should be no hesitancy about committing a few extra frames of film to insure the picture. The tyro photographer should mentally tote the cost per mile of getting to where he is and it may give a different set of values to what is before him.

Sailboat returning to harbor near Miami, Fla. Yellow filter against the sun and clouds.

CHAPTER 7

The Close-in World

There comes a time, usually sooner than later, when most photographers want to take closeup pictures. It may be a handsomely engraved handgun, a collection of trout flies or even fine coins or stamps. For many it may be a one-time thing, but for others, who discover the excitement of this inner world, it opens up new vistas for the creative cameraman.

Too frequently the novice lensman becomes so engrossed in what is viewed through the camera's finder he forgets to move in closer to the subject. It's true a lack of experience may be one answer, but more often it's also a lack of proper equipment as well. A beginner shouldn't be too concerned about his pocketbook because, as with many things in photography, there are alternate ways of accomplishing the same goals. While lesser methods of attempting closeups may be a bit more difficult and insufficient skills may be challenged they will enable the novice to obtain pleasing results right at the start.

If one had the ultimate in closeup equipment what is there to photograph? Many times fishermen have recounted their regret at not being able to photograph live nymphs at streamside. Months later, probably on a cold winter's evening when fly tying equipment was laid out, they couldn't remember what the darn thing looked like. How simple it would have been to take a picture and how convenient to glance at a color slide, and proceed to tie an exact replica.

Some years ago, before the advent of today's easy-to-work-with macro focusing lenses, simple Proxars really saved the day. I was working in London at the time and had a magazine assignment to do a story on the Itchen River, one of Isaac Walton's favorite chalk streams. An old friend, Captain Patrick Hazlehurst, a purist fisherman of the old school, had invited me down to Winchester for a weekend of fishing and photography. Our first morning on the stream was typical of the traditional British way of fishing. A locked gate for privacy (fishing rights are leased in Britain) and well-tended paths set behind chest-high hedges, to prevent casting shadows on the water, and careful stalking of a selected trout.

Unlike American fishing, where the fisherman casts blindly hoping for a strike, in England the fish is selected and the fly presented. If no strike is forthcoming the fly is changed until the fish takes the most appetizing offer.

New to the techniques of traditional fishing I had packed every piece of equipment, both for fish and photography. Fortunately for my assignment a few skillful casts by Pat Hazlehurst netted a handsome trout. After unhooking the fish from a barbless hook, Pat fumbled about in his kit bag and finally withdrew a strange looking instrument. I watched fascinated as he inserted it down the fish's throat and brought up the stomach contents. This, I found, was a gullet spoon, an indispensable item for the purist fisherman. It was also the first closeup of the day. Although somewhat limiting in their use I had a couple of Proxars, closeup lenses that fit over the camera lens, and took a series of tight shots of the spoon being removed, another of the contents spread across my friend's palm and, finally, a series showing the

Woodlands offer many opportunities for excellent backgrounds. Knives by Rod Chappel pictured with a 4 × 5 Linhof. Meter reading taken from a gray card.

124

nymph being tied at streamside. These Proxars, no larger than a filter, saved the day and the only alternative would have been extreme enlargements with the added risk of grain and softness of the image. These same attachments, available under many trade names and fitting many cameras, are still the easiest and lightest way of obtaining closeups.

CLOSEUP LENSES

The least expensive (around $10) method of moving the lens in close, they may be obtained in various powers, 1+ through 10+ diopters and they simply screw onto the lens or fit with an inexpensive adaptor ring. Used with through-the-lens metering systems of an SLR camera they require no calculation for the closeup because the meter reads the correct exposure directly. The disadvantages, unfortunately there are always a few, is the fact that anything placed in front of a prime lens may diminish sharpness to some degree. Like filters they must be kept scrupulously clean in order to deliver quality negatives. The other disadvantage is a limit to the size of magnification possible with close-up lenses placed in front of the lens. Yet, these relatively low-cost items will take superb pictures if used with care and could save the day when a tight closeup is required.

For those who need greater magnification, again at low cost, a number of companies make a macro adaptor with 10+ power that fits normal lenses, 50 or 55mm, and will render the subject ⅘ life size, but again there is a limit since these devices only focus at one distance. Here the price moves slightly higher to around $15.

EXTENSION TUBES

Much greater magnification may be achieved, up to 1¾ life size with another relatively simple and inexpensive item: extension tubes. These have the advantage of not placing anything in front of the lens. They are what the name implies, tubes that fit between the camera body and prime lens and enable the lens to be moved close to the subject. They are available for practically all cameras and the better models couple directly to the camera's automatic diaphragm and metering systems. The cost takes a modest jump, around $20, which is not prohibitive considering the pleasure of making closeups. Extension tubes offer the advantage of various combinations of tube sizes which, in turn, give a choice of focusing distances and greater magnification.

BELLOWS SYSTEM

The next step upward is the bellows system. As with extension tubes the camera's main lens is used. Pictures may be taken from life size (1:1) to well over 4½ times life size. Magnification may be varied continuously without the limitations of fixed tubes. The better bellows systems also work through the camera's metering system. For this privilege of convenience there is a higher price tag: from $60 to over a $100 for a quality unit.

For the backpacking photographer, however, the bellows units may not be the best method for obtaining closeups. For precise work it really is necessary to fasten the camera to a good, solid tripod to prevent vibration or movement. Additionally, I don't feel most outdoor photographers require the capability of such extreme closeups to be gained with the added bulk of a bellows. The bellows is slow working and, when fully extended, the slightest breeze will cause movement. These are problems the sportsman can do without.

MACRO LENSES

The most simple piece of equipment for closeups is the result of technical advances made by lens designers over the past dozen years. These are the macro lenses discussed in the chapter on cameras and lenses. They are small, convenient and simple to use and with the M-2 ring will allow 1:1 closeups. The lens may be used as a normal lens and a twist of the focusing ring will enable the cameraman to move in as close as he desires.

In these days of rising prices it would be foolish to deny any lens is expensive and these macro lenses are no exception. Both camera and lens prices fluctuate wildly depending on dollar devaluation and suddenly imposed import tariffs and a new macro lens from a number

of different manufacturers might cost around $200 with a used one, in good to excellent condition, bringing around $60 less. If close-in work is a prime consideration, and the main interest of a particular sporting area, there is no lens that will give greater pleasure to use or more exciting results than a macro. It is a superb instrument that simplifies closeup photography in the field. This is not to imply that other accessories: closeup lenses, extension tubes or bellows won't do a good job, they will and at less cost. They will satisfy many requirements and won't make quite as big a dent in a bank account, but the macro lens will take pictures with less fuss, won't demand mental calculations and will deliver sharper pictures, too.

TAKING A CLOSEUP

Now that we've run through a minor maze of closeup gear regardless of what is used what are the prime steps in taking any closeups? Steadiness of camera and subject is important for any picture, more so for macrophotography. If a tripod can be brought along use it, but the macro lens may be used hand-held if care is taken and high enough shutter speeds are used.

Let's take a simple subject we all know; someone tying on a fly at streamside. If the subject sits on a rock and rests his elbows upon his knees then his hands will be steady and help keep the fly and fingers in focus. Move in and focus the camera until the required area fills the frame to satisfaction. Using the macro lens with a SLR camera all calculations will be automatic for the extension of the lens, take a meter reading—and gently squeeze the shutter. Take another picture slightly above the meter reading (½ to 1 stop) and another below normal. Remember, if one exposure is all that time allows, fine, but two is better than one and three exposures are best of all.

Why? To compensate for variables in the meter and shutter, the way an individual reads the meter and slight differences in film speed and processing.

Now let's try another exercise. Change the view a bit and even move the camera so backlight hits the subject and, if the camera is placed right, even pick up highlights off the water. But if backlight only hits the rim of the fingers or top of the fly then the foreground will be dark. Correct, but light can be thrown back into the picture with reflectors. What to use in the woods? How about a shaving mirror, a piece of white paper or a white towel. The most convenient reflector, in terms of availability, weight and cost is a roll of aluminum foil purchased at the nearest supermarket. Reynolds Wrap is excellent because it's dull on one side and highly reflective on the other and the bright side may be used for longer throws of light. Impale a square foot on a couple of sticks and move it about until the light reflects properly. Another stunt is to poke a small hole in the center of the foil and place the lens through. That way there is a handy reflector that throws the light where it's needed. If at times the foil seems too bright a sheet of cardboard may be used. It will give a more diffused reflection and still open the shadows.

Aside from the easily carried foil, a small electronic flash may also be used to punch light onto the subject. Even the smallest flash units can be overpowering when used too close to a subject so some experience must be gained before going for broke on an important picture. A clean handkerchief placed over the flash tube will usually cut the light by one half, two folds by one stop and three folds another stop. The automatic strobes will seldom work outdoors so it is best to experiment cutting down the light and a series of tests will show how much is required.

There are so many outdoor subjects that make exciting closeups the cameraman must learn to think small, as it were. Algae, moss, leaves, berries, rock formations, weather-beaten logs, rusty barbed wire and flowers, particularly with side or backlighting, all make fascinating pictures when viewed through the closeness of a lens. Aside from the obvious the cameraman must learn to see and think of pictures all around. This is a different world and efforts to capture it can be rewarding. Swirls of water in an eddy or a leaf floating in a stream can be turned into exciting photographs with a little care and imagination. Perhaps the first efforts will be less than rewarding, due to improper exposure or dull subject matter, but the main effort should be to keep trying and then, suddenly, there will be one picture worth all the effort. One

Indoor photography offers elaborate pictures with simple equipment. Old board and two small lights. Mimaya 67 camera, meter reading from a gray card.

Water lily photographed with 35mm Olympus OM 1MD and 50mm Macro lens.

128

that is better than all the others and then everything falls into place.

Not every closeup has to fit the category of a macro (1:1) type picture and there are many who feel anything taken closer than the focus allowed by the normal lens is still a closeup. Into this mid-range are closeups desired by owners and/or collectors (and there are many) of guns and fine handcrafted knives. Some may want a record picture in black and white, for insurance purposes, while others may have a desire to attempt something more ambitious. For record purposes a plain background is best while a more artful effort may demand accessories in keeping with the motif, historically or visually, of the subject.

When weather permits I favor the outdoors for photographing guns, knives, fishing tackle and all our outdoor gear. These were made to be used in the woods and fields and I feel they belong in their natural environment. Not only do textured woods and old logs enhance a picture, they also make a simple background for a fine gun or hunting knife. Sheaths, sharpening stones or a few pieces of other equipment add much to a photograph and, if carefully selected to complement a subject, can dress a picture. Don't overcrowd with accessories because it is possible to overpower a picture and distract from the main subject, but a few well-chosen articles, carefully placed, can do wonders to brighten the overall effect. If properly done they will also add a certain amount of professionalism as well.

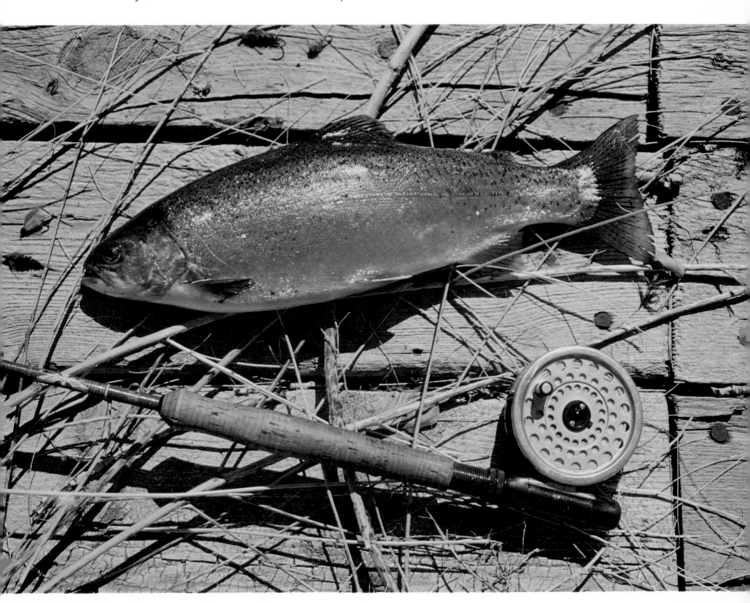

Trout and rod taken with Nikon and 55mm Macro lens.

Setup used to take picture on page 126.

Finely engraved guns photographed in living room of home. Two photofloods used for lighting in small reflectors, camera on tripod. Such setups can be done in small area.

CLOSEUPS AND STILL LIFES INDOORS

Let's take the method of shooting these pictures one at a time. First indoors. We do have long, gray winters in many parts of our country and can't always wait until spring or summer to move outside. Cold weather and snow can do much to enhance a photograph, but we'll move outside for that shortly.

No doubt there were sighs of despair when I mentioned taking still lifes indoors. With lights, backgrounds and the room needed to even take the pictures, it may all seem too much. Not so since a great deal of room isn't required and a few inexpensive lights will do the trick. Most amateurs have some type of light available plus a couple of light stands.

A good, solid tripod is most important—usually with a small extension arm to move the camera over the subject. In the beginning bounce light is best and this means bouncing lights off a white ceiling. This does what it implies; bounces the light back onto the subject with soft, shadowless lighting. It's the best way to take simple, uncomplicated pictures of handguns, engraved knives and other small objects. While two lights will do nicely for most black and white subjects, color, because of the slowness of the film, will probably require four lights in all.

As far as space necessary four or five feet is sufficient for most closeups. To photograph a couple of fine knives purchase a small sheet of buff-colored cardboard at the nearest art supply house and place it on the floor. Set a light to each side and place the knives in the center of the background. Once the camera is set and focused be certain there are no light stands or cables reflected in the blades. If this does happen the knife may be moved slightly or a stand backed off a bit. At times a small sliver of wood or piece of putty placed under the blade may tilt it enough to eliminate reflections. The great problem with steel is to make it look like steel and it is among the most difficult of subjects to photograph. A dulling spray may be used and

131

it can be wiped off the blade without harm. If the ceiling is white it should reflect in the blade and give a quality of steel in the finished print. Should a more artful picture be envisioned a piece of leather, the back of a fringed suede jacket or the corner of a Navajo rug may be used. This is where the eye of the cameraman comes into play and most outdoorsmen have enough props around the house to help any still life.

Simplicity is the key to both accessories and lighting. Too often the mistake is made to overlight and over-accessorize and this can be deadly. A sense of graphics and design will help any photographer attain better still lifes.

When taking pictures in color more light is necessary to enable a minimum exposure and allow the lens to be closed down for sharpness. With color another can of worms is opened. Remember to take color pictures in an area where no other colors intrude from walls or drapes and a white ceiling is a must.

It's not always necessary to have the camera directly over the subject; knives can be stuck into a log and guns leaned against a leather case as part of the props. While the lights may still be bounced off the ceiling it may be necessary to open the foreground shadows. Again alu-

Engraved gun by Walter Kolouch photographed outside his shop with Hasselblad camera.

Salmon flies on an old wooden pier. Macro lens on Olympus camera.

minum foil or white cardboard is called into play. Positioned in front of the tripod, perhaps leaning against the leg, it will reflect a small amount of light into the picture area. If this isn't strong enough a small light may be bounced off this front reflector into the picture. Pictures taken in this manner required close attention to detail. If cloth or other material is used it should be pressed with a steam iron. There is nothing more annoying than wrinkles in a background (unless they are deliberate folds) and it smacks of a careless amateur attitude. Seamless paper obtained from photo supply houses makes an excellent background although it may be rather large for small areas. Often a half roll, cut through the middle, may be purchased and a local photo studio may be willing to sell a few yards. If care is taken it may be reused many times, but a drop of oil from a gun will stain the paper requiring a few feet be cut off the next time it's used.

THE OUTDOOR STUDIO

Moving outdoors eliminates many of these problems, but presents a few of its own. Open shade is preferable for closeups since the soft, even light is diffused and seems to envelop the subject. An exposure in this type of light is fairly even giving good balance to foreground and background. But the low light levels often require lengthy exposures and a solid tripod—plus a cable release—are a necessity.

Start by selecting a good locale, a likely log or tree stump, an old rail fence to lean a gun against or an old weather-beaten barn. These are all excellent for they will add character to the picture.

Care must be taken to see no unwanted obstructions are in the background that will interfere with a well-composed picture. As skills of perception are developed there will be a gain in photography as well as an appreciation of the outdoors.

Now select a spot to photograph an old handgun, an old Colt, for example. Autumn is an ex-

Outdoor settings offer a variety of locale. These mementos of the Revolution were pictured at Fort Ticonderoga.

Woods spider taken with Olympus OM1 camera and 50mm Macro lens.

cellent time for outdoor pictures since colorful leaves on the forest floor make an interesting background. Try to find an area in open shadow and an old tree stump would make an excellent choice to rest the gun on. Be aware of the bark and if there is a colorful patch of moss so much the better. Set the gun down and look at it and—think. Think of what the picture should say and what props or accessories would help to develop the theme. Glance about and look for objects that might intrude. Now place a couple of old cartridges in the picture, lean the gun against an old holster or a pair of beaded gauntlets. Anything in keeping with the period will enhance a closeup and keep it from becoming a record shot of a gun. When everything is in order, and pleasing to the eye, then take the picture. But don't be satisfied with only one picture. Besides bracketing exposures move the camera and try to find another angle, change the arrangement of props and build another picture. This type of outdoor locale is best in color. Every shading and delicate nuance of pastel color will render beautifully. In black and white, however, it won't come off quite as well. What was pleasing in color become busy blobs in the background and only adds confusion.

But don't be pleased with just one setup since a professional might take a half dozen different setups of the same subject. Pick up the equipment and stroll about, look for other locations, a brook or, if in the spring, bright green cabbage leaves for added interest. Never be satisfied with the picture just taken. Seek to improve it, make it more interesting and exciting because only then will pictures improve.

Now let's try another gun, this one a modern target pistol. A wooded glen won't work here since the subject would be out of its natural setting, a target range. Here there is an abun-

Old timer admiring opal bearing rocks at Andamooka, one of Australia's opal fields. 55mm Macro lens. Taken late afternoon to get light onto face.

dance of accessories to add to the picture. Pistol case, shooting glasses, targets, spotting scope, ammunition and a variety of screwdrivers and oil cans.

In the bright open area of a pistol range an overcast sky is not only best for shooting, it's ideal for picturetaking. A well-composed photograph here is limited only by the skill of the cameraman and his ability in arranging props.

Since there are no shadows, at least on an overcast day, black and white will work as well as color. With a surfeit of props (a rare instance) not every one has to be used. Here the photographer may be more selective and eliminate those that don't work or make the picture too busy or cluttered. The beauty of many closeups (including macro) is their simplicity of form, yet a few tastefully selected accessories will do much to enhance these medium-range pictures. Again a series of pictures should be tried changing camera angle and props until the photographer feels he has explored the subject thoroughly. While the reader may become bored with the admonition; film is cheap, take plenty of pictures.

The same technique of outdoor locales may be used by practically any sportsman regardless of his hobby. Fishermen may photograph a fly box with a selection of flies or the mountain climber might want a set of instructional pictures showing the placement of piton or rings. An angler would naturally select surroundings to enhance his pictures; boats, water, a rocky shoreline or wooden pier and the mountaineer a rocky ledge. While the sport of mountain or rock climbing is spectacular many of the skills fall into the area of closeups. A mountain climbing club may want a series of instructional pictures showing the knots used or closeups of hands illustrating holds. The techniques of carabiners, pitons and all the hardware add to a well-covered mountain climbing series.

New and old photographed with 50mm Macro lens.

Capture of a moray eel off the Florida Keys. Hasselblad camera in marine case, CC30R filter to hold colors. Picture taken at depth of less than 20 feet to take advantage of sunlight.

Not all these pictures have to be taken under the hazards of a difficult climb and a traverse of the north face of K-2 isn't quite the place to begin taking photographs unless the climber is experienced. There are plenty of rock fissures at ground level and a jammed fist hold may be taken with ease. The macro lens is ideal for sporting photographs and a properly chosen locale, with the sun from the side, will bring out the texture of hands and rocks.

Obviously not every picture is going to be either a macro or even a medium closeup, but the ability to take such pictures will add to the photographer's enthusiasm and skill in giving fuller coverage to a subject.

There are, indeed, so many facets to this close-in world that it presents a challenge to the cameraman because he is constantly provoked to think of how to make, and take, closeups— and make them interesting. Nothing in photography comes easy and the desire to improve pictures can only come from constantly taking pictures. Composition, perception, light values and form are as important in closeups as they are in the larger view. Good exposures and sharpness should be an accepted fact for without these any picture will fall apart.

To get to the nitty-gritty of photography, especially in closeups and macro work, one must learn to see, not only with the eyes but through the eye of the camera as well. When everything extraneous has been eliminated, when the picture looks right and feels right, then the cameraman has come a long way in gaining experience.

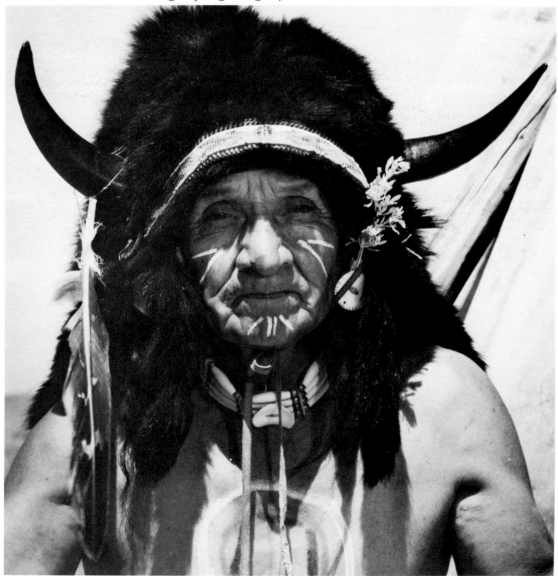

Sioux chief photographed in Wyoming with Hasselblad camera and 150mm lens.

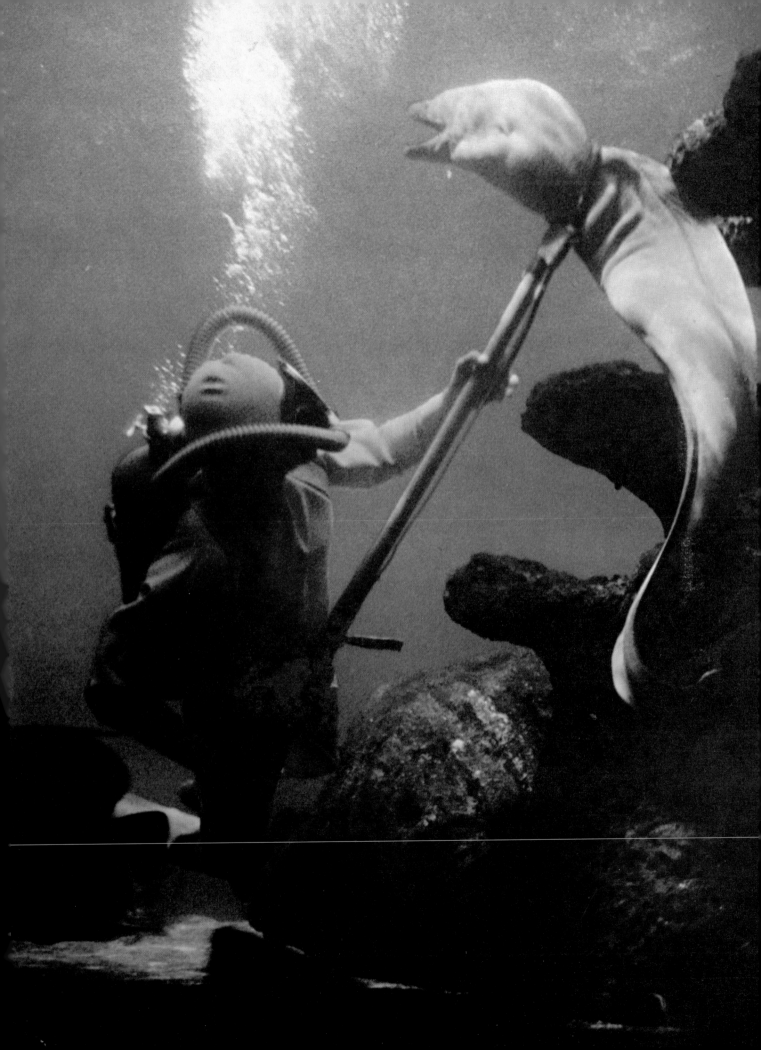

CHAPTER 8

Sea and Air

With increasing frequency sportsmen, scuba divers and just plain sun-soakers are jumping into the sea with cameras around their necks. No, they aren't crazy, just some of the thousands who have discovered the fascination of photographing a strange new world. The fun of taking pictures underwater isn't as difficult as it was a half-dozen years ago and the equipment isn't as expensive. It's great sport photographing tropical fish in their natural locale, taking colorful shots of coral formations and shooting some ghostlike hulk on the ocean floor. With attention to a few details encountered the techniques aren't as haphazard either.

Of course there must be some proficiency in the water. The ability to swim is one and some knowledge of snorkel, face mask and swim fins is another. Scuba gear isn't too difficult to use, but a course is advised. Many resort areas have competent instructors and a few days spent in the safety of a pool will give confidence before venturing into deeper water and unknown seas.

Most sportsmen already own fairly sophisticated camera equipment and clear plastic cases are available for the most advanced equipment. Starting from scratch the best 35mm camera is the Nikonos II. A small piece of equipment that is simple to use, has interchangeable lenses (some specially formulated for underwater use) and the camera itself may be dunked in a pail of fresh water for cleaning after use. It also has a rapid wind lever that cocks the shutter and winds the film with one motion and a slight press of the same lever trips the shutter as well. An adaptor sunshade takes filters which are just as necessary underwater and even a flash may be used if required. The accessory sports finder is a handy addition since it permits ease of viewing through a face mask without difficulty.

But before jumping into the water let's take a look at some of the problems encountered. The most important is light and the position and intensity of the sun above will have a decided effect on the subject below. Surface conditions add difficulties because choppy water, the result of wind and storms, will cut roughly 30% and the deeper the dive the less light available.

Whether good pictures are taken underwater depends on many things, but none more important than the determination and skill of the photographer.

Added to all this is surface chop causing tremendous movement underwater. Plankton, and algae, are constantly shifting about and all cut down on visibility. Frequently the underwater cameraman finds himself shooting in conditions that resemble topside fog. What happens with all the particles suspended in the water is an effect called "scattering" and the result is a lack of contrast, poor visibility and a flatness to underwater pictures. Another difficulty for the photographer who desires color pictures is the color of the water itself. While water may look the same to the uninitiated eye there are subtle variations that require filtration to make the picture look normal. Tropical waters may be blue-green or yellow-green and mountain streams or lakes may often be a muddy brown. The reason for this is that water is one great big filter and not only cuts down on the light, but filters the colors coming through from the surface. The other problem of underwater photography, the absorption of light, is another dif-

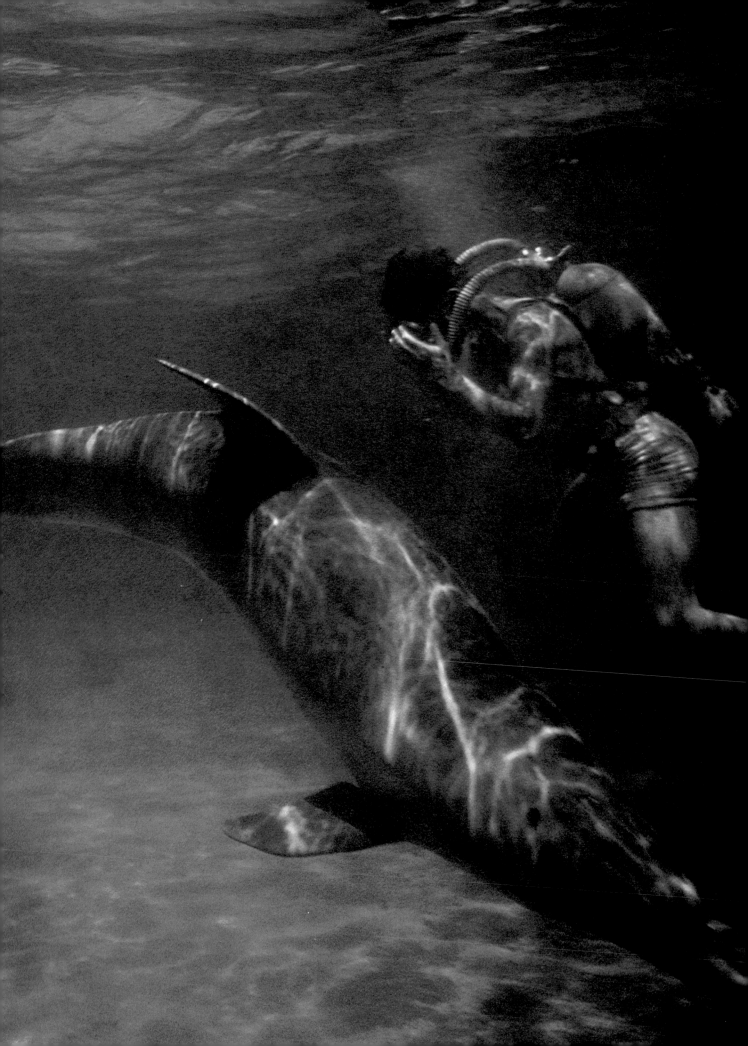

Trout photographed at Colorado's Ranch at Roaring Fork with Nikonos camera. High Speed Ektachrome film (daylight type) and CC30R filter.

ficulty to be faced. Under such conditions a wide-angle lens should be used since it will enable the photographer to get closer to his subject. There is another reason for the wide-angle; light refracts as it passes through water, the glass of the lens and the air on the surface above, and the result is a shortening of the focal length. In fact Nikon introduced a 28mm lens specially formulated for underwater use only. It eliminates these problems and the wider angle permits accurate focus. With a regular lens if it's set for, say, eight feet, it will be in focus for six feet. While the depth of field of wide-angles almost always eliminates this problem, the newly designed underwater lens solves them precisely.

While we've been concerned with the ultimate in bad conditions there are also some exceptionally lovely days, particularly in the Caribbean or South Pacific islands, where the surface is calm, the sky is cloudless and there is only the gentlest movement under the sea. Even under such perfect conditions some filtration is necessary for color and black and white. Black and white will require a medium yellow for contrast and color, depending on the color of the water, will require the red or magenta filters. Incidentally, these work with movie cameras as well.

What are the best films for underwater photography? I stick with two, Ilford FP 4 for black and white and Ektachrome X for color. The Ilford film is reasonably fast, has exceptionally fine grain and gives excellent negatives. Ektachrome X can be pushed a stop without too much increase in grain. Panatomic X (ASA 25) is excellent with good light, Plus X Pan (ASA 80) has more contrast which can be used to advantage underwater. The faster film, Tri-X, should only be used when light and visibility are poor since it delivers grain that looks like sediment in underwater pictures. The yellow filter for black and white films will add contrast, but it won't penetrate haze. Some photographers who specialize in underwater photography like the effect of the red color correction filter with black and white emulsions. Admittedly these filters do increase contrast, but they also darken open areas and give the effect of nighttime pictures taken underwater. It's a matter of personal preference. I don't care for the results and leave it to the individual to try both and make a choice.

Rolleimarin camera, CC20M filter. Exposure by underwater meter.

Nikonos camera and CC30R filter.

Part of series showing underwater escape from boat taken with Hasselblad camera in marine housing. CC30R filter to correct color and Ektachrome X film pushed one stop in processing.

Shooting against the sun with a deep red filter adds drama to any picture.

145

Trying to get a correct exposure underwater can be a nightmare even for the most experienced cameraman. Light conditions are constantly changing, depth will make it more difficult and the picture angle will even add to the problems. The slightest surface breeze will cause the water to ripple and dance causing shadows to flicker about underwater. An automatic electric-eye camera will help since it eliminates a constant check for exposure and the time taken to move controls for adjustment. A camera with built-in light meter, assuming the controls can be adjusted underwater, will also help. In spite of my enthusiasm for the Nikonos II it does lack a built-in meter, but its ease in use helps balance this handicap. If the photographer intends to seriously pursue this underwater world an underwater light meter may be purchased; they cost about a $100, and can be a great aid in obtaining the correct exposure. For the occasional plunge a regular meter, set inside a Mason or pickle jar with a rubber washer as a seal, will also work. The best meters for this type of photography are the direct reading type since the needle will constantly fluctuate with ever changing conditions. A rough guide is to take a meter reading topside, then open the lens by 1/3 for underwater pictures.

Should the purchase of an underwater housing be contemplated for a topside camera try to select one that permits placement of a light meter near the front of the case. This will eliminate one more object to carry or dangle about the person when trying to concentrate on pictures in a foreign element.

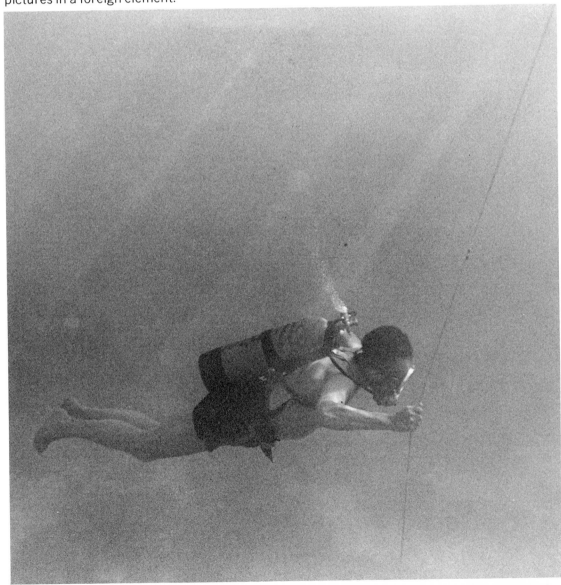

Showing the effect of sediment underwater. With undersea conditions such as these, it is useless to attempt photography.

Taking successful underwater pictures requires more than pulling on flippers, strapping on an air tank and jumping over the side of a boat. Camera angle is even more important underwater than it is above the surface. Care must be taken to position the camera just right to take every advantage of light and the beginner will soon realize Flip Wilson's adage, "What you see is what you get," doesn't always hold true underwater. It soon becomes apparent the eye sees color and objects sharper and truer than the lens. The eye also has the ability to see further underwater and cameras are frequently unable to distinguish, be selective and record objects at the same distance. The deeper the dive the greater the difficulty with light, the harder it is to clear ears and longer decompression times may be required.

The novice might do well to adapt the Latham theory and that is once my head is underwater I take pictures. Over the years I've had reasonably frequent requests for underwater photographs as part of a travel or adventure assignment and I feel it's unnecessary to dive deep, unless I'm doing a story on frogmen or a wreck, because the deeper the dive the more complicated photographic problems become. Usually I seek out some nice sandy beach that slopes gently into the water. I try to work at ten or fifteen foot depths since it eliminates the need to bring lights under, the sandy bottom reflects light upward, the photographer and subject can work in comfort and a CC20M or R filter allows reasonably high shutter speeds with color. The most successful angle is with the camera at the same level as the subject. Don't shoot down since pictures taken from this angle usually look flat. Upward is all right, especially if there is backlight since it will make the picture more striking. With marine life, fish, coral formations and plants in the foreground all add depth and give a more natural appearance.

The angle of the sun is also important, and can often preclude bringing artificial lights under, so try to shoot when the sun lies roughly 30 to 45 degrees over the horizon. If the day is bright it will punch in light giving strong contrast and shadows. When it moves lower it allows back lighting for more impact. The landlocked photographer soon forgets that under water there is continual movement from constantly flowing currents and both the cameraman and subjects are always drifting about to some degree. That is the most important reason for higher shutter speeds. But with the first few rolls of film the newcomer will soon realize this is quite a different world.

Marine life offers another fascinating subject for the underwater camera; often, however, closeup attachments must be used to allow macrophotos to be taken. With this closeup equipment there are situations that call for additional lights. This can be solved fairly easily with underwater flash. The miniature strobes are ideal for underwater lighting, but there are so many on the market we won't discuss each unit, but feel it more help to cover the various characteristics available to the buyer. While the smaller size may be more appealing, don't be influenced by this completely. If a strobe unit has to be packed there are also underwater housings, extension cords, flash arms, various connectors and batteries. The power output of the smaller electronic flash unit is weaker than the smallest flashbulb, and while they are accepted for pictures on the surface, they also make an excellent prime light for underwater closeups. The power supply is either a rechargable Ni-Cad battery or small AA penlight batteries. The Ni-Cads are limited to around 60 flashes while the AA type may run several hundred. In foreign locales, where it might not always be easy to recharge a battery, the penlight cells are the better choice. With the recent excitement caused by introduction of automatic-exposure-control electronic flash, what is the result underwater? Not good! Above the surface the built-in sensor detects the light reflecting back from the subject and works beautifully, but the theory is defeated underwater due to light loss, false reflections from scattering and the inherent low power output of the units themselves.

Some units have an accessory camera-mounted sensor and if this unit can be placed in the housing it may work, but some experimentation may be required on the part of the cameraman if he feels automatic exposure control is the only way to go. Otherwise use the cutoff switch and run tests with the unit on manual.

Beam angle is another factor that must be taken into consideration when using electronic flash underwater. The beam angle, or the angle of the light, was calculated by the manufacturer above water. When the unit is placed in a plastic underwater housing, and the flash

Tri-X film and medium yellow filter to give contrast.

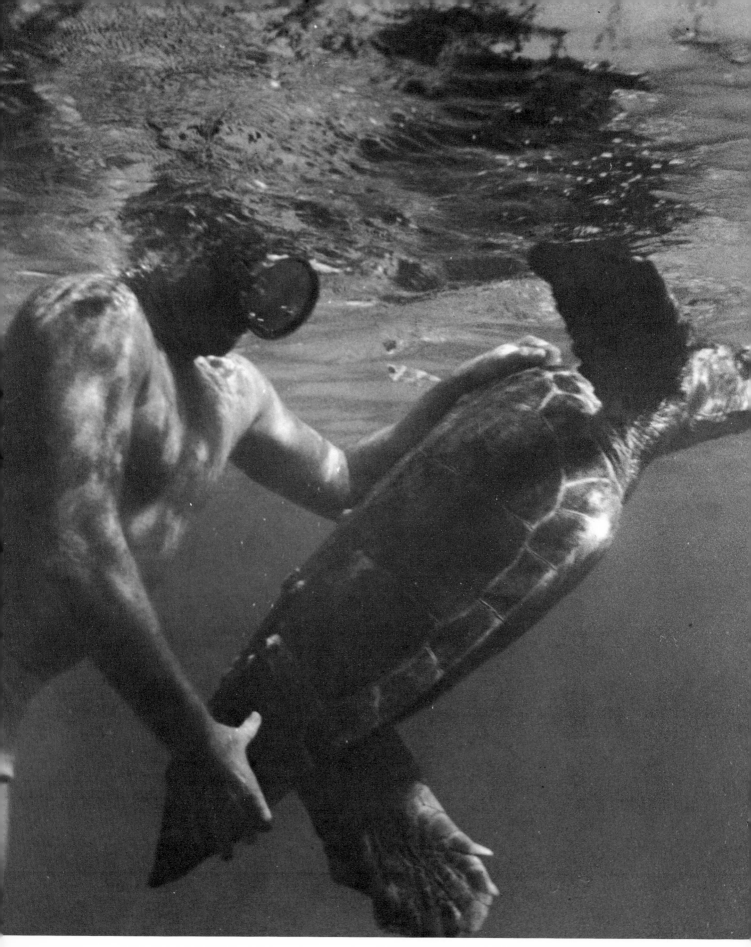

Capture of a sea turtle off the Bahamas. Rolleiflex camera in experimental underwater housing which began to leak after 20 minutes. Tri-X film and yellow filter.

directed through a flat port into the water, the beam refracts, usually about three-quarters and a 50 degree beam angle will refract to around 36 degrees. Plastic diffusers are available for the Honeywell units, some of the Vivitar models and other strobes. While they widen the light they also reduce light about one full stop. If possible select equipment that has a beam angle at least equal to a 35mm lens.

Light angle is also important. While many people fasten a flash directly to the camera it results in poor pictures topside, but this technique can be deadly under the sea. Underwater flash is usually held at a different angle than the camera, say 45 degrees, so the amount of light reaching the subject has less chance to backscatter causing a poor exposure.

The color balance of many units may be too blue since they were designed for daylight films. This bluish cast can be reduced and often eliminated with the proper filter. The CC20 or 30R or M must be placed over the lens for correct color rendition. Filter material, available at many camera stores, may also be placed over the face of the strobe (inside the housing) to hold back blue. If this is done, of course, the filter must be removed from the camera lens otherwise there will be over-correction.

The current batch of miniature strobe housings are tremendously improved over those available only a few years ago. Many have quick-release snaps, moulded construction and improved wiring, coiled connector cords and accessory arms and brackets to move the light a short distance from the camera. For the latest information it's best to consult the nearest dive shop or write directly to the manufacturers:

Ikelite U/W Systems, 3303 N. Illinois St., Indianapolis, Ind. 46208

Oceanic Products, 814 Castro St., San Leandro, Calif. 94577

Sea Research & Development, Box 589, Bartow, Fla. 33803

What to do if the housing leaks? At times a small amount of salt water may sneak into the case and swish about the bottom. If it doesn't get on the camera (or strobe) no harm done. If the case springs a leak or a camera falls overboard dip it in a pail of fresh water, wipe with a dry towel and rush it off airmail to the nearest competent repair shop. The packet should be marked "wet camera" so it won't sit on the shelf awaiting its turn.

For those who are accomplished skin divers, undersea pleasures have already been unfolded; the newcomer has these delights awaiting him. Taking pictures beneath the sea, in spite of our precautionary tone, yields tremendous rewards and a few simple rules will help in accomplishing the seemingly impossible:

1. Pick clear days.
2. Don't go too deep.
3. Always dive with a buddy.
4. Use filters.
5. Hold the camera steady as possible.
6. Try to use the highest shutter speeds.
7. Focus accurately.
8. Stay close to the subject to avoid poor visibility.

For most, the sea begins and ends at the surface, but endless boundaries remain. The diver's world is unlike any other; it is a venture into the unknown and a million discoveries are to be made.

PHOTOGRAPHY FROM AIRCRAFT

If the sea opens up new vistas for the photographer, aerial pictures offer as much excitement. Photographing from aircraft can be as great a challenge as diving into the ocean and, in fact, the alert photographer will encounter many of the same problems. Haze can't be avoided and is always present to some degree in the atmosphere. It exerts a misting or veil effect and requires the use of filters to overcome it. While black and white films have a tendency to give negatives of low contrast, color will turn exceptionally bluish. Don't make the mistake of thinking that because panchromatic films are used, which like the eye are sensitive to most colors of the spectrum, it will reproduce the subject as the eye sees it—no such luck. Unfortunately, under aerial conditions the film is far more sensitive to blue and violet light and, worst of all, extremely sensitive to invisible ultraviolet. Filters must always be used, even on the

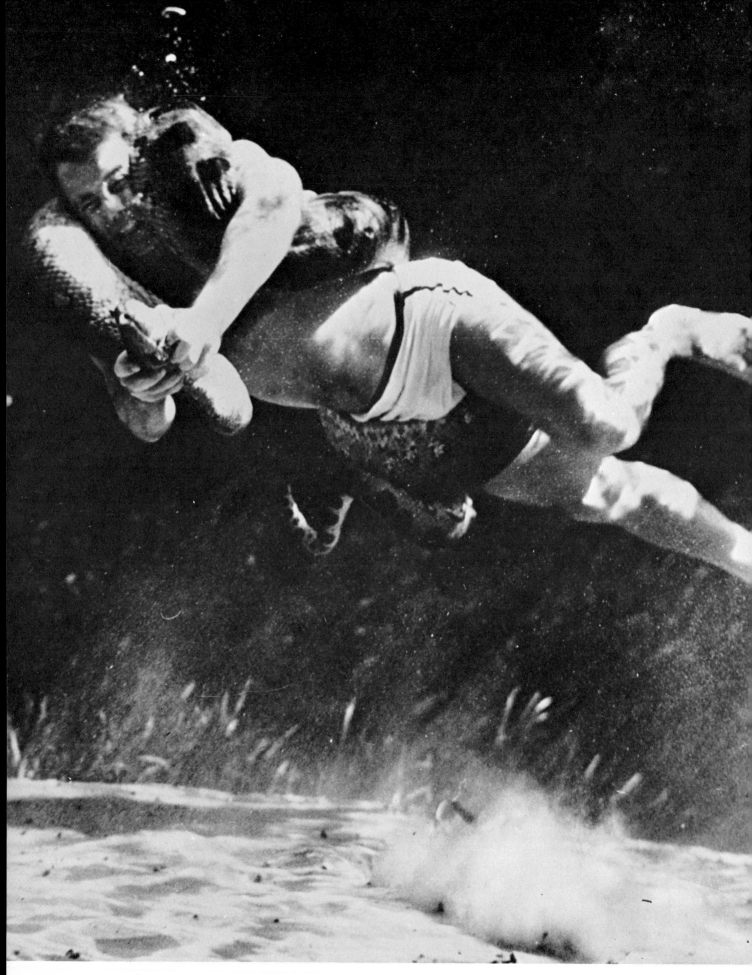

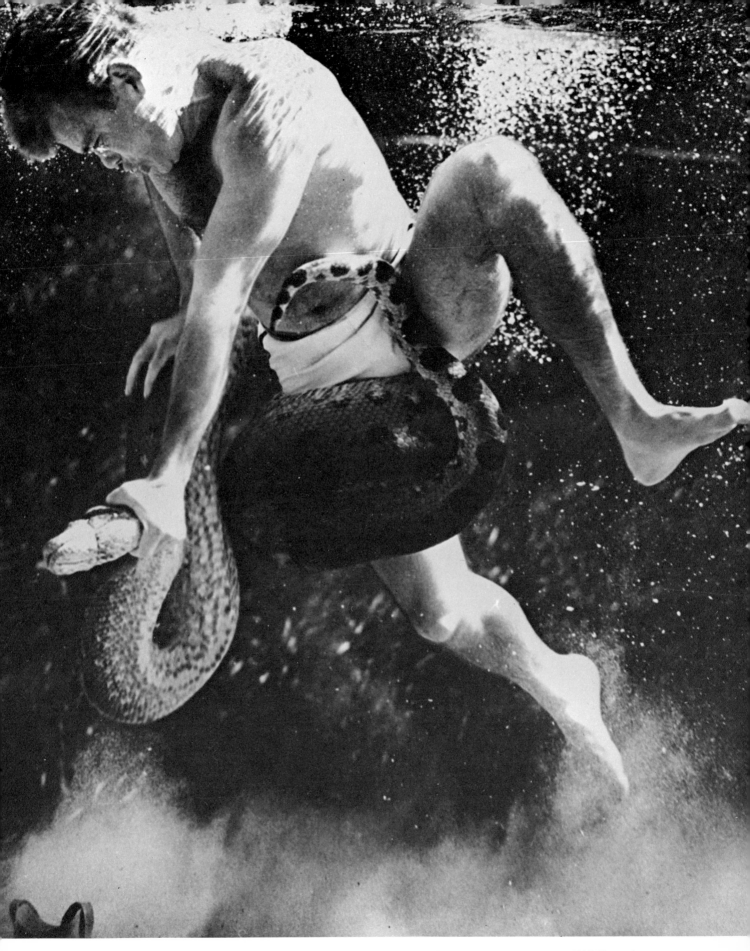

Underwater capture of an anaconda taken in a tributary of the Amazon with Rolleiflex in underwater case. Tri-X film and medium yellow filter. Exposure by Seconic underwater meter.

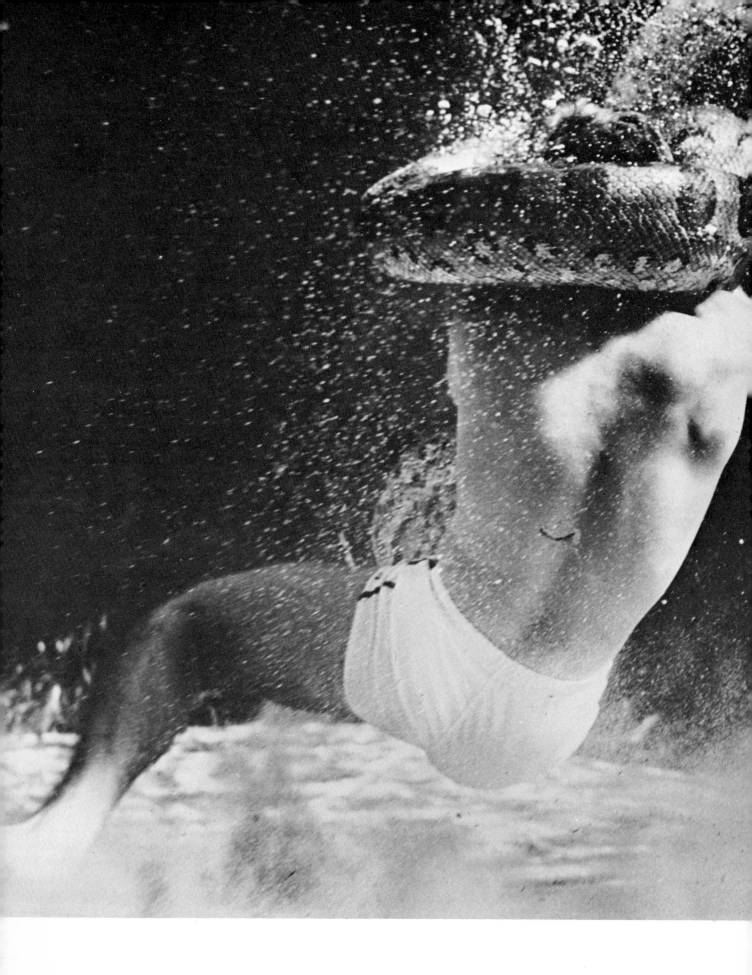

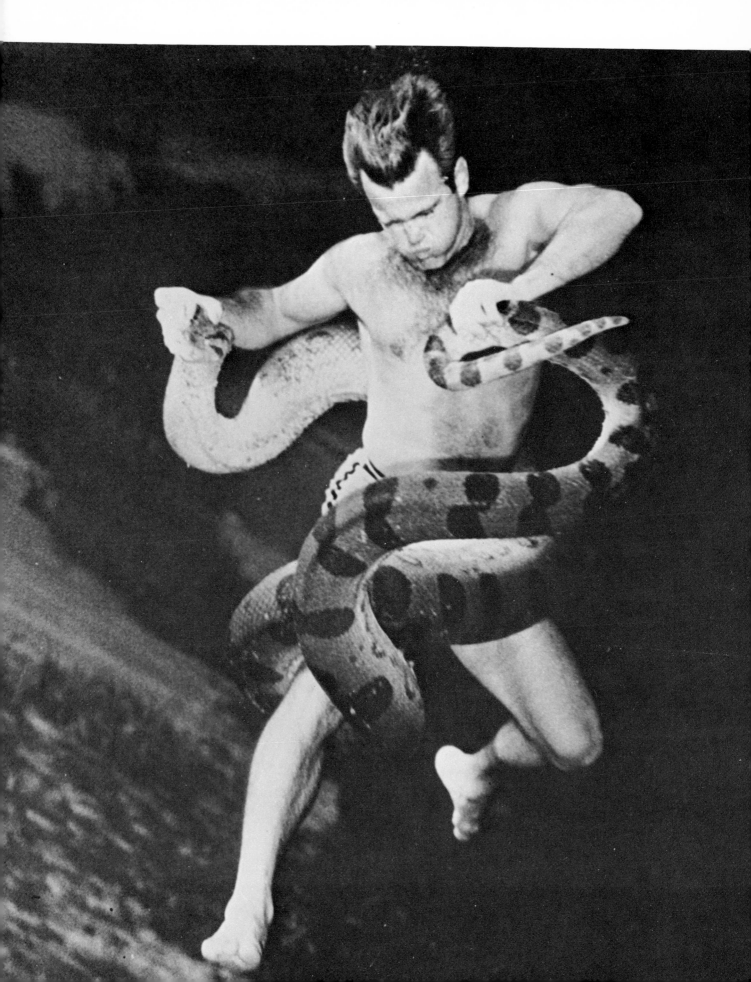

Ronny Lightbourne catching a sea turtle heads for the deep. Rolleiflex camera in underwater box. Tri-X film and yellow filter for underwater contrast. Picture taken near Nassau, Bahamas.

Heading upward, Lightbourne keeps a firm grip.

A tired catch and captor.

clearest days, to obtain good results.

For black and white films the yellows and reds are the answer and the minimum for color is Skylight.

Again a 35mm camera is best for this type of photography since it is light and easy to handle. The focal length of the lens obviously depends upon the altitude being flown, but I have found the range between 85 and 105mm ideal and occasionally go to the 135mm as well. In fact there have been some excellent results taken with nothing more complicated than the Instamatic type of camera and the prints have been astounding. Focus, of course, is simple; set the lens on infinity. Shutter speeds should be set at the highest allowable speed to cut down on vibration and sudden bumps. Rough air and vibration of the aircraft are two buga-boos of aerial photography. A motorized camera is a decided asset in taking pictures from planes and helicopters. If nothing else it allows the cameraman to concentrate on the subject before him and the camera doesn't have to be removed from the eye for winding.

But before clicking away from a flying platform prevailing light must be considered. If it's a day with deep blue sky and puffy clouds, ideal for aerial pictures, the light meter will probably give a higher reading than normal since meter readings from the air are influenced by haze and clouds. Consequently there are times when the indicated reading may lead to overex-posure. Flying in private aircraft, which are usually at lower altitudes, the best method is to point the camera toward the ground for a reading and then point it at mountains or other sub-jects to take the picture. At higher elevations point the camera toward the subject and bracket exposures.

With color film the Skylight will usually correct sufficiently to cut down on blue. If a stronger filter is required, and only experience can tell this, the UV will give greater correction and a Wratten CC15 will give even stronger results.

Oddly enough one of the most successful combinations to use in aerial photography is Kodak's Type A Indoor Kodachrome with the proper salmon-colored conversion filter. Why

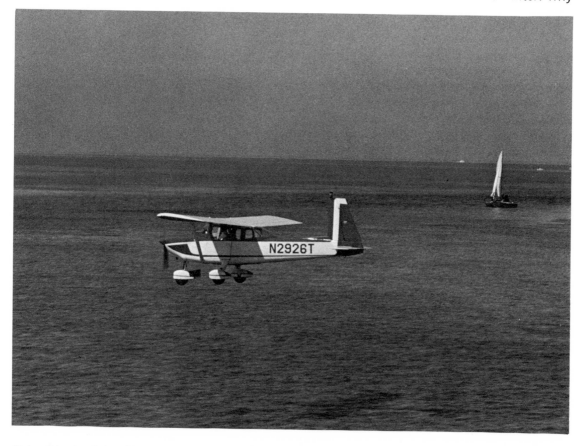

Flying at low level along Florida's Keys, a motorized Nikon with 43-86mm Nikon zoom lens was used to picture companion plane. Medium yellow filter and Ilford FP-4 film.

A deer count with New Jersey Conservation Dept. was taken with aid of a Navy blimp. Nikon camera and Tri-X film (due to heavy winter overcast).

should this be so? Because these films, ordinarily used with artificial light, give much better rendition of color in aerial views. The bluish haze is reduced considerably since the conversion filter absorbs much of the blue and ultraviolet scattered about. Remember, however, when indoor films are used outdoors the rather dense conversion filter lowers the film speed and the meter must be changed accordingly.

The best method of taking aerial pictures is to fly in a small private aircraft or helicopter. This may not be as impossible as it sounds. Very often sportsmen or other travelers find it necessary to fly into a Canadian hunting camp or private resort and the opportunity for pictures should not be missed. Most pilots are gregarious friendly folk and are usually willing to oblige the paying customer. If a door or window can be removed so much the better, but don't get camera or arms in the slipstream once in the air because it's too strong. Ask about the route to be flown. Are there scenic mountain passes, picturesque lakes or some other spectacular views? Suggestions should also be made to the pilot and, if he is a willing type, he may lift a wing or bank the craft for a better view. Don't make ridiculous requests since regulations must always be observed. I have always made it a point, particularly if I have an aircraft under charter for photography, to tell the pilot exactly what I want and how I want it. I'm then told what we can or cannot do and a compromise is reached. In that manner there are no sudden surprises and few disappointments.

The best time for aerial photography is much like on the ground; morning or late afternoon when shadows are long and well defined. Frequently early morning can be too much of a good thing. On assignment for Freeport-Indonesia in West Irian the choppers began warming up in the dark. During the rainy season there were only a few hours of daylight until the rains came. Since it was a sixty-mile trip over mangrove swamps and rain forest to the interior it was understandable the pilots wanted to finish early. With these conditions the pilots naturally wanted to lift off at first morning light. It was great for flying, but not for photography. It can be thrilling whirling over treetops at a couple of hundred feet, but the sun hadn't even begun to peek over the Ertsberg range in the distance. Another problem was the intense vibration from the chopper. This isn't a bother in bright light where high shutter speeds may be used, but with the meter nudging zero, even with high speed color, it meant exposures of 1/30th with the lens wide open. How did the pictures turn out? Well, a few pretty good and the rest, ugh! One particularly striking shot showed another chopper in the distance with the sun's rays just coming over the mountains. As I recall there were only three usable frames on the entire roll, but it proves photographic films have greater latitude than most photographers give them credit for. And it also makes sense to keep shooting, even when the meter doesn't read the light.

Flying in commercial airliners keep a camera handy in a flight bag or brief case. In the United States there are few restrictions on taking pictures from planes (use care overseas, however) and commercial aircraft pass over many scenic landmarks.

Glass and plastic windows can be troublesome since they are invariably dirty or scratched, but if the lens is moved in close (don't touch the window) it will throw everything out of focus in the foreground and help eliminate reflections. When boarding the plane try to request a seat toward the rear, far from the wings, and on the shadow side of the plane. A rough rule of thumb is going west sit on the right and flying east take the left. North or south depends upon the time of day and cabin attendants can advise on that.

Pictures taken inside the cabin may be exposed the same as those taken on the ground in the shade. High clouds will brighten the interior since the light is reflected inside. Natural light is best for color and black and white. Flashbulbs or electronic flash can be a bother to other passengers who may be dozing or reading and, in most instances, are forbidden since they can interfere with the aircraft's navigational equipment.

Takeoffs and landings offer some of the best opportunities for exciting photographs. Hong Kong's Kai Tak airport is one of the world's most spectacular and mountain views, harbor islands, shipping and mainland China can be seen in the distance.

Tahiti offers another memorable opportunity for pictures. Although many aircraft arrive in darkness, takeoffs are usually scheduled in daylight. Planes fly along the coast of Moorea and since it's so close to the airport cruising altitude hasn't been reached. The lush coastline with magnificent beaches, sailboats and outriggers plying the sea can be photographed with ease.

162

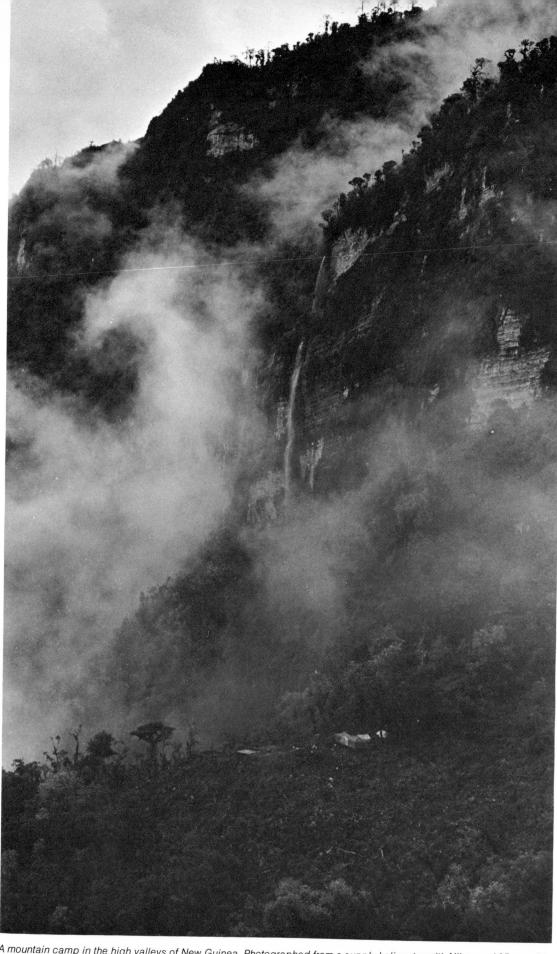

A mountain camp in the high valleys of New Guinea. Photographed from a supply helicopter with Nikon and 35mm wide angle on Tri-X film.

Deer tracks in the deep snow. Nikon and 85mm lens.

Aside from the usual run of films infrared color is worth a try when shooting aerial pictures. It is, at best, a most unpredictable film, but the unusual results are worth the effort.

Let's look at some of the results with this film. Without any filter grass is deep pink, mountains purple and the sky a pale pink. Place a deep yellow filter over the lens (No. 15) and the grass turns a deep red, mountains and fields green and the sky blue with a greenish cast to it. It's also possible to combine a Polaroid filter with the yellow for even more dramatic and "exotic" results. There may be a slight darkening of the corners when using two filters, but it works and that's the important thing.

The full name of this interesting emulsion is Ektachrome Infrared Aero and I won't apologize for not giving more pertinent information. The ASA speed runs from 40 to 100 dependent upon the density of the filter used. While bracketing exposure is important with all exposures it becomes a necessity with infrared film. Exposures should be taken at increments of one full stop both above and below the estimated meter reading.

Black and white infrared film gives interesting results without the more drastic changes of the color emulsion. The prime characteristic of infrared material is its ability to penetrate haze, often beyond the range of the human eye. Pictures taken with infrared emulsions have a striking appearance. Skies and water appear almost jet black, leaves photograph silver-white

164

and clouds stand out like piles of cotton. It should be noted, when using infrared emulsions, the infrared focusing mark on the lens must be used and focusing tests made with some distant object before taking an important picture.

Filtration should be with a Wratten A filter and it can also be used with regular black and white film. Incidentally all black and white aerial film should be developed to a slightly higher contrast than is usually normal, either by increasing the developing time or using a contrasty developer. If an outside lab is used advise them when aerial film is brought in for processing.

If taking pictures from the air presents its own set of unique problems, as with underwater photography, it should be remembered that modern films and cameras have made the photographer's life a lot easier than it was only a few years ago. There are no short-cuts to proper control and while the stress has been on accuracy some experimentation is necessary in the worlds of sea and sky.

CHAPTER 9

A Short Talk About Movies

To many it might appear that all that is necessary to make a good movie is set up the camera, focus sharply and obtain a proper exposure. Even for a rank amateur the qualifications are slightly more demanding than that. Sure, it's fun to point a camera at a youngster, let the automatic exposure control take over and just press the button. But, as with still photography, there should be some knowledge of lenses, an understanding of filters and what films will do under certain lighting situations.

Small movie cameras, once a home medium, are now important enough for TV news, industrial films and instructional movies. Super 8 size and upward features enough advanced hardware for the most serious filmmaker. And whatever the use—businessman, traveler, outdoorsman or sports fan—the tools are here for more satisfactory filming. Unfortunately, for many, the disparity of what was taken and what comes back from the lab is just too great. They feel let down, cheated, like the kid with a windup train that soon breaks. In a world that is constantly rushing helter-skelter and almost everything can be had instantly, experience isn't one of them. Why should the first 100 feet of film be any less wobble-free than the first downhill run on a new pair of skis? In fact the first couple of rolls run through the camera will probably pay dividends later on when many mistakes are ironed out.

Not everything has to be learned in five minutes so take time to study the camera until every function of knobs, buttons and dials are understood. Learn what batteries run the motor and those that work the meter—where they are located and how they are charged or changed.

Learn how the camera is loaded and held and if the insertion of the cartridge tells the meter the speed or if a dial must be set manually. Even practice "filming" without film, but be certain to follow the manufacturer's recommendations on filming speed limitations with an empty camera. Follow youngsters dashing about the yard or a dog running down the street. Try following focus and watch the horizon line of the finder. And don't try to pack everything seen into one view like a radar screen scanning the horizon for enemy planes. There are frustrations faced in trying to show everything when, in fact, nothing is shown. It was once felt when a cameraman made the transition to a Super 8 or 16mm camera he was moving from dull record shots of birthday parties and vacations to photographic greatness.

Well, it isn't always true, but he had better learn pretty darn fast because the audience will head for the nearest bar to relax frayed nerves. The advent of Super 8 equipment with single or double system sound, fast lenses for available-light pictures, built-in exposure systems, macro zooms, fades, dissolves and all the other costly appurtenances of larger cameras let a cameraman with a small, but not miniature, piece of equipment carry a movie camera on any journey. What he records may be dull or exciting, but the world of cinematography is truly without equal for picturing the glamor and thrills of the most exciting world of all—the outdoors.

167

Taking movies: first introduce the subject and show viewers what is happening.

While the professional filmmaker constantly works with motion the amateur, less experienced, seems to find this the most difficult task of all; simply making movies that move. In one respect that's not really true because they do have movement, but it's the wrong kind. Jiggles, jounces and all the undulating quivers of a Cairo belly dancer. But this is accidental movement and can be controlled by using a tripod or learning to hold a camera steady. The movement of the camera itself frequently lends interest and fast cuts, swift pans, choice of subject and careful composition are only some of the variables that may be introduced to move a picture.

What about hardware for all this? Some cinema cameras, like many of their still counterparts, have limitations, but most modern movie cameras in Super 8 or 16mm will probably offer more than their user's ability can handle.

Lenses are a good example. Ted Devlet, a prize-winning commercial filmmaker in New York, has strong opinions about lenses and the zoom in particular. "The zoom is a perfect example of a misused lens. It offers a compact size and a variety of focal lengths, but it must be used with a light hand. Every tyro who first uses a zoom makes the audience seasick with continual zooms. They think it's a lovely toy and it goes 'zooomm' and 'swiish' and every sequence resembles a poor man's roller coaster in Cinerama. As an experienced director and cinematographer Devlet feels the zoom should be used to (1) segregate a situation or, (2) reveal a situation.

A simple example of this would be two men talking about a fine gun. There would be a tight closeup on the head of one man talking, then the lens would slowly zoom back to reveal a handsome shotgun held by the speaker. The zoom is held and also reveals his friend who reaches out for the gun. Another example is a visit to some marketplace in Santa Fe or Denver's Old Town. Shopping with a friend there would be a medium wide shot to establish the locale then, very slowly zoom in, to feature the subject looking at some unusual artifact. Another aspect of the zoom is its ability to either set the pace of a sequence or help build a mood. If the subject is immediate—zap fast. If it requires a more tantalizing approach move *s l o w l y*. A good filmmaker can do a professional film with zooms and the audience will never be aware it was used. That is the ultimate.

Another common error is not taking enough footage while filming. The film usually resembles a series of quick snapshots better taken with a still camera. Charles Halgren, president of a graphic arts service in New York, is an experienced traveler and hunter and carries both still and movie cameras on worldwide hunts. Charles admits, however, while the scene looks great through the camera's finder he doesn't expose enough footage to edit properly and this is a habit he's trying to break. "The sequence goes too darn fast when it's projected. It's gone before I realize it and I have to yell, 'That's a diving eagle.' " There is no other solution except to hold footage and gain sufficient length to enable a complete editing job. It's better to have too much, since the film must be cut unmercifully anyway, than too little and wonder what to do.

Movement, as we mentioned earlier, is probably the greatest problem with amateur filmmakers. Too often cameras are pointed toward subjects where there just isn't any movement at all. We've all seen people pick up a movie camera and expose footage of their wife or friend sleeping on a chaise lounge? Where is the movement? How about someone kneeling by a lion, with rifle in hand and squinting into the camera? Wouldn't it have been better, and just as easy, to have the subject walk toward the lion, lean the gun against the trophy and examine the huge head or paw. Then slowly zoom into the pug, cut to safari cars moving into view, closeup of skinners sharpening knives and long or medium shots of other general activity. Then there would be movement and interest.

Motion is the most important part of any movie and if the subject doesn't move then the camera should. While a motion picture can be made from any subject some have more inherent action than others. Movement doesn't have to be obvious. A gentle breeze may move leaves or branches or a tree framing a static mountain view. And if there is no breeze a friend can gently shake the branches or a string tied out of the camera vision may be tugged. A scene of a cabin can be static without people, but smoke curling up from the chimney will bring the scene alive. Pebbles tossed into a pond to create dancing ripples or rain falling onto a lake will all add motion.

Move back for a long shot.

Change the angle and take a medium shot.

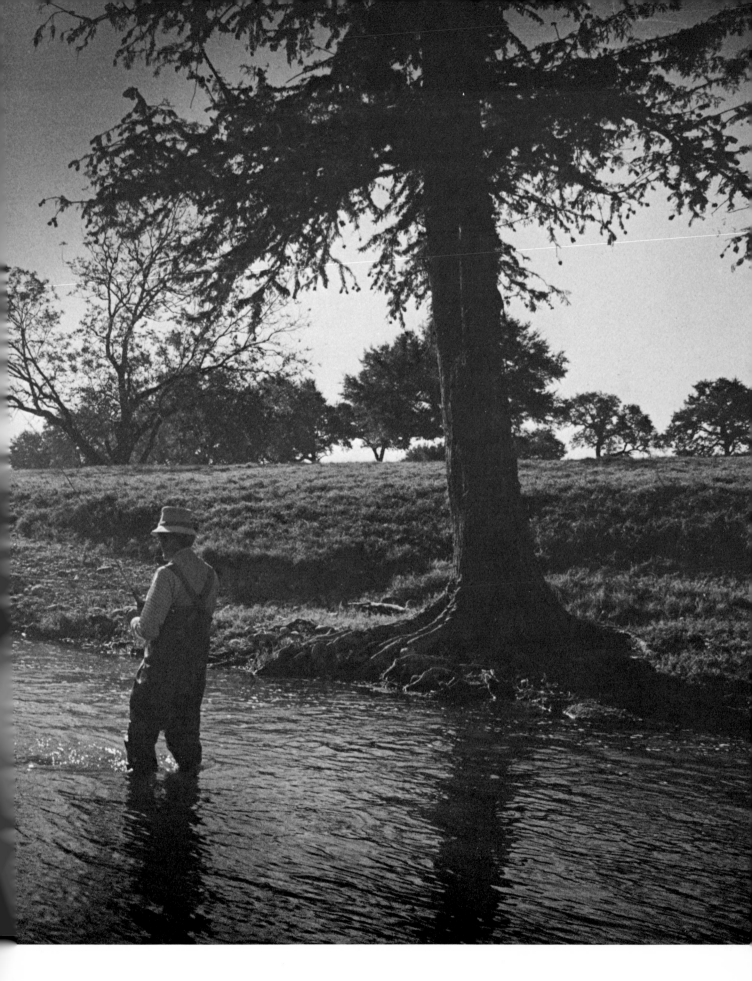

Move in for a medium close view.

The logical approach is to have people in the scene and it works if their presence is natural. If it is forced by placing someone near a tumbling waterfall, or a historical site for the sake of having a person in the picture, then the practice is questionable.

The other bit of having someone enter a scene, remove their sunglasses and glance about is not only old-fashioned, but artificial and out of place. Anything that distracts from a scene is bad because it will attract attention from what should be shown.

Placing people in a scene requires some thought. Are they natural and doing things that belong in that particular locale?

A sportsman cleaning a gun or even shaving with an old camp mirror works as well indoors as out. Even packing camping gear on the porch of a cabin is just as natural as working on a bunk indoors. But a woman combing her hair or putting on makeup while sitting on a log is unnatural and will look out of place. Subject movement that does not help to create a proper mood of what is being told should be tossed out before film is exposed because it will interfere with a smooth progression of scenes.

Winter scenes require extra attention to detail. Most nature is lifeless and is better pictured with closeups of frigid tranquility showing icicles or frost on the window pane. Selective focus or "rack focus" can be used here. An interior shot with tight focus on icicles framing the window, then slowly change or "rack" the focus to throw the foreground out and bring the exterior into view with someone nearing the cabin on snowshoes. A scene such as this tells the viewer it is winter, a rack focus shot will add interest and a hiker on the trail gives action.

Of course movement doesn't always have to come from a tightly composed foreground. A medium shot of a fisherman casting will give some action. It can be improved if it's framed through branches and made better yet if the right camera angle is chosen. With back light or side lighting sparkles of light will dance across the water and make the scene more exciting and professional.

The basic camera angle, and lines within the frame, all play a part in the sensation of movement. Continual vertical and horizontal lines tend to make a scene static while diagonal lines imply action. A tilted camera is often used to impart confusion and disturbance and moving lights can contribute movement to a stationary object. Car lights flashing over a person's face or a campfire flickering work well.

If a zoom lens is used a 'dry run' is advisable since it will allow the cameraman to view and frame the subject before film starts running. Choice of lens is also important. While various focal lengths may be used for an identical scene each will present the scene in a different manner. The amount of movement can also be varied by the correct selection of a lens. As with still cameras the wide-angle offers a greater view and telephotos a narrower one. But whatever subject is being photographed the cameraman must learn to think in terms of a "master" shot. These master shots will show what's happening and then a series of medium and closeup shots will tell the story in greater detail. While many photographers don't care to move beyond a simple record shot, others require something more forceful in their pictures. Planning will enable the cameraman to do a more total job. Let's review events on a typical duck hunting trip. If these are taken in sequence, and the cameraman shoots it in chronological order, there will be less problems with editing. A series of shots might go like this:

1. Long shot of two men getting into boat
2. Medium shot of boat traveling toward duck blind.
3. Getting into the blind.
4. Closeup of loading guns
5. Closeup of petting the dog
6. Long shot of ducks flying overhead
7. Companion firing
8. Closeup of ejected shell
9. Medium shot of duck falling
10. Medium shot of dog jumping into water
11. Tight shot of dog grabbing duck
12. Medium shot of dog swimming toward blind

A tight shot to show the subject.

13. As dog nears shore camera is slowly zoomed from tight shot to medium wide to show hunter taking bird from dog

What has been accomplished is a series of long, medium and closeup shots. With imagination many other views may be added. For instance a wide-angle taken outward from the blind will show what the hunters see. If it's early in the morning, with the sun still rising, it will make an impressive scene. It also allows a natural transition for the camera to move gracefully on. All this is reasonably near what a professional film crew might do. The sequence has those three important ingredients; a beginning, middle and end with enough different shots in between to maintain pace and interest.

What of those other devices that can help in making a picture? Panning is one that is the most popular, but also the most frequently overworked method. To keep pans from becoming bores they must be executed with care. The mistakes are fast pans that make the viewer dizzy. Eyes can't adjust swiftly and they seem to be predominant among amateurs. Panning can show the dimensions of a great mountain range, but the camera should be set on a tripod to do this successfully. Transition pans to connect two scenes are fine and they may be used to build suspense by moving the audience with it

A good example of a transition pan is a shot of a quail flying away with a fast pan to the cha-

Take a closeup of hands tying on a lure.

178

grined face of a hunter or a leaping trout to the happy face of a fisherman. The transition pan is particularly effective if it begins with a blur and pans to rest, the other begins with a static subject and ends blurred. Either are great for tying two scenes together if the subjects are related to each other. There are no stated rules for panning but usually pans with a wide-angle lens can be done more swiftly than those with tele lenses.

There is nothing wrong with moving the camera either. It will give the audience the feeling of being in the middle of action. Dolly shots while on roller skates or sitting in a small cart and the various rides of an amusement park will add excitement, or a waterproofed camera while riding water skis are all excellent ways of imparting movement to a camera. Such techniques shouldn't be overdone, but handled properly will add professionalism to any film.

The various filming speeds available to the creative photographer shouldn't be completely ignored. Low speeds give the jerky effect of old-time movies and higher speeds will give a slow motion, dreamlike quality to the footage.

Angle of filming is also important. Don't be afraid to get dirty and get down on the ground if it offers a more interesting angle. Going high is also good and don't hesitate to shoot from a high window or the tailgate of a station wagon. The change in view adds punch to pictures and, very often, brings more drama to the scene.

Lenses, as with still cameras, offer the opportunity of doing the unusual. Unfortunately many newcomers began with a zoom and have never used anything else. They have forgotten that different focal length lenses are primarily used for creating the most effective image. Too many zoom shots are ineffectual because the lens zoomed in tight gives just another view of what has been shown before. It's a waste of time and film. Let's look at a wide-angle for a moment. On holiday with the youngsters visiting some Western town with horse and wagons. With all the atmosphere about, some photographers plant themselves firmly as though they were resisting physical change—and shoot. A better picture might have resulted if the youngsters had been set in the foreground, the camera placed at ground level with the lens set at its widest angle. Then, as horses and stage coach come lumbering down the street begin filming. Let the subject come into view, move past and out of the picture. As for longer lenses the 150mm would be excellent and something even longer, if the cameraman can afford the luxury, would be ideal. Long lenses give the opportunity of segregating the subject and add interest with foregrounds and background thrown out of focus. Long lenses on a movie camera can be difficult to focus, but practice will help. When the youngsters are running about the yard playing is an excellent time to take the camera out and practice focus. Keep checking the focus ring to see how well this exercise works. There is no short-cut to quick focus and it must be done until the knack is acquired.

This search for perfection will pay off, however, when the sportsman is trying to photograph game and grazing animals constantly drift in and out of focus. This new-found skill of keeping in focus, and getting all the magnificent detail these longer lenses can deliver, is of prime importance to the nature photographer.

Filters are pretty much the same for motion pictures as they are for stills. The Skylight is the most widely used since color is predominant among moviemakers. The Polaroid will give excellent results and with black and white emulsions the red and yellow filters give much the same results as they do with stills.

As to film ratings professional cinematographers aren't that locked in with film speed ratings as the amateur. They do have greater latitude with processing, due to the emulsions used, and the amateur filmmaker might also consider shooting when the meter needle barely moves. Sunsets are a good example and often spectacular effect can be taken when the meter won't even register a reading.

Indoors the best lighting is still bounce. It's easiest to use and will give even exposures. If the proper lights are used color will be true. Quartz-Iodine lights, particularly the small units, are compact, easy to pack and throw an exceptional amount of light. In a normal size room two lights are about the limit due to the danger of blowing fuses. Even then it's a good idea to check the lines and not plug two lights into the same outlet.

A handy item to have when taking movies is a roll of Gaffer tape (obtained from most big city camera stores or professional movie supply houses). It may be used for taping up white

Frame the picture for added interest and run sufficient film to allow editing.

Change angle and frame again.

sheets as reflectors, sealing film tins, taping wires to walls, hanging lights and even for emergency repairs to faulty cameras.

Perhaps the most important factor in taking moving pictures, aside from creative skill, is to keep the camera steady. With their small size, particularly the Super 8mm's, there isn't that much weight available to keep the camera from shaking. While tripods are heavy and cumbersome, and fairly inflexible in use, they are stable and the only way to insure rock-solid pictures. For pan shots it is an invaluable tool if the attempt is made with long telephoto lenses. Don't make the mistake of using a cheap, inexpensive tripod even with a small camera. It won't work and will only add to the photographer's woes.

There is another misconception about tripods when switching to movie cameras and that is any tripod will work. But a tripod made for movie cameras, with a fluid head, will work better. With this type of head the cameraman, especially on pan shots, is pushing against resistance (adjustable) of oil or other fluids which permits smoother pans and tilts. There are other methods of keeping a movie camera steady; baby legs which are shorter than normal and top hats that lower the camera to a few inches from the ground. None of these devices are cheap ($150 to well over $1000) so practice in camera holding might be the best of all.

As obvious as it may seem, read the camera manual thoroughly. The manufacturer often advises the best method of holding his camera, and the same company may also offer accessory aids such as anatomical grips which allow a more stable grasp of the camera. Holding a camera firmly doesn't mean brute force since such action tends to tense muscles that can result in jerky movement-producing gigantic jumps projected on a screen.

In the open without any support requires that the cameraman become his own tripod. A few gurulike thoughts help. Plant the body solidly on the ground and literally think of joining the earth with a plumbline descending through the center of the body and being anchored to the ground. Experienced handgun shooters will understand this. Take a deep breath, but don't hold it in. Exhale slowly, but only part way—then hold it. There will be less tension in the body. Panning from such a stance will be smoother and less apt to wobble. In fact the body should face the end of the pan and not the beginning. The torso, from the hips upwards, is slowly moved toward the point where the pan starts. In this manner the body is slowly wound up much like a spring and then slowly unwinds as the pan progresses. This is a safe way to insure reasonably steady results, but should not be used if a tripod is at hand. The standard professional stance; with elbows braced against the chest may help. Others may find it too confining with a movie camera and prefer to have one elbow free in the breeze. Any object to brace the camera against is better than nothing. Trees, a vehicle, railings, an old fence, buildings or walls all give excellent support.

Filming speeds will also help in cutting down camera movement and, to a lesser extent, so will subject matter. Less movement will show in those scenes taken at wide angle and higher framing speeds will help to eliminate movement emphasized by long lenses. To some degree camera jiggle will be less obvious if the subject is fast moving. A rodeo with bucking horses and cowboys hitting the dust won't show quite as much movement in the camera as a graceful flight of geese gliding across a lake.

Unlike still cameras where high shutter speeds will minimize careless handling on the part of the photographer, the movie camera will record every bump and jolt. Professional filmmakers can resort to such devices as the gyro that permits shooting from aircraft, fast cars or boats, but they are expensive and usually beyond the realm of the amateur. In spite of the availability of such advanced equipment some thought on the part of the photographer will enable shooting under difficult situations and still obtain excellent results.

Working on the James Bond film, *Thunderball*, being filmed in the Bahamas, I was assigned aerial photographs to be taken during a boat chase. With two helicopters on hand only one had the proper camera cradle to eliminate vibration and this, of course, was assigned the cinematographer. Regardless I strapped myself into the waiting chopper and we took off. Since the doors were removed it make my task fairly easy. I braced my feet on the steps, kept elbows and body away from the door frame, cradled the camera carefully and allowed my body to move with the chopper. With pardonable pride I must confess the pictures turned out fine.

Start tight and slowly zoom back as an ending.

One aspect seldom mentioned to amateur filmmakers is the fact that slating or identification of each roll is a must and makes life easier when it's time to edit. Exposing a half-dozen rolls on a trip can become confusing when everything comes back from the lab without sequence numbers. A small slate and piece of chalk will work wonders and keep hair from turning gray months later. Before beginning a roll, number the slate and run a couple of seconds of film through the camera. Put the same number on the tin or box and even keep notes of what went on the film in a small notebook—it helps.

A few of the technical areas that may aid the aspiring cameraman are: transition or the way film moves from one subject to another. The quick method is a straight cut when editing. Another is the professional way of including a series of fast cuts that maintain a quick pace. Fades and dissolves are used to imply a lapse of time, or a change between two scenes. But none of this amounts to much unless each scene is cut to the correct length. The photographer can put in every bit of technical skill at his command, have beautiful color, accurate focus, the right movement, pans, dissolves, tricky angle shots and judicious zooms and it can still add up to a boring effort if it isn't paced right.

An audience expects a movie to move and it must or the viewers will be lost during the first few moments of screening. Longer scenes must be tightly cut and enough film must be exposed so editorial skills have the opportunity to come into play. One fast scene won't do it, but the continual flow of fast moving scenes will and one of the ways to accomplish this is to eliminate unnecessary scenes. It's cruel to cut lovingly taken footage and difficult to ruthlessly snip away at our own efforts, but it's the only way to trim excess footage and end up with a tightly paced film.

Bear in mind that as soon as an audience has seen everything once it's redundant to keep hitting them in the face with the same scene. Out of focus and poorly exposed sequences are also out. There is no excuse for these and verbal excuses only lessen impact of the good that is shown. Don't have too many long scenes either. Break them into shorter footage, do different camera setups from different angles. While total footage may remain the same, and run the same length of time, it will screen more vividly because of the constantly changing view. This is one reason why swiftly cut scenes impart more motion than too many pans or zooms which are, really, nothing more than one long scene taking forever to unfold.

Even closeups should be broken up with short takes. What may appear slow can be paced swiftly. A simple sequence of loading a shotgun would have a hand removing a shell from a case, change camera angle and show fingers holding the shell moving toward open breach, switch to offside of gun and have shell being loaded. None of these scenes have to be long, just a few seconds each, but they will add action and put movement in the picture.

A particularly effective professional technique that may be adapted by anyone is the freeze frame. This is done electronically in television or by optical printing houses that specialize in film special effects.

It is the scene that starts with a stationary subject that suddenly begins to move or a moving subject that suddenly freezes on the screen. Imagine beginning a film on Africa that shows a charging lion or elephant and suddenly the animal is frozen and the titles appear? Not difficult, if a modest amount of skill is used. There are two ways of accomplishing this. The first method requires the use of a copying or macro device that enables the particular camera used to copy film frames. If this is available just set the frame of film in the copying device and run film of the same type through the camera for as long as the freeze is desired.

The second method is just as simple. Have a color print made of the desired frame and then copy it with the movie camera. This is especially striking and all the more so since it is unexpected in an amateur film. It is guaranteed to be an audience grabber.

A fast moving film will hold audience interest and the skills of the cameraman will make it all the more stimulating. Continual experimentation will do much to improve these skills and give greater knowledge of cameras and films. And the best advice of all: know the rules and then toss them away.

CHAPTER 10

The Sportsman's World

The sportsman's world is vast indeed. So vast that many are tempted to overlook nearby woods and mountain lakes. True our thoughts are often of towering mountains and Arctic tundra or some far off salmon stream in Norway or Newfoundland, but there is much that is frequently passed over in our own country.

Some of the finest bass fishing I ever had was only a short drive from downtown Miami. In Florida with Jack Samson, then doing public relations for Rockwell International and the late Oscar Godbout, outdoor editor of the *New York Times,* we had just flown up from the Ocean Reef Club near North Key Largo. We had spent the weekend deep-sea fishing without too much success and felt there was enough energy left for casting a few more lines. Sitting around a swimming pool near Miami International Airport I suggested we go to the Everglades and try for some bass. Samson looked up with a grin and said, "That's using the old noodle," and Godbout, showing a nicety with words that became a *Times* writer, simply grunted and stood up. A short drive along the Tamiami Trail, a couple of stops at the numerous Indian villages to inquire about airboat rentals and we were soon racing across the tall sawgrass. Within a very few minutes the three of us were casting into the canal and pulling in bass that seemed to strike at anything that was tossed at them. As I recall, the boat and guide cost us about $25—that was a few years ago and prices surely are higher now—but it was one of those rare and memorable afternoons that simply refuse to fade from memory.

Any sportsman who may be spending a holiday at one of Florida's resorts near the Glades and, who, perhaps, may have become blase about deep-sea fishing can get a quick recharge from a few hours spent in the solitude of the Glades. Most think of the Everglades, if indeed they ever give it a thought, as a wild wilderness crawling with reptiles, alligators and all sorts of creepy things. Indeed it is, but it also has a great, strange beauty and teems with herons, cranes and hungry fish. The Everglades is part of a wildlife environment where man can be overwhelmed by the opportunity for sport or, quite simply, getting away for a few hours of peace and quiet.

There is little specific information about where the Glades start and stop, but the generally accepted figure is roughly 2700 square miles for the entire area. It is a world of tangled mangrove, sawgrass, twisted tree trunks and gnarled roots. Lakes, ponds, hammocks and enough twisting labyrinthine waterways to make the most woods-wise expert wish he had stayed in his own backyard. It is also the home of snakes and alligators, bobcats, whitetail deer, turkey, ducks and geese, and it would take a foolish man indeed to venture more than ten yards within its grasp without a guide. Near the Gulf is a strange world of mangrove islands and the coastal regions offer some of the finest tarpon and snook fishing to be had anywhere in America. While it isn't possible to catch a glimpse of the high rise buildings along either coast, it is still an eerie sensation to be in this empty land and think of the crowded beaches, busy airport and fancy hotels only a handful of miles distant.

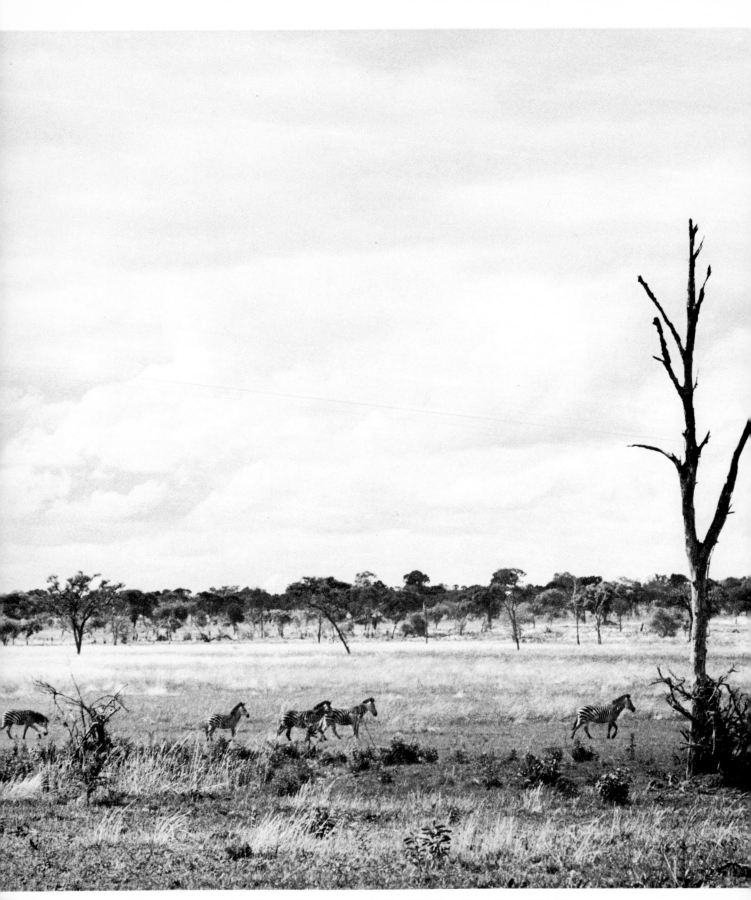

Herd of zebra on the plains of Kenya. Nikon camera with Ilford FP 4 film and medium yellow filter.

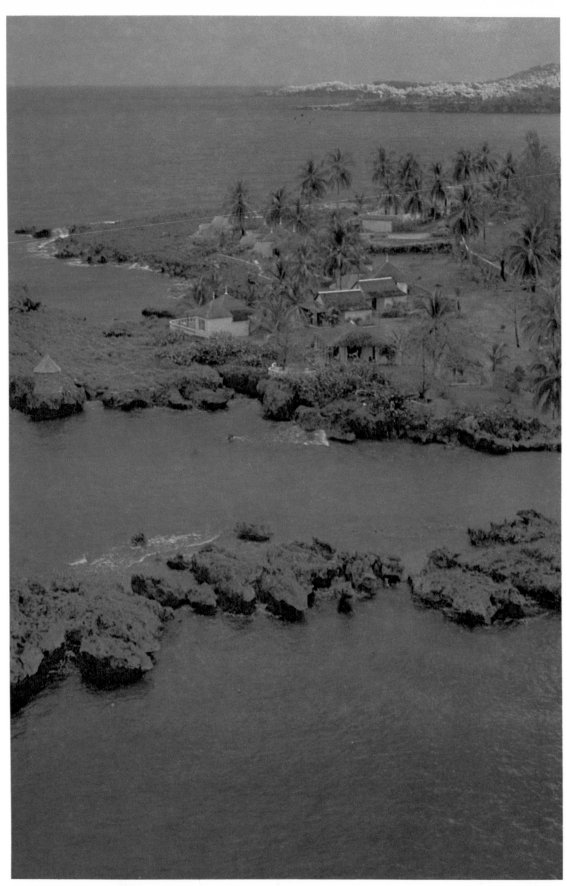

Jamaica as seen with Aero Infra Red film.

Perhaps memories do play tricks, but Samson and I have recalled that pleasant afternoon many times and still agree the bass were giants and the loneliness of the Glades, with an occasional plop of sound as a fish jumped or some small creature slid into the water, was one of the finest days we've ever had in the outdoors.

With the ever-increasing urban sprall cutting across our land, there are still many enclaves tucked away near some big city that offer a modicum of tranquility. Even near New York City, Bear Mountain Park reaches inland from the Hudson and becomes a land of trails and lakes. Of course the well pictured mob scene on the lawn of the Inn there is enough to turn many off (and I can picture sneers curling the lips of some of my friends), but what of those lakes, hidden trails and great panoramas of the Hudson from some peak? True, few of those visitors wander far from the security of the stone buildings, but those who are willing to expend a small amount of energy and hike into the surrounding hills will reap the peace and tranquility of a few hours spent away from the day picnickers and noisy throngs.

Farther north in Adirondack State Park are wilderness lakes, high mountains and enough different peaks to climb to satisfy the most ardent sportsman. A few years ago, doing a story for *Holiday* magazine on the Hudson River, I hiked with ranger Orville Betters to Lake Tear Of The Clouds, the source of the Hudson. It was a tremendous trip. We saw deer, beaver, raccoon, a couple of bear cubs, and it was only a one day journey from the Adirondack Mountain Club hut.

The great states of the Rocky Mountains offer some of the finest recreational areas for the sportsman. Indeed, enough to keep the enthusiastic outdoorsman happy for an entire lifetime.

Going into the great outdoors can be an adventure and, aside from personal gear, what cameras and lenses should be taken along to record all those wonderous sights? If the photographer is serious about pictures, and there is a modest investment in time and money to travel to a distant destination, then a second camera body is the only insurance. No matter how new a camera may be, accidents can happen or it may suddenly quit for no apparent reason.

On a job in California, two Hasselblads stopped working for me in one afternoon. Cameras don't have to be dropped to go out of service—at times they simply clunk and stop altogether!

Photography on any trip, long or short, at home or abroad, is risky with only one camera, and an extra body to take care of emergencies will guarantee pictures. As to lenses, taking everything in the camera cabinet would be nice, but really isn't necessary. A basic minimum for a sporting trip or family holiday would be a wide-angle and a macro tele-zoom lens. These two will surely cover 90 percent of the pictures required and, at the same time, these two lenses will cut down on bulk while strolling about sightseeing in some new city.

One specialized piece of equipment that would be nice to have is the PC (perspective control) lens that eliminates tilting buildings. This lens is a tremendous asset on many travel assignments and a slight movement of the control knob will bring the topmost spires of cathedrals and the tops of buildings and tall timber into view. The lens acts much as a rising front on a view camera and keeps parallel lines straight without the obvious tilt so noticeable in most amateur efforts.

Filters are a necessity for better pictures and no cameraman should be without them. The red and yellow for black and white plus a Skylight and Polaroid for color will cover most situations. Even a couple of spare filters won't add too much weight and could come in very handy indeed if a filter is dropped or scratched.

A small tripod or camera clamp is good to have along for those times when slow shutter speeds won't permit hand-holding the camera and, don't forget those cable releases. Should they be left behind, the self-timer on the camera can be used for tripping the shutter. It will work more gently than the trigger finger.

As to film estimate of what might be needed, double it, then add ten more rolls! It's cheaper, and safer, to have extra film along than be forced to buy it at inflated prices at some fancy resort. When going out of the country, and this includes Canada and Mexico, American films may be available but they will also be more expensive. As to film processing, wait and have it done at home. Foreign film labs usually don't give the same quality (black and white always

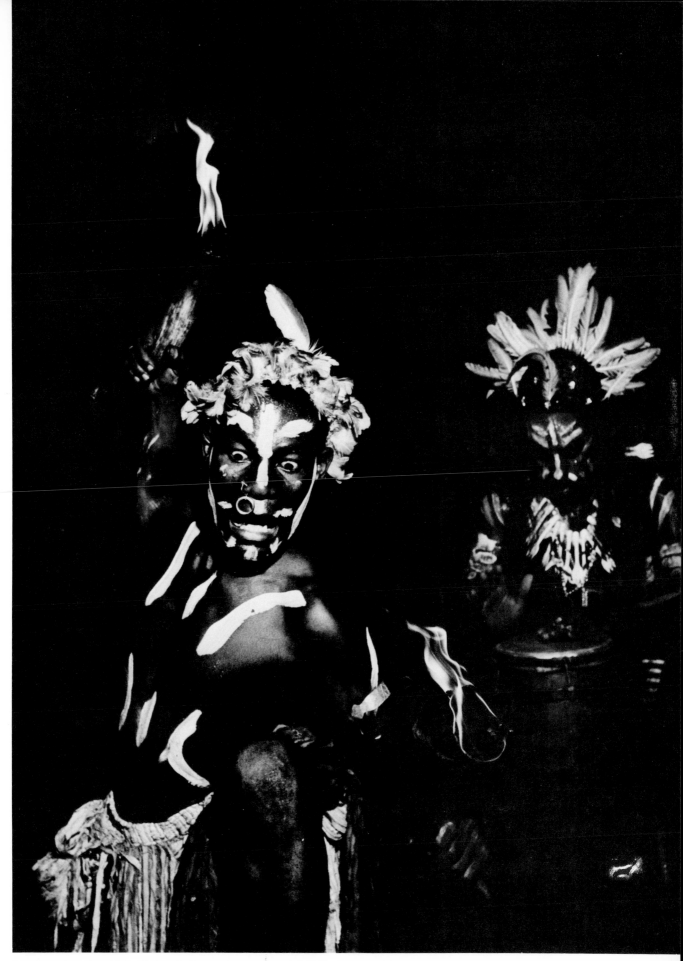

Jamaican shows how his forefathers held a voodoo ceremony. Rolleiflex camera with two electronic flashes and Tri-X film.

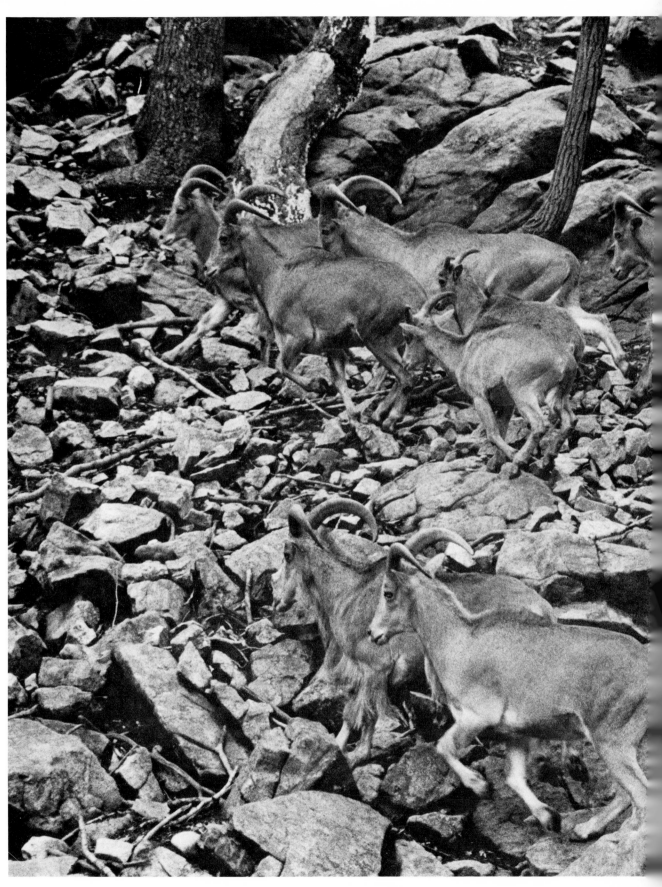

Barbary sheep in New Mexico move away from oncoming horseman. Olympus OM 1MD with motor and Vivitar Series 1 70-210 zoom. Tri-X film used due to high speed of shutter and low level light.

192

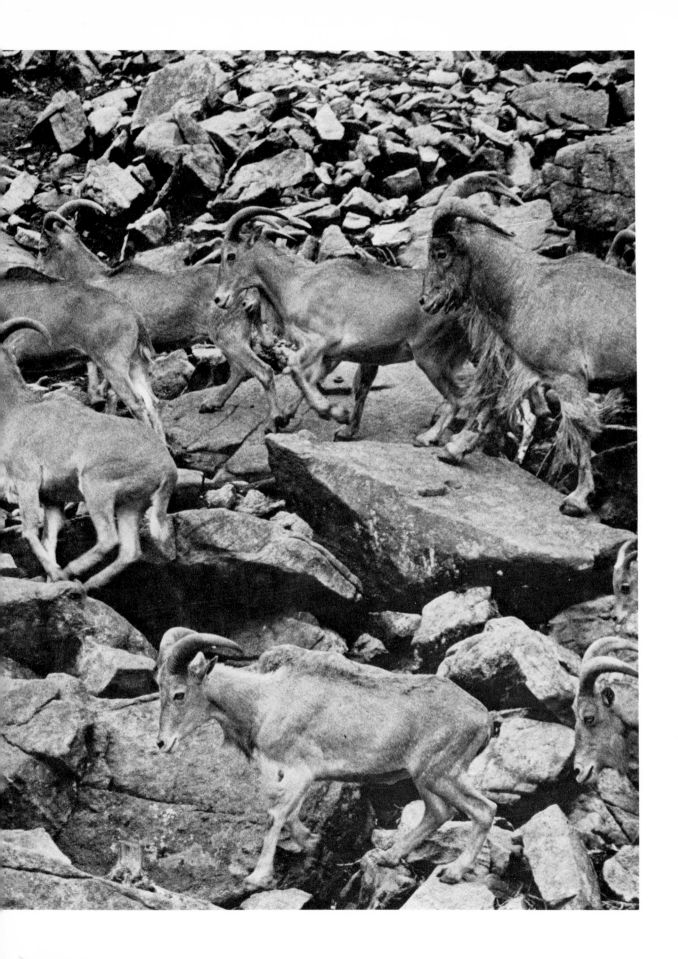

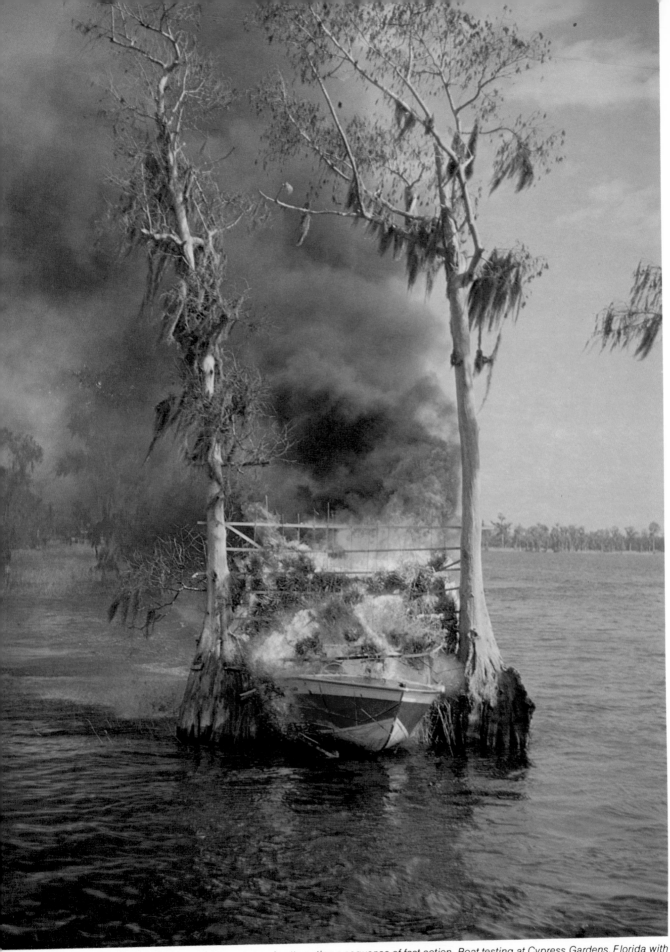

Motorized cameras are necessary in attempting a sequence of fast action. Boat testing at Cypress Gardens, Florida with Barry Burgoon. Crashing through a flaming barrier, the high-speed boat moves fast.

seems to be overdeveloped), and the danger of losing film in the mail, or having packets x-rayed isn't worth the risk. Even a trip of a month or longer won't affect film too much if it's left in an air-conditioned hotel room.

A handy item to carry along—and it won't take too much space—is a small electronic flash unit. One of the newer thyristor types with a second set of batteries could come in handy. These units are quite small, some only slightly larger than a pack of playing cards, and they punch out sufficient light to make quite a difference in many picture situations. All of this equipment can be carried in a small, lightweight canvas shoulder bag, and carry it yourself. Incidentally, never trust camera cases to airlines, porters, doormen or bellboys. Sling the case on a shoulder and play safe. To complete a photographic travel kit some tiny screwdrivers, lens tissue and a camel's hair brush will add only a few ounces and all these tiny items can be stuffed into a side pocket or small case.

The big question arises—where and when should pictures begin for any trip?

I've seen some camera nuts (and I use the term advisedly) expend a roll of film at the airport before anything has happened, continue to shoot continuously aboard the plane—annoying other passengers with their constant antics—and work their way into town clicking everything in sight through the bus window. If it's necessary to have a continual record of everything that happens on a trip I suppose this is the way to go. On the other hand such techniques will give quantity, but little of quality. When the film is viewed back home (assuming the photographer is a glutton for more punishment), most of the pictures will be tossed out and another victim of the snapshooter virus will put his camera away and forget the whole thing.

Dr. Edwin Land, inventor of the Polaroid camera, once stated there are two kinds of photographers: those who want to take good pictures and don't care about photography, and

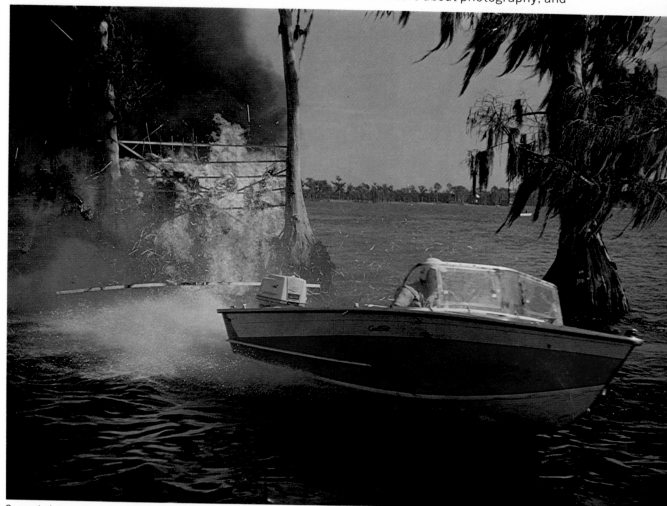

Second picture shows the boat safely moving away from the flames. Entire sequence showed approach of boat to barrier and three pictures of it hitting the flames. Nikon with motor, Ektachrome X film and 35mm F.2 lens.

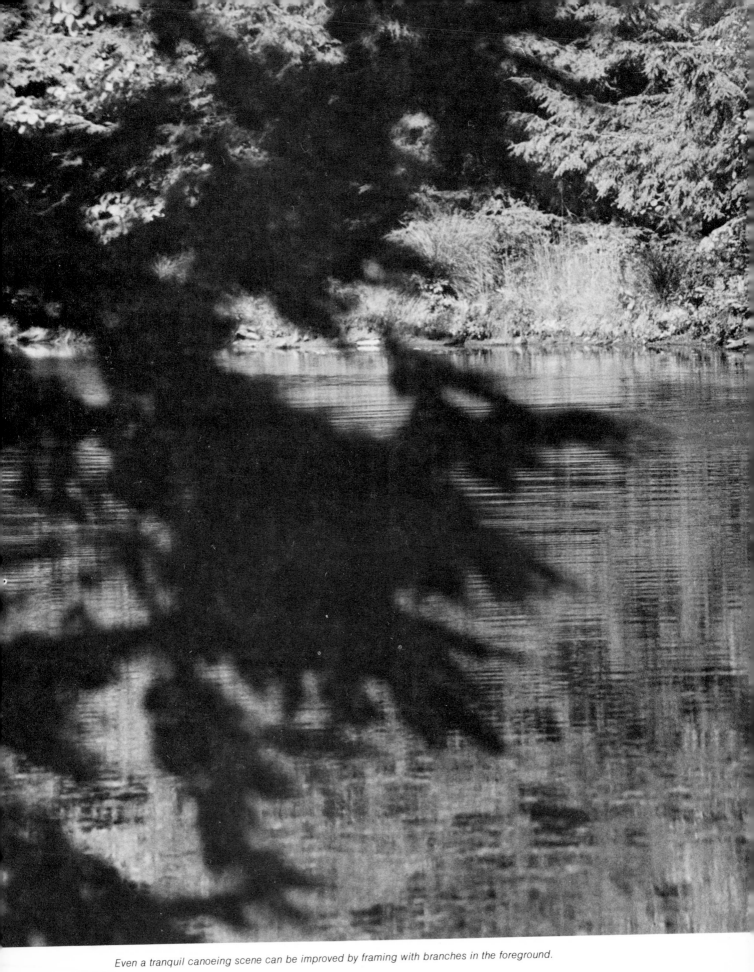

Even a tranquil canoeing scene can be improved by framing with branches in the foreground.

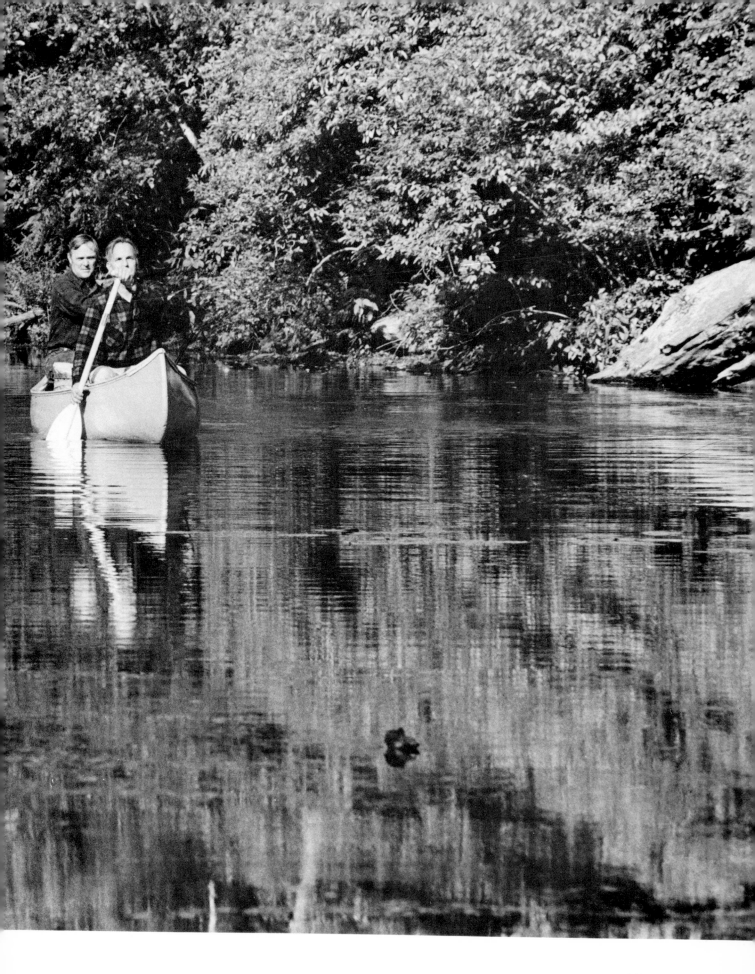

Air views from commercial aircraft. A Borneo Airways DC-3 flys low enough to permit photographs of the offshore islands.

those who care about photography and want to take good pictures. Fortunately, many of the serious camera fans I've encountered fit the second category and have a strong desire to take better pictures. But facing the great outdoors, or even strolling out of a hotel in some strange city, requires something stronger than desire. It requires some thought and planning and a bit of preparation before going off helter skelter in all directions. The outdoorsman, in a city street or deep in the woods, should bring his powers of observation into play. He should look and be aware of what is before him. Watch what the light does, where the sun rises and sets, what shadows do and where they fall. The best way to begin to photograph a strange city is fairly simple. Do some research, lay on a bus tour and get a geographical orientation before beginning serious picturetaking. Granted it's not easy to take pictures through bus windows, even if something interesting is seen, but it's a good way to travel about and find what a city has to offer photographically. Make notes of interesting locales and return later to photograph at leisure. There is only one really good way to see and photograph a city, and that is on foot. The most important accessory for this is not a special lens, but an old, comfortable pair of shoes. Time is needed to study old buildings and their relationship to the light, and the narrow alleyways of New Orlean's French Quarter or the charm of San Antonio's picturesque Paseo del Rio only present themselves after a couple of visits.

The photographer shouldn't feel too limited if there is only one camera along for the walking tour since it can often work to advantage. Too often lugging weighty camera cases can become a chore and the less heft tugging at the shoulders the more concentration can be given to pictures. Vantage points are just as important in picturing a city as they are in photographing some spectacular view and very often an overview or long shot at dawn or dusk can be tremendously exciting.

The cameraman must quickly develop a sensitivity to the new surroundings. Try to look at

198

everything in a different way and with a fresh eye. Overseas it is important to recognize what is foreign: how people dress, the architecture, shops and marketplaces are all different, and in that sense foreign. It isn't always necessary to have the exotic environs of the Grand Bazaar in Istanbul or the souks of Marrakech to create interesting pictures. Nearer home the charm of Old Town in Albuquerque with its fascinating adobe buildings, Spanish square and great cathedral will seem just as foreign to many visitors and will offer as many interesting views.

Frequently the best time for photographing a city is at dusk or twilight. Moviemakers call it the "Magic Hour" although it may only last a few moments. It is that time of day when lights come on to bring a city to life and yet there is still a glow where buildings can be seen against the velvet sky, and the building lights sparkle like jewels set against a curtained backdrop. Rather than laze afternoons away napping in a hotel room (from too much sightseeing) now is the time for serious picturetaking. Once the straightforward picture has been made, try something more difficult. Use Star-effect filters to dramatize the lights, shoot some slow shutter speeds, zoom during exposure and even try a few pictures as the camera is moved during a longer exposure. Blur can frequently add an undefinable mood to color pictures and a few extra frames are worth the effort because, if the pictures are pleasing, it will have added that much more to the photographer's wealth of experience.

Often, in our ever-changing world, travel, home or abroad, can be more of a challenge than it was even a half-dozen years ago. In many places greater personal diplomacy is called for and nearer to home, in some of the newly-independent Caribbean islands, there is a growing tendency to be unpleasant to strangers. If a smile and a friendly word doesn't work, and they frequently don't in some of the former British islands, the safest bet is to walk away. Most of us take pictures to recall happier times and nasty incidents are best avoided. Not to depart our travels on an unhappy note, there are many parts of the world where travelers *are* welcome. Mexico and Canada are two such places I can recall with pleasure and others of recent memory are Hawaii, Fiji, and Tahiti. All those islands have lovely picture-poster beaches with warm turquoise waters. But, except for sunbathing, don't approach any beach for pictures when the sun is high overhead. Such scenes can be the most difficult with dazzling light and

The stunning effect of backlight in color. Taken at Port Antonio, Jamaica with Nikon and 35mm lens. Ektachrome X film.

199

bright reflections off the sand and water. Under such conditions care must be taken when reading a light meter, be it built-in or hand-held.

While the photographer should have faith in the meter used, also move in toward the face of the subject a bit to eliminate excessively high readings. If it becomes necessary to shoot anyway, particularly with a person in the picture, the small flash for synchro-sunlight will open up those deep eye shadows; otherwise wait until the sun moves lower on the horizon when it will fall full on the face, cast some shadows in the background for modeling and generally result in more pleasing pictures.

Side lighting is still the best and will give character to any picture. Great expanses of beach and water, or ski slopes, can be pretty dead without anything in the foreground. So frame through something when taking such pictures; palm fronds, fishing nets strung up on a pole, shells, the bow of a boat—anything will help to give both interest and depth to the picture. High overall views shouldn't be forgotten either. Hotel terraces can offer some interesting angles, and peering through a long lens from an overhead perch can deliver some interesting shots.

When taking pictures in color remember most knowledgeable photographers prefer to take their color before 10 in the morning and after 3 in the afternoon. They know the light is warmer and the lower angle of the sun will give more pleasing results.

Close-to-sunset backlighting is particularly effective with the slanting rays of the sun creating drama. Of course those who won't risk an extra few frames occasionally shouldn't fool around with marginal light; keep the sun over the right shoulder all the time (never mind the dullness of the pictures)—but those who are willing to experiment should try taking pictures

The mountains of Turkey pictured from the flight deck of an F-27 in late afternoon.

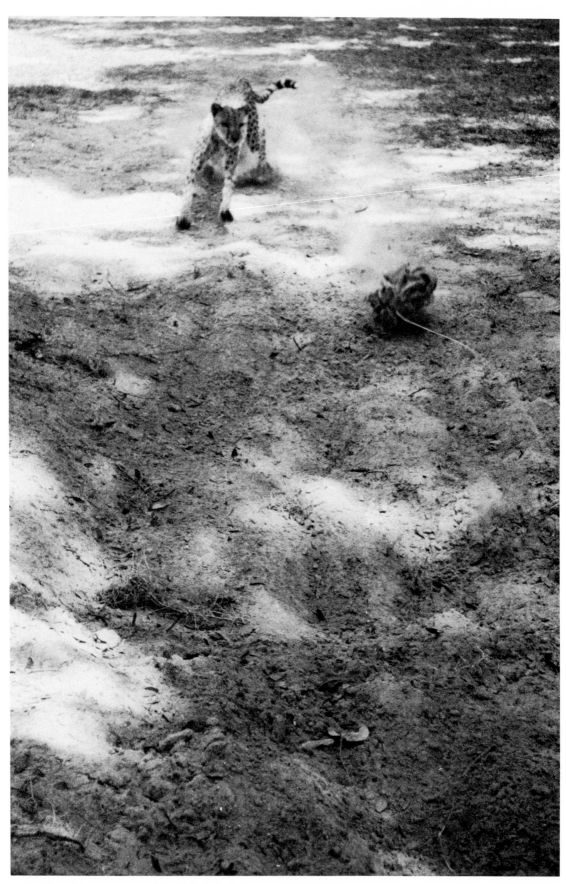

Hunting cheetah being trained to a lure. Tri-X film and motorized Nikon.

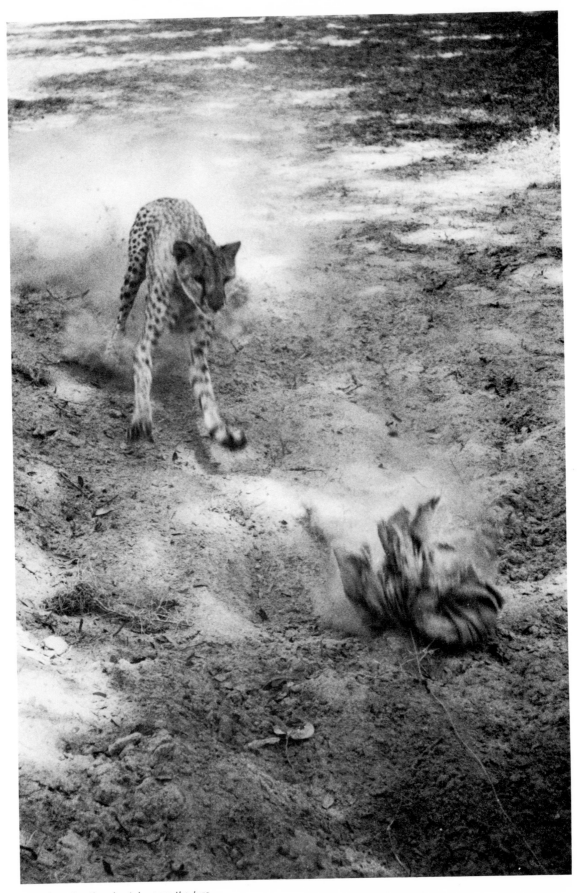

In swift motion the cheetah nears the lure.

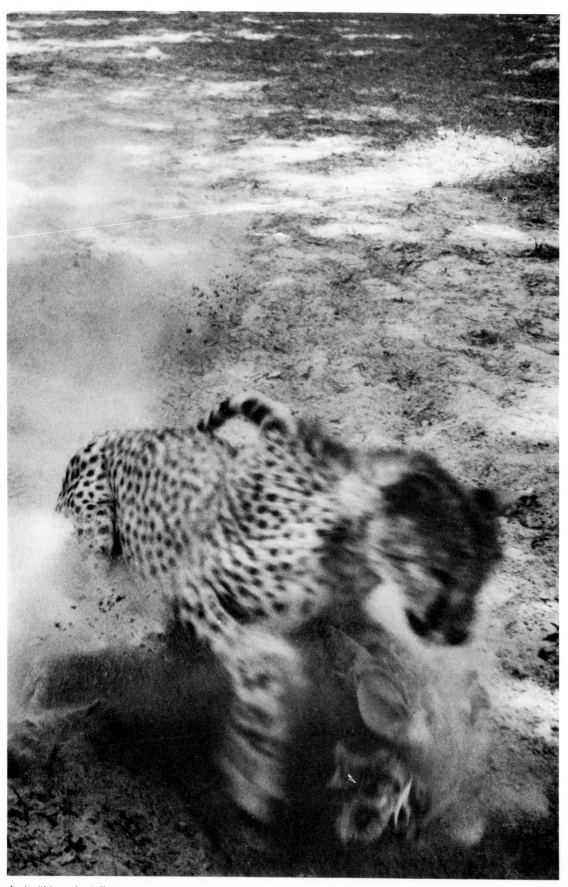

And within a short distance overcomes the prey.

Morning backlight adds interest to young lady bird shooting in Georgia.

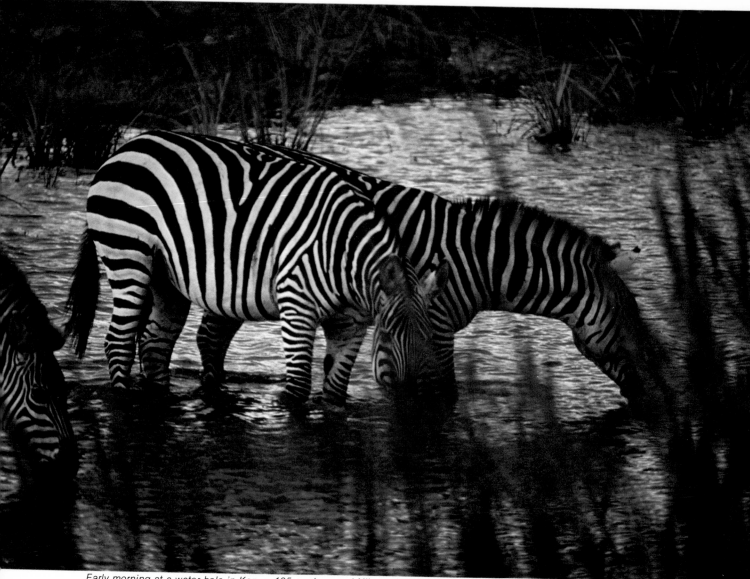

Early morning at a water hole in Kenya. 135mm lens and Nikon camera.

when the light is warmer.

Even the deepest woods will reveal soft, gentle hues when the exposure is correct. Those times of day when larger game isn't about will offer the gratifying antics of tiny squirrels or chipmunks scrambling about trees and logs. The cameraman who has a 135 or 200mm lens on his camera will be able to capture many charming pictures. The graceful forms and golden tones of aspen or the flaming red of maple leaves in autumn become fine subjects for a macro lens. Game tracks in the snow or rotting blowdown, the darkness of hemlock or the deep blackness of hardwoods—these all offer pictures to the observant photographer.

The sportsman who goes into the outdoors (and he doesn't always have to carry a gun) will discover a world much as it was thousands of years ago. He will stride over mountains, barrens, muskeg, rock or desert sands and the skills demanded of the hunter and the sporting photographer are often identical. Woodcraft, tracking, the location of game during different seasons are all within the scope of the average woodsman and they should be learned by the avid nature photographer. With cameras no game laws need restrict the photographer and he is free to roam the outdoors at all times and during all seasons.

As with successful hunters the best technique for pictures is to let the game come to you.

The close confines of a boat call for a wide angle lens. Here a 24mm gives full coverage to a sunning beauty.

Cheyenne Frontier Days offers visual excitement to the cameraman. 135mm lens on a Nikon plus 1/60th second shutter speed to add slight feeling of movement.

Deep sea fishing off Port Antonio, Jamaica. Nikon with 35mm lens and KB 17 film.

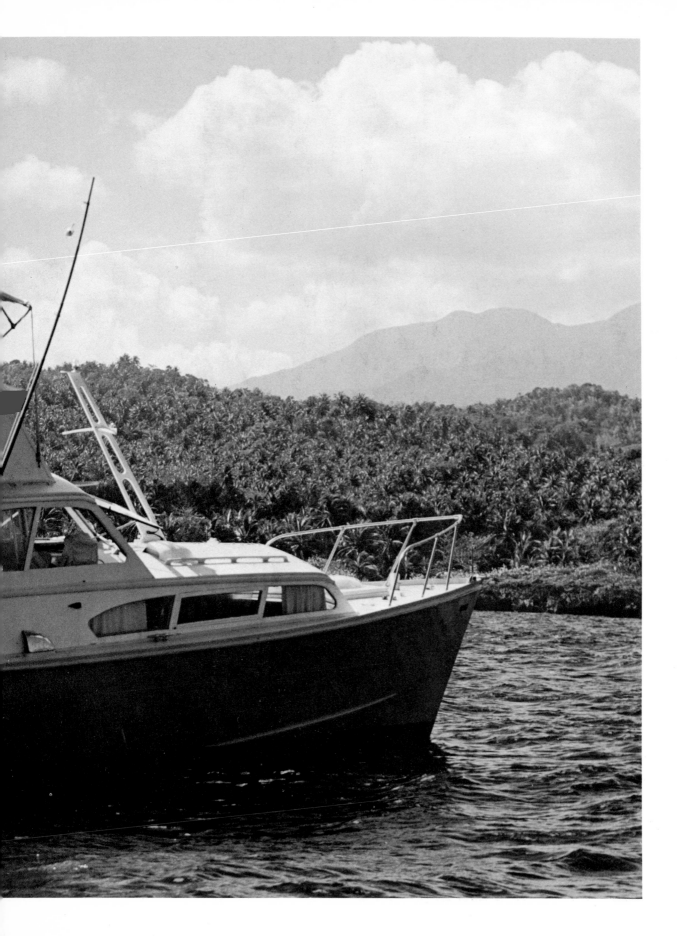

Photographed near Buffalo, Wyoming with light yellow filter.

The effect of slow shutter speeds adds mood to the bullfight. Taken in Mexico with a 135mm lens and Nikon. Ektachrome X film rated normal.

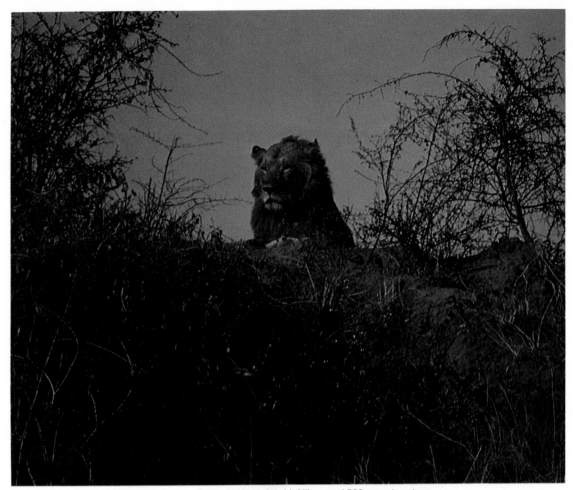
Early morning light adds an orange glow. Taken in Uganda with Nikon and 500mm mirror lens.

When continuously moving afield, only a fraction of the wildlife can be seen and rather than expend energy attempting lengthy stalks, it's often best to wait. Sitting near a well-used game trail is one method and the use of a blind is another. With a well-concealed blind the photographer has the opportunity of becoming part of nature and it offers the best chance to observe and photograph game.

One time near Buffalo, Wyoming I needed some pictures of a buffalo herd. It's extremely difficult to get too near a grazing herd since they are constantly on the move. A young Indian I met told me a walking man can't keep up with a moving herd and the best way to get my pictures was to note the direction of the animals, ride down a bit farther, then settle down behind some rocks and wait. Sure enough. Within the hour the grazing herd came into view and passed quite close by.

Of course it's quite possible to run onto game quite by accident. In northern Tanzania I was driving along a back road with a game ranger when we spotted a young bull elephant dining on a couple of trees. As we drove closer we noticed he paid no attention to our Land Rover. Although he was less than 100 yards distant, the heat waves caused heavy mirage with the long lenses and would cut down on sharpness. I changed to a 35mm wide-angle on one camera and put the 55mm macro, used as a normal lens, on the other body. Walking slowly toward the bull I covered roughly 25 yards when he noticed me. His ears fanned out, he shook his head from side to side violently and pawed the earth. It was a threat display, testing my intentions. I stood perfectly still until he subsided. As he began eating once more, I slowly began to move closer and this time covered about 30 yards and that was it! Trumpeting, pounding the dust and taking a couple of steps toward me, it said halt to the intruder. I slowly raised one camera

Elephant bluffing a charge. Photographed in northern Tanzania with Nikon, 50mm lens and FP 4 film.

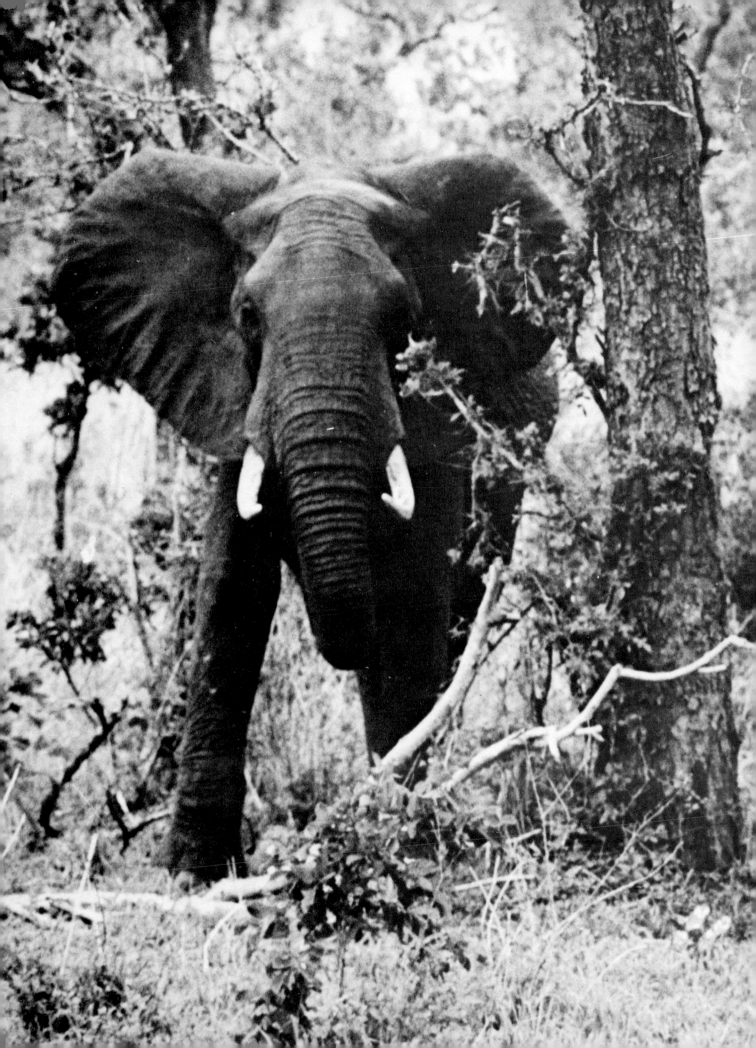

Hippos swimming at the headwaters of the Nile in Uganda.

and began to click away. When that roll was finished I reached for the other camera and continued to shoot. Aside from an occasional glance in my direction he continued to devour the delicacies in front of him. Rather than risk any more distractions, and not wanting to push my luck, I slowly backed off to a safe distance, then hurried to the vehicle.

Frequently the method of transport chosen will get the camera near game. On a moose hunt near White River, Ontario, a friend, Jim Rikhoff of Winchester, and I were paddling along the lake in a canoe when a moose strolled out of the woods and went to the water's edge for a drink. It wasn't a very spectacular specimen, but it did present an opportunity for some fairly close shots.

At other times there won't be any photographic rewards for hours spent in a blind except, perhaps, the dubious pleasure of watching ants, some high-flying birds or the simple diversion of brushing mosquitoes off the back of the neck. Even far ranging rides jouncing along corduroy roads often won't pay off any better except for a sore spine and, at such times, it's best to pack it in and conserve your patience for another day.

Make no mistake about taking wildlife pictures. It can be dangerous and the risk, of course, is that the photographer must move much closer to the subject than a hunter. High-powered rifles can keep bison, bear, deer or elk at least 300 yards away, but to obtain reasonably satisfactory pictures, the cameraman must shorten that gap by half, and frequently get even closer. All of these animals are big, strong, and fast. While they will often run from man it's not something to count on. The reactions of most wild animals can be learned and, up to a point, most are predictable, but like humans each is an individual and they may not follow any set rule. The elephant is a good example. Elephant-bluffing is a game played by a few hardy souls and, it is said, if you don't cut and run, the elephant won't charge. On the other hand I know of few brave enough to play the game with cows or young about. Any female with young is predictable in only one sense: she won't abide by the rules, and generalities can be thrown away.

Shade for soft lighting and props for mood. 4X5 Linhof camera, Skylight filter with Ektachrome X.

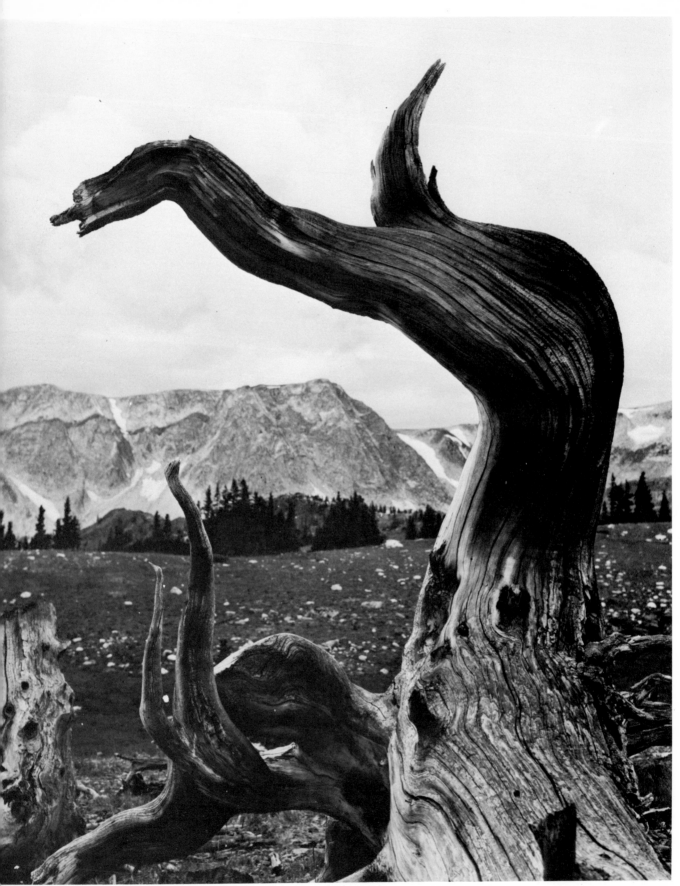

Weather beaten limbs offer a striking foreground above timberline in Wyoming. Superwide Hasselblad and Ilford FP 4 film.

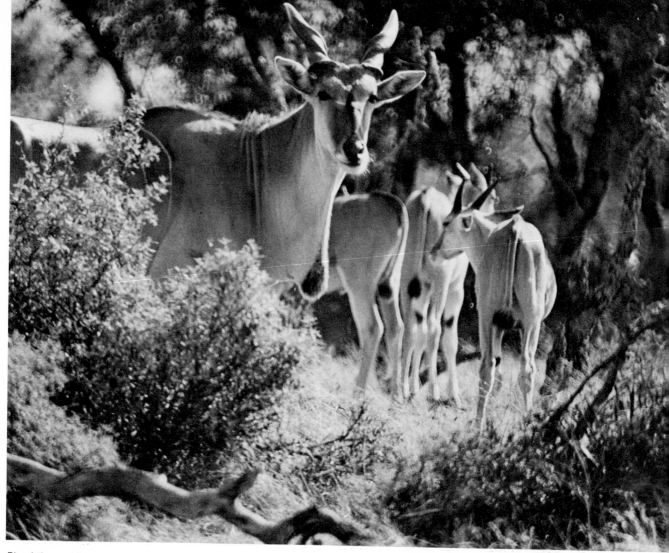

Eland, the world's largest antelopes, roam in a herd at Texas' YO Ranch. Olympus camera and Vivitar Series 1 70-210 zoom. Ilford FP 4 film and medium yellow filter.

For today's sportsman who wants to photograph exotic game, it isn't necessary to travel halfway across the world. African Barbary sheep, Himalayan markhor, Siberian ibex, gemsbok and Persian gazelle may all be found in the American Southwest. New Mexico is a fine example of a state that has worked hard to import these rare species. Even domestic game has been planted in many of these same areas and pronghorn antelope, deer and wild turkey populations have increased with stringent law enforcement and sound game management.

Twenty-five years ago Barbary sheep were introduced with a herd of only 52. Ten years later there were 2500 and it is felt there are now more Barbary sheep in New Mexico than all of Africa. Since those early days, Texas has started a herd as have Nevada, Utah, and Hawaii. Now sportsmen, aside from the opportunity of acquiring fine trophies for their dens, may stalk this handsome game with camera as well.

Incidentally, it might be interesting for all those avid anti-gun cranks to note, this was accomplished by enthusiastic sportsmen and state conservation departments who saved much of this game from extinction by poachers in its native land.

Taking pictures of game and the great outdoors, pictures that are a little different, means taking the camera out in all seasons and all weather. Seeking fresh angles, a new point of view and, when necessary, breaking rules. The greatest danger is that modern cameras have almost made photography too easy. Everyone with a reasonably good 35mm camera and a couple of rolls of Tri-X film thinks he is a photographer. Sadly, this isn't so, but photography certainly has become much simpler and from the casual snapshot to instant color, the camera has almost reached a height of perfection where it is liberating photographers from a dull obsession with the mechanics of *doing* to the freedom of *creating*.

217

A simple picture that adds interest to any trip. Camera was held firmly against the glass window, meter reading taken, and shutter gently tripped. The technique will work from any hotel giving an overview of the city.

An inexpensive prism repeats the image of this Indian lance. No exposure increase is necessary and filters may be used.

Pocket Instamatics, tucked into the pocket of almost every traveler, allow pictures to be snapped without fuss and Polaroid's latest miracle delivers full-color prints within a moment. Ironically, photography is becoming almost too simple and the quick response to all this technical perfection is dulling the eye and slowing the wit of many photographers. Cameras are just pointed and clicked, without any thought to the subject. For the skilled this ease of picturetaking can be, and is, a blessing. For the less talented it has become a double-edged sword, requiring little thought and less perception. It has made the man behind the camera lazy when he should be bolder, trite when he should be exciting, and careless when he should be exacting.

No matter how precise automated cameras become they will never replace the brain for making a command decision nor will these electronic wonders ever replace the human eye. All these cameras can do, and they do it very well, is make the mechanics of exposure and picturetaking simpler and ease the way to recording what is before the lens. The camera must still be directed with care and imagination and the photograph is still an instrument of personal expression. How the photographer reacts to what is before him and how he records his impressions of what is seen is what photography is all about.

The key to success lies in the photographer's willingness to experiment constantly and strive for something different, to be daring and try something that shouldn't work—but does. Then he will be a photographer.

Air view of deserted opal mines turns it into a moonscape. Taken from a light plane near Andamooka opal fields in Australia.

Index

(*Note:* Page numbers in boldface type refer to illustrations and/or their captions.)